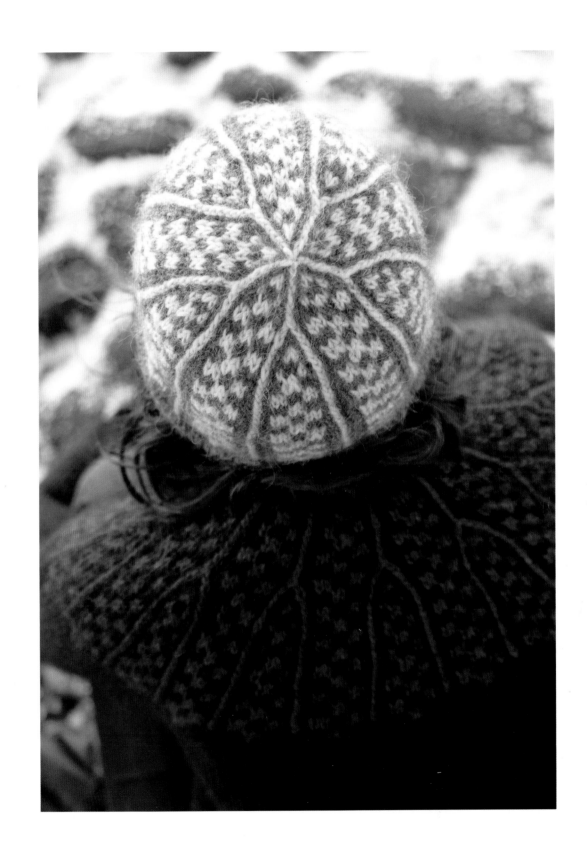

ICELANDIC HANDKNITS

25 HEIRLOOM TECHNIQUES AND PROJECTS

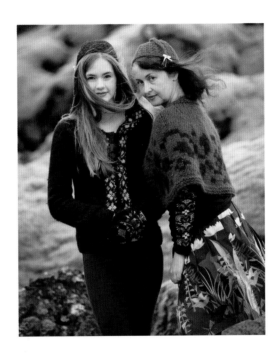

Hélène Magnússon

Foreword by Elín S. Sigurðardóttir, manager,
the Textile Museum in Blönduós, Iceland

Voyageur Press

This book is dedicated to Margrét Jakobsdóttir Lindal.

First published in 2013 by Voyageur Press, an imprint of MBI Publishing Company, 400 First Avenue North, Suite 300, Minneapolis, MN 55401 USA

The information in this book is true and complete to the best of our knowledge. All recommendations are made without any guarantee on the part of the author or Publisher, who also disclaims any liability incurred in connection with the use of this data or specific details.

We recognize, further, that some words, model names, and designations mentioned herein are the property of the trademark holder. We use them for identification purposes only. This is not an official publication.

Voyageur Press titles are also available at discounts in bulk quantity for industrial or sales-promotional use. For details write to Special Sales Manager at MBI Publishing Company, 400 First Avenue North, Suite 300, Minneapolis, MN 55401 USA.

To find out more about our books, visit us online at www.voyageurpress.com.

ISBN-13: 978-0-7603- 4244-2

Editor: Kari Cornell
Design Manager: Cindy Samargia Laun
Design: Simon Larkin and Mandy Kimlinger
Layout and charts: Mandy Kimlinger

On the front and back cover: Photography © Amaldur Halldórsson

Library of Congress Cataloging-in-Publication Data

Hélène Magnússon, 1969-
 Icelandic handknits : 25 heirloom techniques and projects / Hélène Magnússon; foreword by Elín S. Sigurðardóttir, manager, the Textile Museum in Blönduós, Iceland.
 pages cm
 Includes bibliographical references and index.
 ISBN 978-0-7603-4244-2 (hardcover)
 1. Knitting--Iceland--Patterns. I. Title.
 TT819.I2H43 2013
 746.43'2041--dc23
 2012028391

CONTENTS

Foreword by Elín S. Sigurðardóttir
 A Brief History of the Textile Museum in Blönduós . . . 6

Introduction . **14**

Chapter 1: Inspired by Mittens **16**
 Checkered Mittens & Beanie 18
 Leaf Mittens, Slouchy Cap & Scarf 24
 Skagafjörður Mittens 34
 Skagafjörður Tote Bag 38
 Nordic Leaf Mittens 44
 Perlusmokkar: Beaded Wrist Warmers 50
 Perluband: Beaded Armband & Hairband 54

Chapter 2: Inspired by Traditional Costumes **58**
 Skautbúningur Sweater 60
 Mötull Capelet 66
 A Perfect Little Icelandic Sweater 70
 The Missing Lopi Sweater 74

Chapter 3: Inspired by Footwear **80**
 Icelandic Shoe Inserts 81
 Icelandic Soft Shoes 88
 Step Rose Cushion 92
 Broken Rose Blanket 96
 Togara Socks 100
 Sock Band Socks 104

Chapter 4: Inspired by Lace **108**
 Halldóra Long Shawl 110
 Margrét Triangular Shawl 114
 Lace Hood 120
 Klukka Skirt 124
 Lacy Skotthúfa 128

Special Techniques **132**
Abbreviations **140**
Yarn Sources **140**
Knitting References **140**
Acknowledgments **142**
About the Author and Photographer **143**
Index . **144**

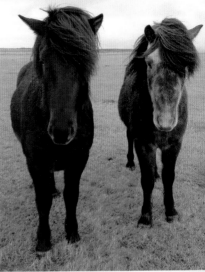

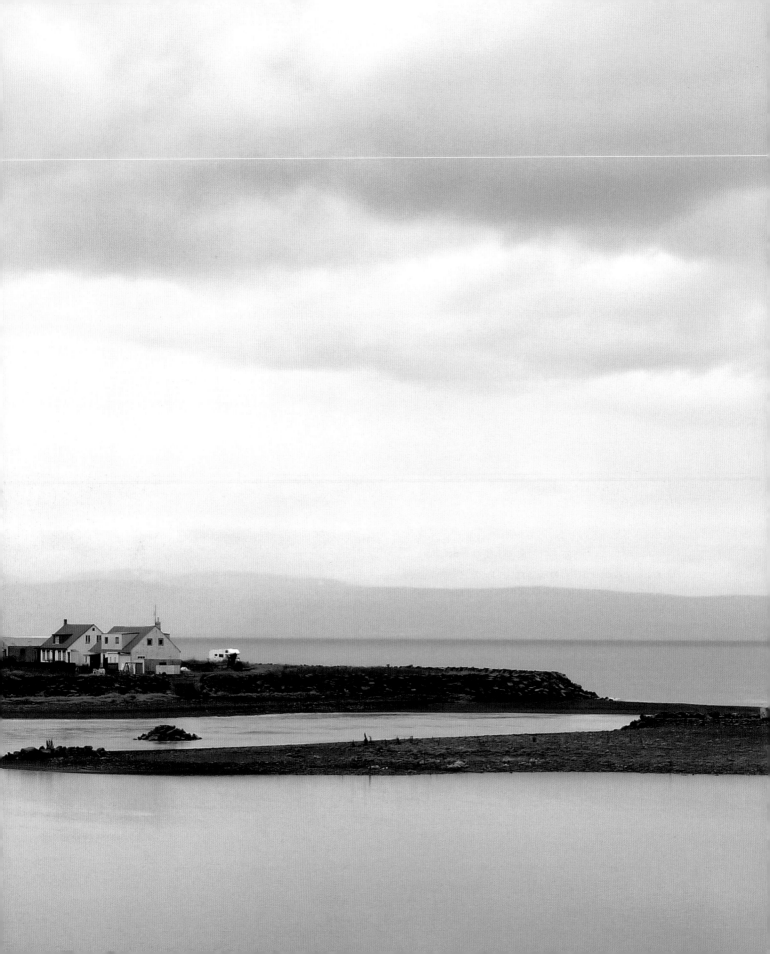

FOREWORD

BY ELÍN S. SIGURÐARDÓTTIR, manager,
Textile Museum in Blönduós, Iceland

The book that you now hold in your hands, *Icelandic Handknits*, provides thoughtful insight into the knitting traditions practiced in Iceland during the nineteenth and early twentieth centuries. During this time, very fine yarns were spun with the soft undercoat or the rougher outer coat of Icelandic sheep and made into artistic artifacts, knitted and woven, in a vast array of natural sheep colors or plant-dyed hues.

It is so inspiring to see how the old knitted artifacts from the Textile Museum's collection have been given new life in Hélène's hands. Some of the artifacts have been simply re-created, while others have served as a springboard for an entirely new design. The Textile Museum is honored to be a part of this book.

On the first day of the Icelandic summer, April 19, 2012
Elín S. Sigurðardóttir, Textile Museum Manager

A BRIEF HISTORY OF THE TEXTILE MUSEUM IN BLÖNDUÓS

The Textile Museum was originally opened in 1976 on the centennial commerce anniversary of the town of Blönduós, located approximately 155 miles (250 km) north of Reykjavík in Northwest Iceland. The foundation for the museum was laid by members of the Women's Union of Austur-Húnavatnssýsla (In Icelandic: *Samband austur-húnvetnskra kvenna*), which had formed a folk museum committee in the early 1960s composed of representatives from ten women's organizations from three counties: Eastern Húnavatnssýsla, Western Húnavatnssýsla, and Strandasýsla.

There was some disagreement about where the museum should be located, but the committee finally decided to establish the Húnavatns- and Strandasýslu Folk Museum at Reykir in Hrútafjörður. Many folk museum committee members were unhappy with this decision, but when it became clear that there was no basis for creating another folk museum in Blönduós, the committee changed their name to the Textile Museum Committee and focused on collecting items that told the story of Iceland's rich textile history.

Opposite: *View from the Textile Museum in Blönduós of the mouth of the River Blandá, one of the best rivers for salmon fishing in Iceland.* The Textile Museum in Blönduós

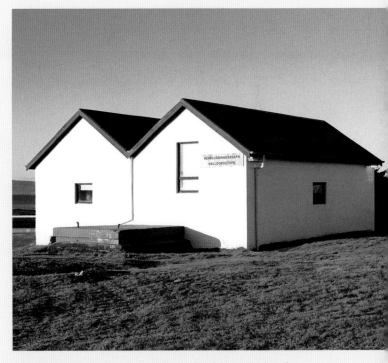

The Textile Museum was created in the old cowshed and barn of the Women's School. In this old building, there was very little space and many of the artifacts were kept in boxes in the basement.

A New Building

The original site for the present Textile Museum was an old building that once served as the cow shed and barn for the Women's School in Blönduós. A great deal of work was required to get the building into acceptable shape. Each of the women's organizations contributed what they could to finance the project, and many volunteers donated their time to renovate the building.

Eventually, the Textile Museum of Blönduós emerged. At first it was only open on weekends, but gradually the hours were extended. It soon became evident that many small organizations could not run the museum properly. Yet it wasn't until 1993 that a holding company for the museum was founded, which included the local municipalities.

At this time, the board of the museum's holding company began to give serious thought to expanding the premises, seeking the professional advice of textile experts and museum curators. After careful consideration, the museum decided to erect a new building that would connect to the old museum building.

Construction on the new building began in October 2001, and it was inaugurated with a formal ceremony in May 2003. The start-up cost was fully paid off in just over two years. The building, which features three exhibition halls, a coffee room, an office, and a service area, is connected to the old building on both floors.

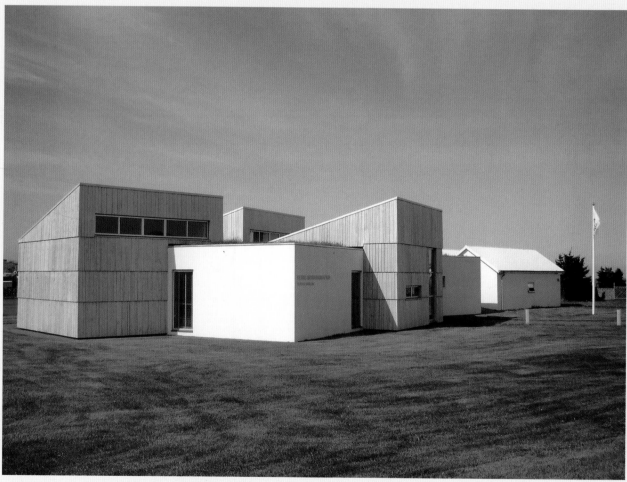

In 2003, the museum was greatly expanded with the construction of a new building connected to the old one.

8

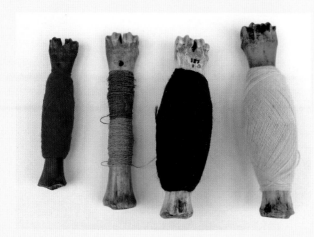

These yarn bobbins, made from sheep bones are called
þráðaleggir in Icelandic, which literally means "thread's legs."
Some are dyed, hence the brown and green color. The Textile
Museum in Blönduós, Reference HB587

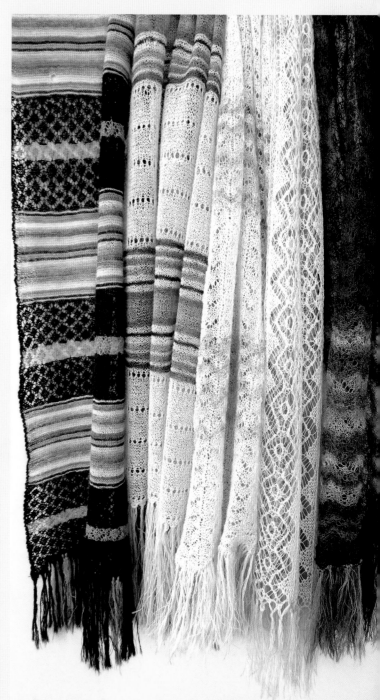

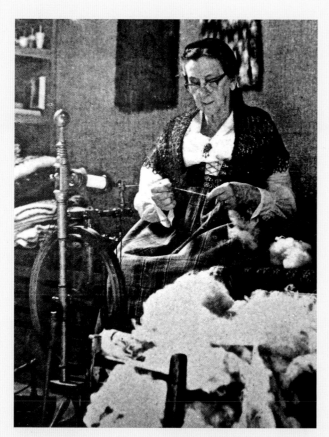

Hulda Á. Stefánsdóttir (1897–1989), former director of the
Women's School in Blönduós, is spinning on an Icelandic vertical
wheel. The Textile Museum in Blönduós

Long shawls knitted with the tog—the coarser hair. Although
tog would normally be reserved for rougher projects such as
rugs and ropes, it makes a very crisp and elegant lace. Wearing
a tog shawl is a unique experience—the shawls has weight to
it and envelopes the wearer, yet it is light as feather. The Textile
Museum in Blönduós

Exhibitions

When the new building opened, the museum's board established that the theme of the exhibitions displayed in the new section should be "The Thread." Thread is the foundation of all textiles, and it defines the connection between past and present. The emphasis of the textile exhibitions was to induce moods and impressions of eras, rather than attempt to display many similar artifacts at once.

The exhibitions are independent, created from the museum's artifacts. There is, for example, a special embroidery exhibition, where beautiful women's lingerie from times past, decorated with artful embroidery, crochet, and other detailing, are on display. Curators take care to ensure that the exhibition changes and evolves over the years, making the best use of the diverse selection of the museum's artifacts.

The museum has a variety of Icelandic traditional national dress costumes (In Icelandic: *þjóðbúningar, skautbúningar, upphlutir, peysuföt*), mostly from the nineteenth century, and these costumes make up a special exhibition at the museum.

In the wool exhibition, the entire production of wool is represented, from the fleece off the sheep's back to processed garments. This exhibition allows guests to touch the Icelandic wool and feel the difference between *tog* and *þel*. The *tog* is the outer, protective layer of hairs that make up the fleece, while the *þel* is made up of the soft hairs that lie closest to the skin. In the past, the wool was always separated in a process called "taking off the top"; that is, dividing the *tog* from the *þel*.

Beautifully handcrafted shawls, made from *tog* or *þel*, can be viewed in this exhibition. The threads of some have been dyed with herbs, while others maintain the natural colors of the sheep. It is wonderful to behold how finely spun both the *tog* and *þel* threads are. Patterned mittens, woolen underwear, riding clothes, vintage photographs showing people processing wool, and a selection of wool processing artifacts are on display.

Halldórustofa

Halldóra's Room (In Icelandic: *Halldórustofa*) is a special division within the museum dedicated to the life and work of the remarkable woman Halldóra Bjarnadóttir (1873–1981), who was best known for her pioneering work in the education and culture of women and the promotion of the textile industry in the last century.

Bjarnadóttir completed a pedagogical degree in Norway in 1899 and taught at the Reykjavík Elementary School for the

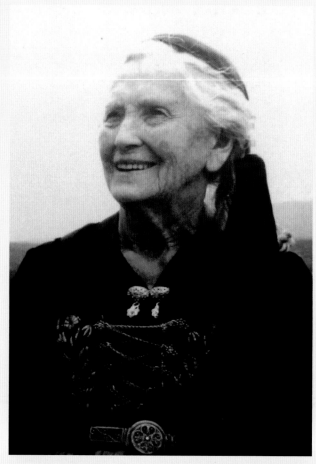

Halldóra Bjarnadóttir at age 91, wearing the peysuföt *and the* skotthúfa. *The Textile Museum in Blönduós*

next year before moving back to Norway, where she taught until 1908. Then Bjarnadóttir was offered the position of principal at the Akureyri Elementary School, which she accepted alongside teaching duties for the next ten years. During this time, she introduced various innovations in education, including teaching arts and crafts, which was considered unnecessary since the children could learn those skills at home. Bjarnadóttir stayed active after she resigned from the position of principal in 1918. She taught at the School of Education in the Kennaraskóli Íslands, held seminars and lectures all over Iceland, helped found local women's organizations and their umbrella unions, and worked mainly with the Women's Union of the North. Bjarnadóttir wanted to uphold the women's culture by showing what the women were making in their homes, stressing how each home was really a factory where wool was being transformed into clothing.

Bjarnadóttir organized many exhibitions in Iceland and abroad where she displayed Icelandic textiles such as mittens, shoe inlays, and shawls, all made from scratch with homespun and home-dyed thread. In her travels around the country, Bjarnadóttir collected all kinds of woven and knitted samples and items and tools for working with wool. Many of the items from her collections are on display in Halldóra's Room, along with some other items.

Bjarnadóttir held an advisory position (In Icelandic: *heimilisráðunautur*) with the Agriculture Union of Iceland and founded and published the annual journal and magazine *Hlín* for forty-four years. When she was in her seventies, Bjarnadóttir founded the Wool Processing School (In Icelandic: *Tóvinnuskólinn*) in Svalbarð in the county of Suður-Þingeyjarsýsla, in Northeast Iceland, which she ran for nine years, from 1946 through 1955.

Bjarnadóttir corresponded with more than five hundred people and wrote numerous papers, magazine articles, and the book *WEAVING in Icelandic Homes in the Nineteenth and First Half of the Twentieth Century* (In Icelandic: *VEFNAÐUR á íslenskum heimilum á 19. öld og fyrri hluta 20. aldar*). Originally published in 1966, the book was reprinted by the Textile Museum in 2009. The new edition contains an introduction about Bjarnadóttir written by historian Áslaug Sverrisdóttir, which has been translated into English. The book is enhanced with old black-and-white photos and color photos of various woven samples, artifacts, and other items. This book is quite remarkable since it not only covers the weaving practices and artistic tendencies of Icelanders in the past, but it also discusses the domestic structure and working conditions in those times, making it a valuable common folk history of the Icelandic people. The majority of the textile artifacts that are presented in the book are preserved in Halldóra's Room.

During the last few years of her life, Bjarnadóttir stayed in Héraðshæli Austur-Húnvetninga (the health care facility in Blönduós). When she moved to the nursing facility at the same institute around 1976, she bequeathed her last possessions to the Textile Museum in Blönduós. She died at the old age of 108. Her belongings were placed in an inner room of the old museum building called Halldóra's Room. After the new building became functional, the entire upper floor of the old building was dedicated to Bjarnadóttir and became Halldóra's Room.

Summer Exhibitions

When the museum opened the new building, Icelandic textile artists and designers were invited to exhibit their work in

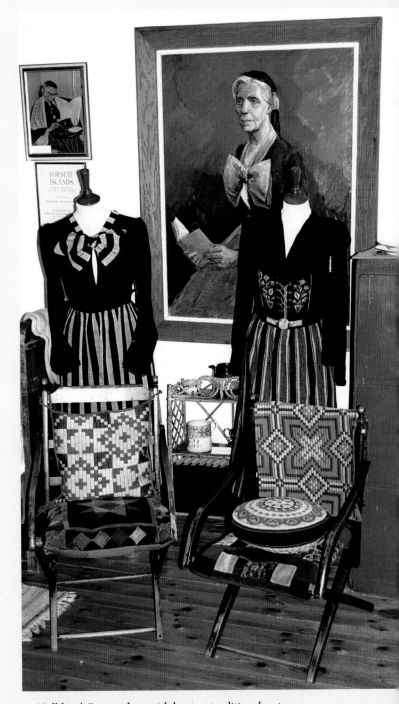

In Halldóra's Room, along with her two traditional costumes is a portrait of Halldóra made in 1960 by painter Örlyg Sigurðsson (1920–2001). Hanging on the wall to the left is also a black-and-white picture of Halldóra wearing her peysuföt and the tog shawl, made by Jóhanna (pattern "Halldóra Long Shawl," page 110). The Textile Museum in Blönduós

the museum's open area. The goal was to have very different exhibitions each year, providing museum visitors with a sampling of the diversity inherent in Iceland's textile world. More information about the Textile Museum's summer exhibitions is available at www.textile.is.

Many people await the opening of each new spring exhibition at the Textile Museum with great anticipation. Admission is free on opening day, and visitors enjoy coffee and *kleinur* (an Icelandic doughnutlike pastry, see recipe on page 28) while they listen to traditional music performed by everyone from kindergarten and elementary school children to highly trained professional musicians.

A National Treasure

The Textile Museum in Blönduós is the only museum of its kind in Iceland. Its purpose is to collect, preserve, and catalog textile-related items from throughout the country. The museum is a research institute for domestic and foreign students and academics. The museum offers workshops, seminars,

and lectures as well as special student exhibitions of textiles throughout history.

The Textile Museum tells the story of the forgotten textile practices from the past to the present, providing insight into the work that was carried out within Icelandic homes every day for centuries. Throughout history, the production of wool in Iceland was a quiet cottage industry, in which each home was self-sufficient, transforming wool into clothing and making full use of all the available raw materials. Through the efforts of the Textile Museum, this essential part of Icelandic history has come to light.

The museum shows a sliver of the nation's occupational history, illustrating how self-sufficient farming and home industry met modern, business-oriented farming in the late nineteenth and early twentieth centuries. The museum is a cultural institution that fulfills a diverse role. Iceland is rich with nature, culture, and history, all of which we are obligated to preserve and convey to future generations. The Textile Museum plays an active role in these preservation efforts.

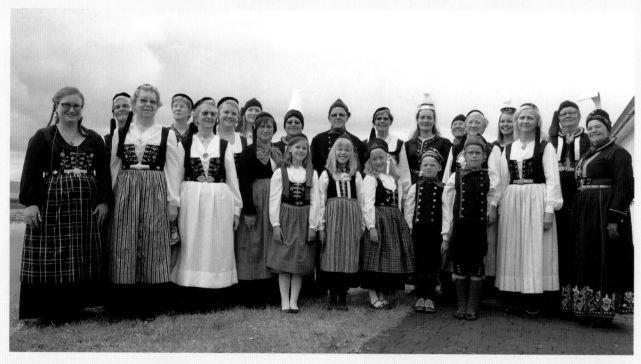

Women, men, and children wear costumes from nineteenth- and twentieth-century Iceland during Costume Exhibition Day at the Textile Museum in Blönduós. The event, which was held on July 27th, 2012, was co-hosted by the Icelandic Handicraft Association.

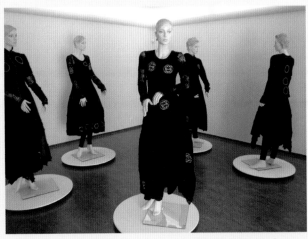

Dresses from Rósa Helgadóttir, decorated with embroidery inspired by metal jewelry from the museum, were part of the Textile Museum's summer exhibition in 2009.

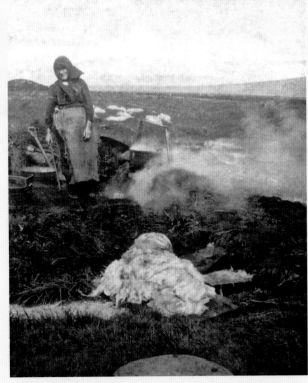

Sigurlaug Bjarnadóttir (1865–1953) is washing wool in a hot spring. The Textile Museum in Blönduós , Reference HIS1326

This traditional turf church, which dates from 1842, was once in Silfraðastaður near the fjord of Skagafjörður, a half hour away from the Textile Museum. The church is now at the Árbær open-air Museum in Rykjavík, where it is part of a little village created from historic houses that have been moved from all over the country.

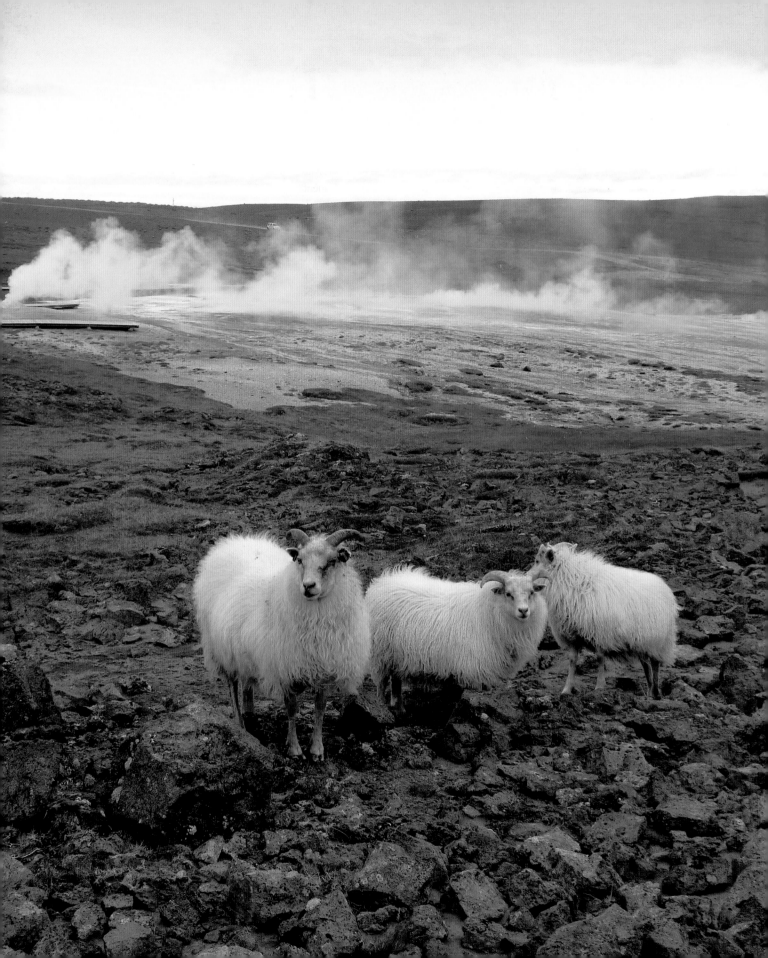

INTRODUCTION

The Icelandic knitting of today conjures up visions of lopi yoke sweaters knit in natural colors, but you won't find any lopi sweaters in the textile museums in Iceland. The reason for that is simple: the "traditional" Icelandic sweater is a relatively recent invention. In the 1950s, as yoke sweaters became fashionable in the Western world, a yoke sweater with a definite Icelandic flair emerged, and by the 1970s, it was immensely popular. The unspun lopi with which the *lopapeysa*—which literally translates as "sweater in lopi wool"—is knitted is a bit older, dating back to the early 1900s, when "lazy" women began to knit without spinning the wool into yarn first.

But Icelandic museums do have many beautiful handknits: all kinds of mittens with color-stranded work that have been decorated with cross-stitch, socks, caps, lace shawls, trousers, costumes, jackets with a great deal of shaping, underwear, inserts for shoes, blankets, pillows, and more. The abundance of so many different handknits is not at all surprising; there is indeed a rich tradition of knitting in Iceland, dating back to the early sixteenth century. English, German, or Dutch merchants may have brought knitting to the island. I don't think it came from English merchants, though, because Icelanders don't knit the English way, but hold the yarn in the left hand. Knitting quickly spread throughout the country and soon became the main cottage industry. Everyone was knitting—young and old, men and women—and all were supposed to produce a specified amount of knit goods over a certain period of time. People were knitting both refined knits on tiny needles for special occasions and more utilitarian garments for their own everyday use. They were also knitting an enormous quantity of goods, probably much rougher and in plain colors, aimed for exportation.

Evidence of this early knitting heritage can be found in district museums here and there throughout Iceland. Few pieces date back earlier than the nineteenth century, but the artifacts provide a good overview of traditional knitting in Iceland. The National Museum has many knitted artifacts, but few of them are on display within the permanent collection, and you will have to wait for a special temporary exhibition to admire them.

The Textile Museum in Blönduós, however, displays one of the best permanent collections of handknits in Iceland.

My introduction to the rich knitting heritage housed at the Textile Museum in Blönduós came in 2000, while I was studying textile and fashion design at the Iceland Academy of the Arts. The museum's extension was then just a project, and the building consisted solely of a little house that was the ancient barn of the Women's School, now known as Halldora's Room. At the time, the museum had little room to display artifacts, so a large part of the collection was kept in storage on the ground floor.

I remember the visit quite well. I was pregnant with my first daughter, it was during the winter, and the museum was quite cold. We were given white gloves and permission to open all the artifact boxes, take everything out, and touch the pieces. It was an amazing experience, like going on a treasure hunt and indeed finding the treasure! We felt like children in a candy store who were allowed to eat as many sweets as we desired.

For some reason, I was particularly drawn to the knitting artifacts, and I took many pictures of all the knitting in the museum. Some ten years later, when Voyageur Press asked if I would like to write *Icelandic Handknits*, I had much of the precious first research material already on hand, and I suggested we work with the artifacts from the Textile Museum. I hope this book will bring more attention to the amazing museum in Blönduós, where, if careful and if wearing the white gloves provided by the museum, one may open the drawers and touch the garments.

Inspiration for the patterns on these pages came joyfully: sometimes I modernized an old design and adapted it to today's yarns and standards, but often I was inspired to create a completely new design based on different artifacts I discovered in the collection. All the designs I've created have a recognizable traditional look but with a modern touch. I hope you enjoy knitting a few of your favorites for family and friends. I invite you to join me on trip to the Textile Museum during the knitting tours I guide in Iceland (For more information, go to icelandicknitter.com).

Opposite: Two hours from the Textile Museum, sheep graze in an Icelandic oasis—a hot spring area in the middle of the desertic highlands. I often take knitters there during my tours.

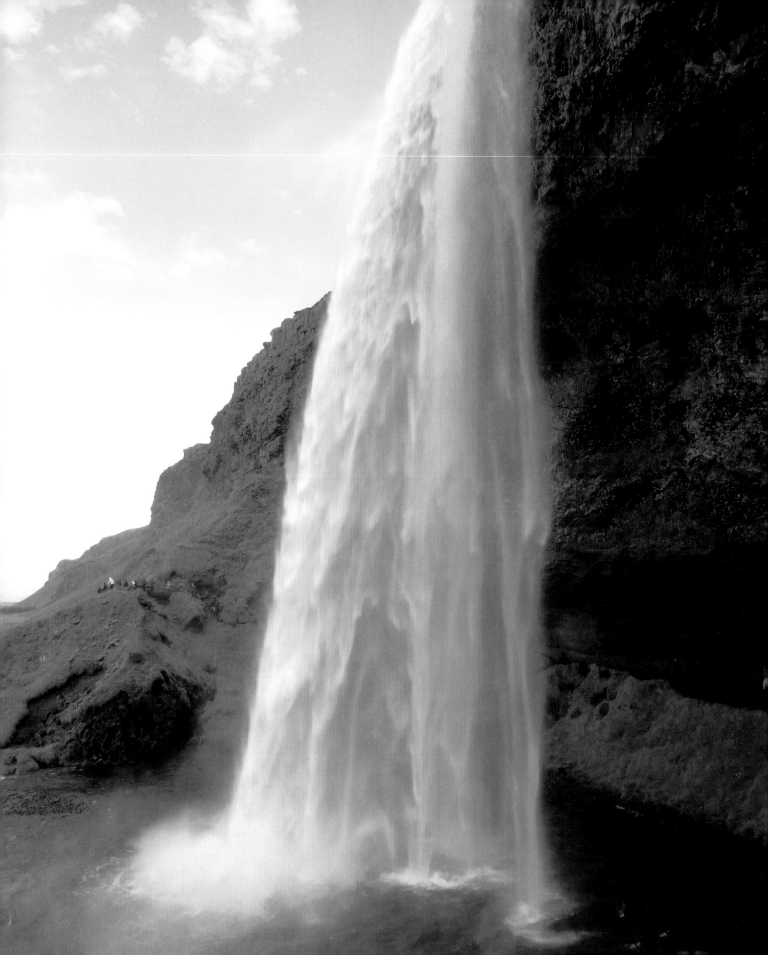

CHAPTER

1

INSPIRED BY MITTENS

There are many different types of mittens in the Icelandic knitting tradition. Specific motifs and patterns may originate from an area of the country or even from a particular village or family. Before knitting came to Iceland in the sixteenth century, mittens used to be sewn out of woven woolen, and as recently as the nineteenth century, a woman from North Iceland reported that she had seen a pair of sewn mittens. This chapter presents the main Icelandic mitten styles, often knitted with very fine yarn and worn only on special occasions: stranded mittens, leaf mittens from the Westfjords, embroidered mittens, Nordic-style mittens, and beaded wrist warmers.

Opposite: *I took this photo during my knitting trek between Fire and Ice of the beautiful Seljalandsfoss Waterfall. You can walk behind the falls.*

CHECKERED BEANIE & MITTENS

Stranded mittens with a simple pattern of no more than a 3-stitch, 3-row repeat created a fabric that was very thick and warm—entirely suitable for mittens. Knitted in Icelandic wool and slightly felted, the mittens were water repellent. One of my favorites is a light brown pair with a white patterning intended for men. The decreases for the hands are not on both sides of the palm but within each pattern repeat, thus there is no left or right mitten. I love how the gusset thumb opens out from the cuff to the base of the thumb and then closes again around the hand, as a mirror image of the thumb. The result is not only extremely pleasing aesthetically but also produces one of the best-fitting and most comfortable mittens I have ever come across. The original mittens were knit at a very small gauge on fine needles, but I chose to work with a much thicker yarn. The Checkered Beanie came very naturally as an ode to the gusset. I used the same types of decreases to shape the crown as I did for the mittens.

CHECKERED BEANIE

Sizes
Child S (Adult M/L)

Finished Measurements
Head circumference: 20 (23)"/51 (58.5)cm

Materials
- ístex *Léttlopi*, 100% pure Icelandic wool (light spun, medium weight), 50g/1.75 oz, 109 yds/100m per skein: #1420 mottled brown (MC1) and #0051 white (CC1), 1 skein each
- Sizes US 4 and 6 (3.5 and 4mm) circ needle
- Magic loop is used for smaller diameters or double-pointed needles
- Stitch markers
- Darning needle

Gauge
22 sts and 24 rows = 4"/10 cm in St st using size 6 (4mm) needle
Adjust needle size as necessary to obtain correct gauge.

CHECKERED MITTENS

Sizes
Adult M (L, XL)

Finished Measurements
Hand circumference: 7 ¼ (9 ¼, 11 ¼)"/18.5 (23.5, 28.5)cm
Hand length: 7 (8 ¾, 9 ½)"/18 (22, 24)cm
Note: You can achieve more sizes by changing needle size.

Materials
- ístex *Léttlopi*, 100% pure Icelandic wool (light spun, medium weight), 50g/1.75 oz, 109 yds/100m per skein: #0053 acorn heather (MC2), #0059 black (CC2), 1 skein each
- Sizes US 4 and 6 (3.5 and 4mm) circ needles
- Magic loop is used for smaller diameters or double-pointed needles
- Stitch markers
- Darning needle

Gauge
22 sts and 24 rows = 4"/10cm in St st using size 6 (4mm) needle
Adjust needle size as necessary to obtain correct gauge.

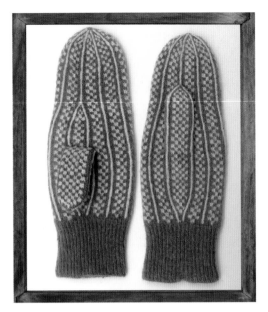

In her quest to preserve traditions and valorize handiwork, Halldora Bjarnadottir organized competitions from time to time. She writes in her register in 1961 that these mittens were part of one such competition, but there is no specific information about the location of the competition, the knitter, or the date. The Textile Museum in Blönduós, Reference HB652

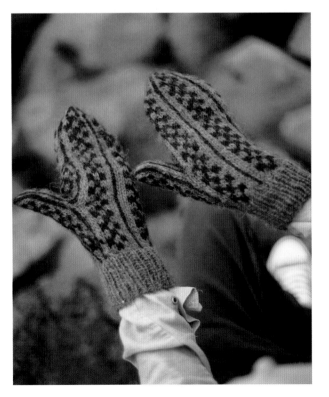

BEANIE INSTRUCTIONS

With MC1 and smaller circ needle, CO 88 (110) sts. Join, taking care not to twist sts, pm at end of rnd. Work in *k1, p1* rib for 5 (6) rnds. Change to larger circ needle. Following Beanie chart, work Pattern A 4 (5) times across and upward following shaping. When Pattern A is complete, 4 (5) sts rem.

Break off yarn, draw it through the sts. Weave in loose ends.

MITTENS INSTRUCTIONS

Mittens (Make two)

With MC2 and smaller circ needle, CO 35 (46, 57) sts. Pm for beg of rnd and join, taking care not to twist sts. Work in *k1, p1* rib for 2"/5cm. Change to larger circ needle. Following Mitten chart, work Pattern B1 across and upward according to chart.

Thumb Opening

Following chart, knit the 8 (9, 9) sts indicated for thumb with contrasting scrap yarn, place sts back on left needle and knit them again in pattern motif, knit to EOR (end of rnd).

When Pattern is complete, 3 (4, 5) sts rem.

Break off yarn, draw it through the sts.

Thumb

Remove scrap yarn and set sts on needle. With MC, pick up and knit (lifted inc) 2 extra sts on each side of the hole: In size S only, knit those 2 sts together (double lifted dec, see Techniques)—18 (20, 20) sts. Following chart, work Pattern B2. When chart is complete, 6 (8, 8) sts rem.

Break off yarn, draw it through the sts. Weave in loose ends.

Finishing

Weave in all ends.

CHECKERED BEANIE

CHART A

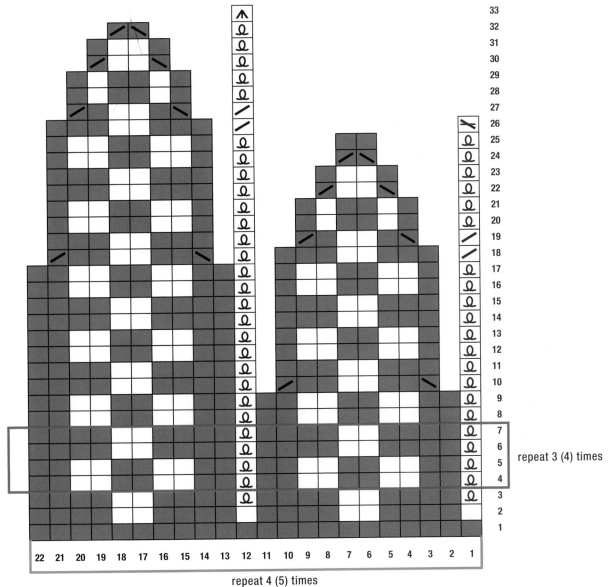

repeat 3 (4) times

repeat 4 (5) times

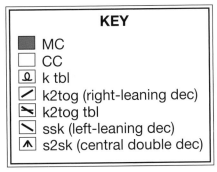

KEY	
▨	MC
☐	CC
℧	k tbl
╱	k2tog (right-leaning dec)
✖	k2tog tbl
╲	ssk (left-leaning dec)
⋏	s2sk (central double dec)

CHECKERED MITTENS CHART

HAND PATTERN B1

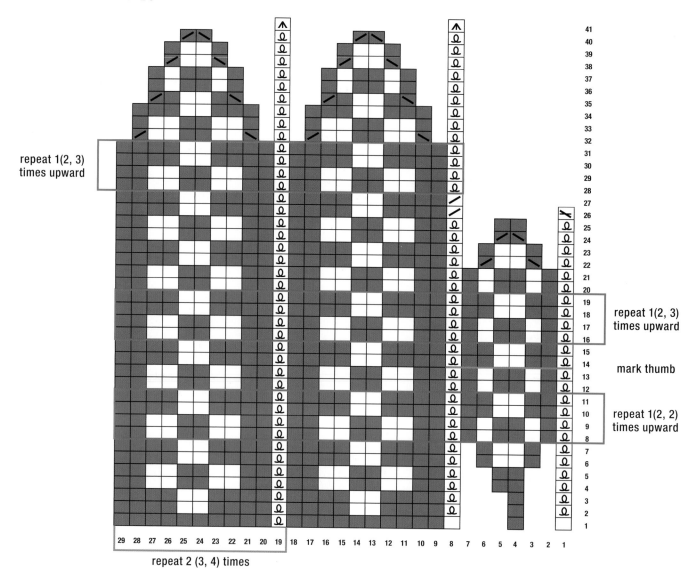

repeat 1(2, 3) times upward

repeat 2 (3, 4) times

repeat 1(2, 3) times upward

mark thumb

repeat 1(2, 2) times upward

THUMB PATTERN B2

repeat 1(2, 2) times

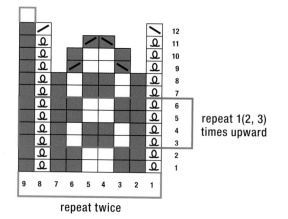

repeat 1(2, 3) times upward

repeat twice

KEY

- MC
- CC
- k tbl
- k2tog (right-leaning dec)
- k2tog tbl
- ssk (left-leaning dec)
- s2sk (central double dec)

22

TWO THUMBS MITTENS

Men's mittens typically had two thumbs for practical reasons. These mittens were used for work, and the thumb usually wore out quicker than the rest of the mitten. When a thumb developed a hole during a day of work in the field or at sea, the wearer could simply turn the mitten to the other side, use the other thumb, and continue to work. The thumb not in use was worn inside-out inside the mitten. Because of the additional thumbs, mittens had no right or left—they fit both hands. The mittens for everyday use were usually knitted in one color with rough wool, whereas finer mittens were knitted with finer yarn and smaller needles. Sometimes they were decorated with a few lines of purl stitches or with stranded colorwork in two colors. Stripes and checks were most common.

Fishermen's mittens were knitted rather big and felted only slightly, as they would continue to felt when worn in seawater. The cuff was never very long because the fishermen wanted to be able to get rid of the mittens by simply slapping the hand in the air. If the mittens felted so much that they became too tight for fishing, they could still be used on land in very cold weather. Fishermen's mittens were usually knitted in two or three colors, and the cast-on was always in a different color than the hand. *Sprökuvettlingar*, which were used only for fishing halibut, featured a three-color striped cuff. Crosses were sometimes included in the design of fishermen's mittens as protection against evil.

Mittens for exportation, seamen mittens in particular, were knitted in really big quantities. For example, business records indicate that 12,232 pairs of mittens were sold in 1624. Knitters felted the mittens by washing and rubbing them together before allowing them to dry on a wooden form. A little piece of wood was also placed inside the thumb to help the mitten hold its shape.

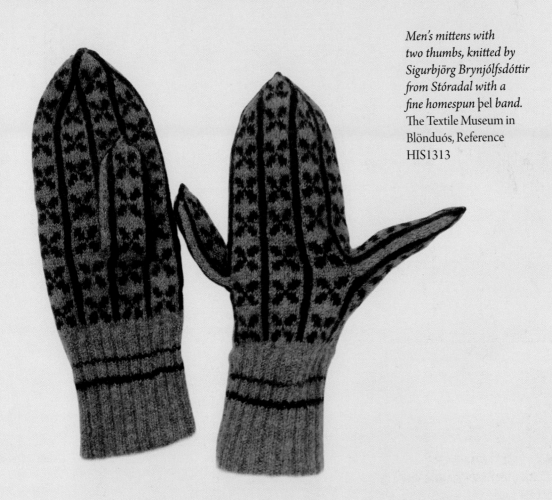

Men's mittens with two thumbs, knitted by Sigurbjörg Brynjólfsdóttir from Stóradal with a fine homespun þel band. The Textile Museum in Blönduós, Reference HIS1313

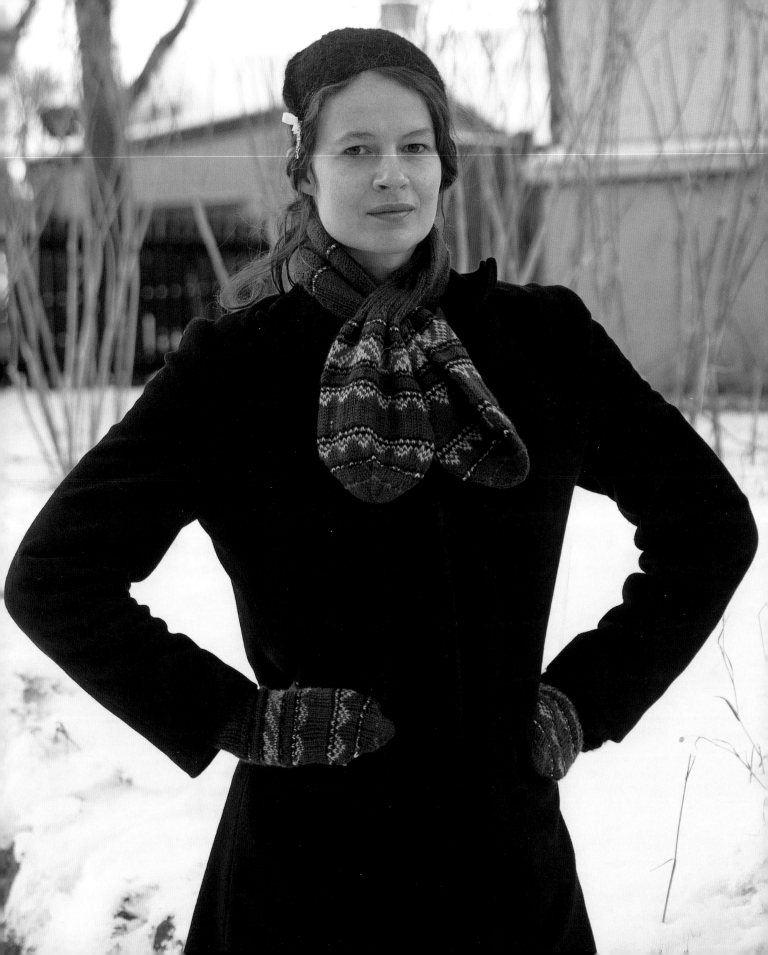

LEAF MITTENS, SLOUCHY CAP & SCARF

The motifs used in this hat, mitten, and scarf set are based on a type of mitten that is referred to as *vestfirzkir* or *laufaviðar vettlingar*, meaning "mittens from the Westfjords" or "leaf mittens," respectively. I've always loved the colorwork in these mittens, and when I reinterpreted them with the Icelandic Kambgarn yarn (imported merino wool but Icelandic production), I was delighted by the result. The mittens fit very well with tip decreases starting already when reaching the little finger. The apparent lines of central double decreases are enhanced in the matching Leaf Slouchy Cap, where they make a pleasing structure at the top of the hat. The scarf is my new take on the classic garter stitch bow-tie scarf and is reminiscent of the bow tie worn with traditional Icelandic costumes.

MITTENS

Sizes
Woman's S (M) tight fit

Finished Measurements
Hand circumference: 6 ¾ (7 ½)"/17(19)cm
Hand length: 7 ½ (8)"/19 (20.5)cm

Materials
◆ Ístex *Kambgarn*, 100% new merino wool (3-ply worsted), 50g/1.75 oz, 164 yds/150m per ball: #9652 brown (MC), 6 balls; #1204 light brown (CC1), 1 ball; #1213 dark blue (CC2), 1 ball; #1215 light blue (CC3), 1 ball; #1211 yellow (CC4), 1 ball; #9664 red (CC5), 1 ball; #0945 green (CC6), 1 ball; #0059 black (CC7), 1 ball

◆ Sizes US 2 and 3 (2.5 and 3mm) circ needles

◆ Magic loop is used for smaller diameters or double-pointed needles

◆ Darning needle

Gauge
28 sts and 36 rows = 4"/10cm in St st using larger needle
Adjust needle size as necessary to obtain correct gauge.

Special Abbreviation
s2sk = slip 2, slip 1, knit: Slip 2 sts as if to knit them together, slip 1 st as if to knit, insert left needle in the 3 sts and k3tog through the back loops (double central dec).

Note: Because of the double central decs, end of rnd moves 1 st to the left in those rnds, and you will have to replace your marker accordingly.

SLOUCHY CAP

Sizes
Adult M (L) to fit head 21 (24 ½)"/53.5 (62)cm

Finished Measurements
Head circumference: 20 (23)"/51 (58.5)cm
Note: You can achieve more sizes by changing needle size.

Materials
◆ Ístex *Kambgarn*, 100% new Merino wool (3-ply worsted), 50g/1.75 oz, 164 yds/150m per ball: #9652 brown (MC), 6 balls; #1204 light brown (CC1), 1 ball; #1213 dark blue (CC2), 1 ball; #1215 light blue (CC3), 1 ball; #1211 yellow (CC4), 1 ball; #9664 red (CC5), 1 ball; #0945 green (CC6), 1 ball; #0059 black (CC7), 1 ball

◆ Sizes US 2 and 3 (2.5 and 3mm) circ needles

◆ Magic loop is used for smaller diameters or double-pointed needles

◆ Darning needle

Gauge
28 sts and 36 rows = 4"/10cm in St st using larger needle
Adjust needle size as necessary to obtain correct gauge.

Special Abbreviation
s2sk = slip 2, slip 1, knit: Slip 2 sts as if to knit them together, slip 1 st as if to knit, insert left needle in the 3 sts and k3tog through the back loops (double dec).

Note: Because of the double central decs, end of rnd moves 1 st to the left in those rnds, and you will have to replace your marker accordingly.

Opposite: *When worn together, the lacy* skotthúfa *(page 128) and the bow-tie scarf make a modern version of a* peysuföt, *the traditional everyday costume of Iceland.*

LEAF MITTENS FROM THE WEST FJORDS

The oldest leaf mittens found in Icelandic museums are from the middle of the nineteenth century, but the tradition is probably much older. In the seventeenth century, leaf patterns were included in the Old Sjónabók (Icelandic pattern books). Why this style of mitten was fashionable in the West fjords is unknown. The mittens were knit in the round on four needles and were, as their name suggests, decorated with a leaf pattern. The patterns were named according to the number of rows needed to create one leaf motif, with each row being repeated twice, such as *fimmtekinn* (referring to number five), *sextekinn* (six), and *sjötekinn* (seven). The leaf motifs were often taken from cross-stitch patterns where each square translated, in knitting, to 2 stitches and 2 rows. A *fimmtekinn* leaf would therefore be 10 rows knitting, a *sextekinn* 12 rows, etc. The men's mitten would often have a 12- or 14-row pattern, whereas the women's would only have 10 or 12 rows.

The main color was often in natural, such as brown or white, and the leaf pattern was usually yellow or green on a black background. There were smaller patterns called "check," "small leaf," "tong," or "twist," that were used on both sides of the big leaf motif to adjust the mitten to the correct size. Smaller patterns were also perfect for using up the tiny bits of yarns in those days, when no color yarn could be wasted. The small patterns were used to decorate the thumb as well. Mittens like this were knitted on very small needles (less than 1.5 mm, less than 0 US) with a fine band. They were "Sunday-best" mittens.

In an article published in 2001 in the Icelandic craft magazine *Hugurog Hönd*(p. 25), Sigrún Guðmundsdóttir explained how her great-grandmother knitted leaf mittens only on Sunday afternoons. She always used colorful yarn, some of which she had dyed herself, and used up as many leftover bits of yarn as she could. The family is from the village Reykjarfirði of Hornstrandir in the West fjords, and the women in Sigrún's family were known for their beautiful mittens.

MITTEN INSTRUCTIONS

Mittens (Make two)
With CC7 and smaller needle, CO 44 (52) sts. Change to MC. Join, taking care not to twist sts in the rnd, pm EOR (end of rnd). Work around in *k1, p1* rib for 2"/5cm. Change to larger needle and work Pattern A1 (A2) from right to left (right mitten) or from left to right (left mitten), inc 4 sts in first rnd, [k11 (13), M1] 4 times—48 (56) sts.

Thumb Opening
Note: Mark thumb on Row 22 (24):

Right thumb: K1, k8 (9) sts with contrasting scrap yarn, place sts back on left needle and knit them again with MC, knit to EOR.

Left thumb: K39 (46), k8 (9) sts with contrasting scrap yarn, place sts back on left needle and knit them again with MC, knit rem st to EOR.

Tip: Work dec on both sides: *knit to 1 st before side st, s2sk* twice in every other rnd. End of rnd moves 1 st to the left in the rnds where the central double decs are worked.

When pattern is complete, 8 sts rem. Turn mitten inside out and BO using three needles on the inside, back to front.

Thumb
Remove scarp yarn and set sts on needle. With MC, pick up 2 extra sts (lifted inc) on each side of the hole and knit them together (double lifted dec, see Techniques) = 18 (20) sts. Following Chart B1 (B2), work even (= rep Rnd 1) in St st for about 1 ½ (2)"/4 (5)cm. Work dec on both sides in every other rnd:

Rnd 1: *Knit to 2 sts before extra side st, ssk, k1, k2tog* twice.

Rnd 2: Knit all sts.

Rep Rnds 1 and 2 until 6 (8) sts rem. Break off yarn and draw it through the sts.

Finishing
Darn in loose ends. Weave in loose ends.

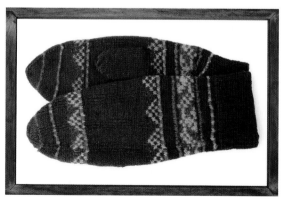

Halldóra Bjarnadóttir mentions that these mittens are special to the Westfjords and were sent to her from the Vigur village, but there is no information about the knitter or when they were knitted. The Textile Museum in Blönduós, Reference HB344

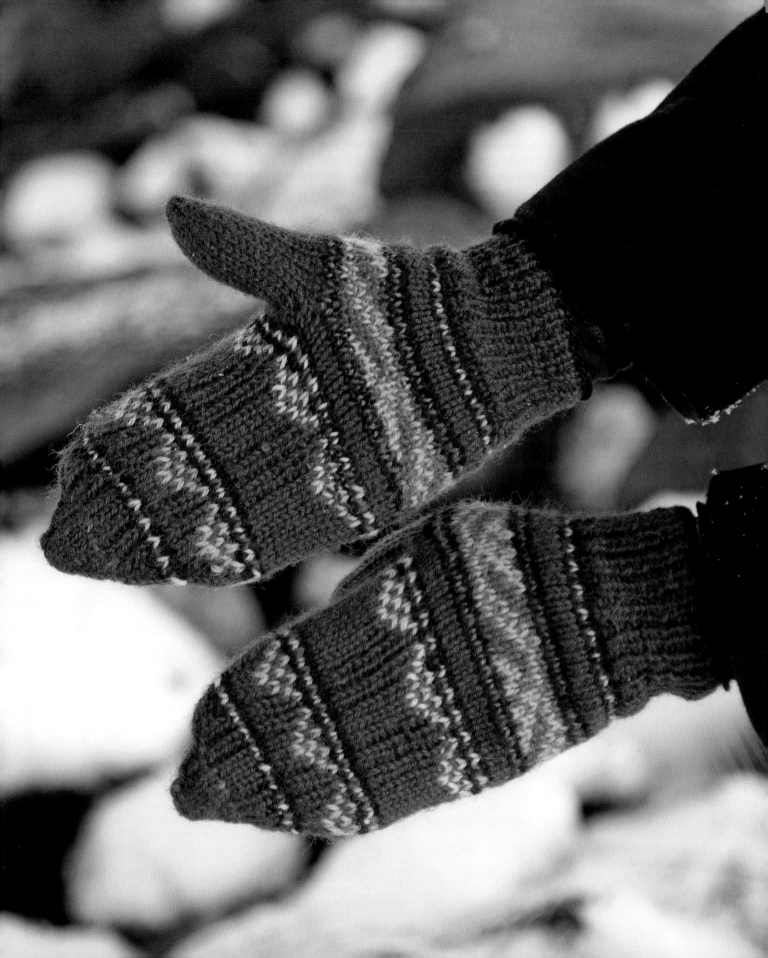

KLEINUR

The *Kleinur* is an Icelandic twisted doughnut, similar to what you might find in other countries. It is traditionally deep-fried in very hot sheep tallow, but vegetable oil will do.

2 c. (500 g) flour
½ c. (150 g) sugar
¼ c. (40 g) cold butter, cut into small pieces
1 tsp. baking powder
2 tsp. salt
1 tsp. ground cardamom
1 tsp. lemon zest
2 eggs
⅔ c. (150 ml) buttermilk

Mix together flour, sugar, butter, baking powder, salt, cardamom, and lemon zest. Add eggs and buttermilk. Knead well and flatten into a disk about 2–3 mm thick. Cut strips about two fingers large and cut diagonally across to make diamond-like shapes about 4" long. Cut a slit in the middle of each diamond and pull one end of the dough inside the slit to make the twist in the doughnut. Deep-fry in very hot oil, 350°F (180°C), for 1–2 minutes or until brown. Remove with a slotted spoon and allow to cool on a plate covered with paper towel. The recipe makes about 40 doughnuts.

SLOUCHY CAP INSTRUCTIONS

With CC7 and smaller needle, CO 144 (168) sts. Change to MC. Join, taking care not to twist sts, pm EOR (end of rnd). Work around in k1, p1 rib for 1"/2.5cm. Change to larger needle.

Rnds 1–69: Work Rnds 1–69 of Pattern A1, rep 6 (7) times across. When pattern is complete, 24 (28) sts rem.

Rnd 70: *S2sk, k1*; rep from * to * around—12 (14) sts.

Rnd 71: Knit all sts.

Rnd 72: *K2tog* around—6 (7) sts.

Break off yarn, draw it through the sts.

Weave in loose ends.

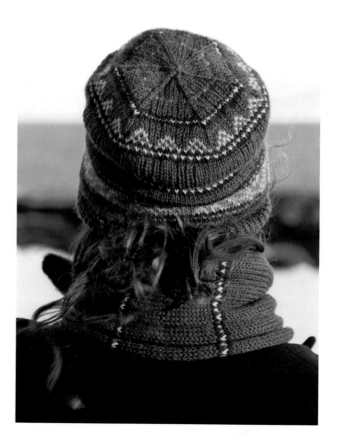

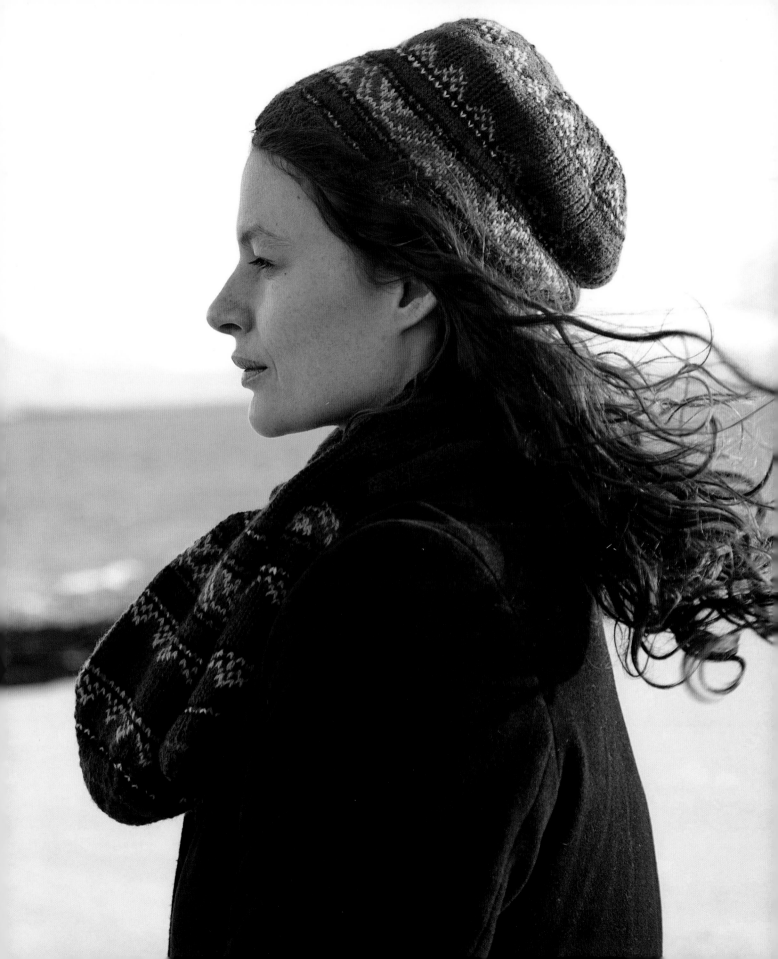

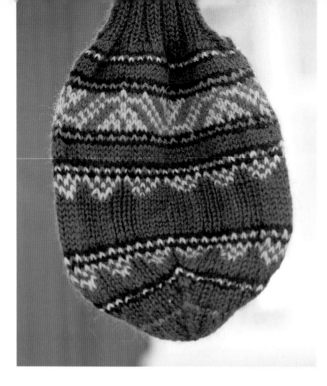

SCARF

Sizes
One size fits all

Finished Measurements
Circumference: 16 ½"/42cm
Note: Size can be easily changed by adding or removing rows.

Materials
- Ístex *Kambgarn*, 100% new merino wool (3-ply worsted), 50g/1.75 oz, 164 yds/150m per ball: #9652 brown (MC), 6 balls; #1204 light brown (CC1), 1 ball; #1213 dark blue (CC2), 1 ball; #1215 light blue (CC3), 1 ball; #1211 yellow (CC4), 1 ball; #9664 red (CC5), 1 ball; #0945 green (CC6), 1 ball; #0059 black (CC7), 1 ball
- Sizes US 2 and 3 (2.5 and 3mm) circ needles
- Magic loop is used for smaller diameters or double-pointed needles
- Darning needle

Gauge
28 sts and 36 rows = 4"/10 cm in St st using larger needle
Adjust needle size as necessary to obtain correct gauge.

Special Abbreviation
s2sk = slip 2, slip 1, knit: Slip 2 sts as if to knit them together, slip 1 st as if to knit, insert left needle in the 3 sts and k3tog through the back loops (double dec).

Note: Because of the double central decs, end of rnd moves 1 st to the left in those rnds and you will have to replace your marker accordingly.

SCARF INSTRUCTIONS
With MC and a provisional cast-on, CO 96 sts using larger needle. Work Pattern A1 (Rnds 1–69), rep 4 times across. When pattern is complete, 16 sts rem.

Next rnd: *K2tog* around—8 sts.

Break off yarn, draw it through the sts.

Remove provisional cast-on and with MC, *k2tog* across—48 sts. Divide sts in half and work separately: Knit first 24 sts back and forth in rib (k1, *p2, k2,* to last 3 sts, p2, k1) for 20 rows. Place on holder. Knit last 24 sts back and forth in rib (k1, *p2, k2* to last 3 sts, p2, k1) for 20 rows.

Cont knitting the 48 sts in the rnd:

Next rnd: *K1, M1* across—96 sts.

Work Stripes
Rnds 1–20: Work 20 rnds with MC same as Rnd 43 of Pattern A1.

Rnds 21–23: Work 3 rnds in colorway same as Rnds 18–20 of Pattern A1.

Rep these 23 rnds 5 times but with different colorway strip: alternatively like Rnds 24–26, 44–46, then again Rnds 24–26 and 18–20 of Pattern A1.

Work 20 more rnds with MC same as Rnd 43 of Pattern A1.

Note: You can work more or less than 20 rnds to achieve different length.

Work Pattern A1 (Rnds 1–69), rep 4 times across and work shaping like the other tip.

Finishing
Weave in loose ends.

Hand wash delicately in lukewarm water with gentle wool soap. Leave flat to dry.

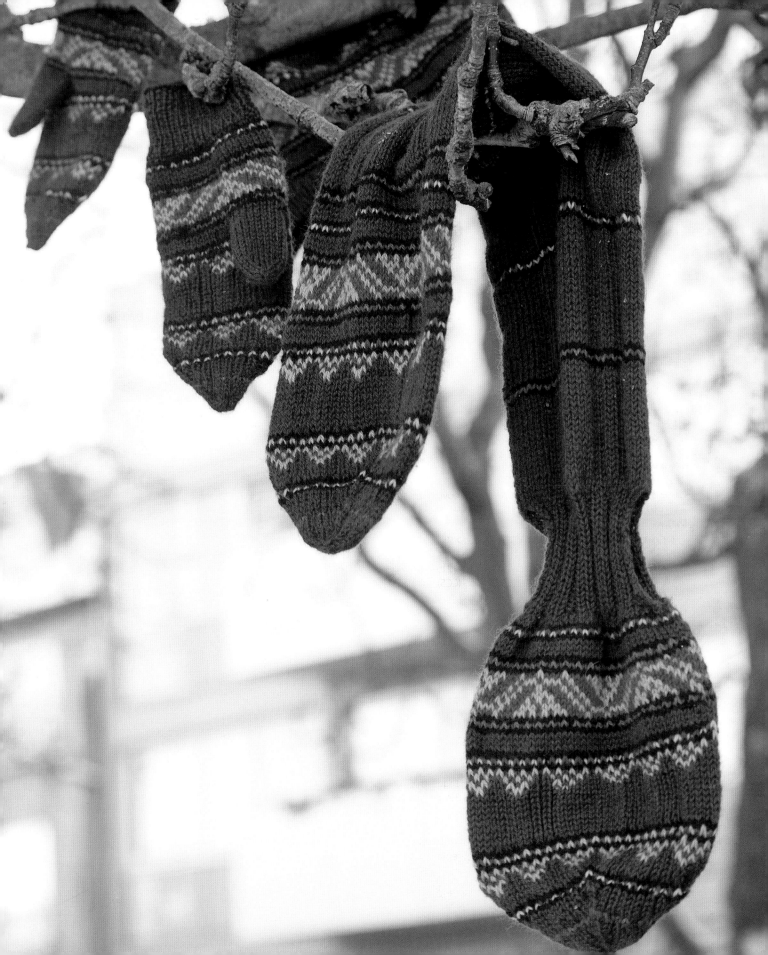

LEAF CHART A1

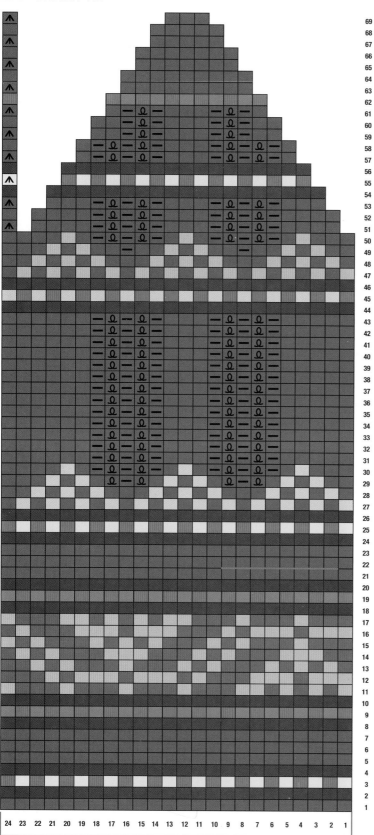

KEY

- ▣ MC
- ▬ MC Purl
- ▤ CC1
- ▦ CC2
- ▧ CC3
- ▫ CC4
- ▥ CC5
- ▨ CC6
- ▩ CC7
- Ω k tbl
- — p
- ╱ k2tog
- ╲ ssk
- ⋀ s2sk (moves EOR 1 st to the left)

THUMB B1

repeat rnd 1 for about 1.5"/4cm

mark thumb

repeat twice across

LEAF CHART A2

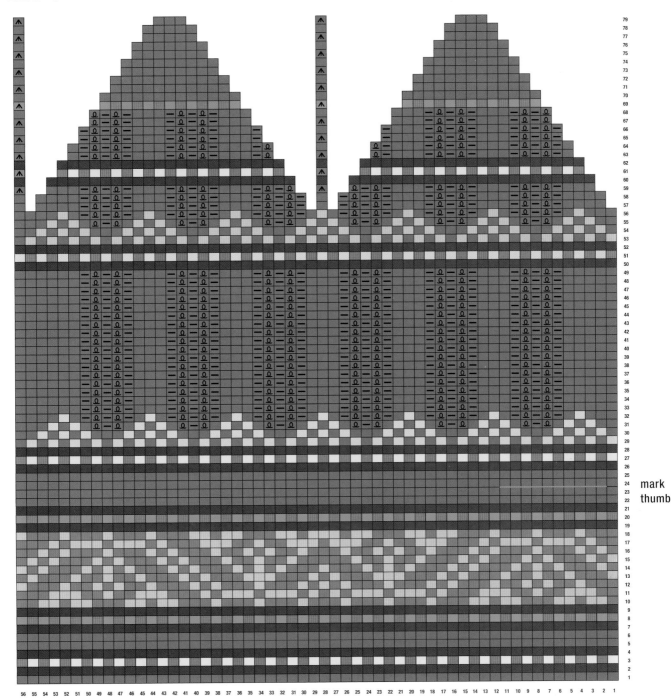

mark
thumb

rep rnd 1 for
about 2"/5cm

THUMB B2

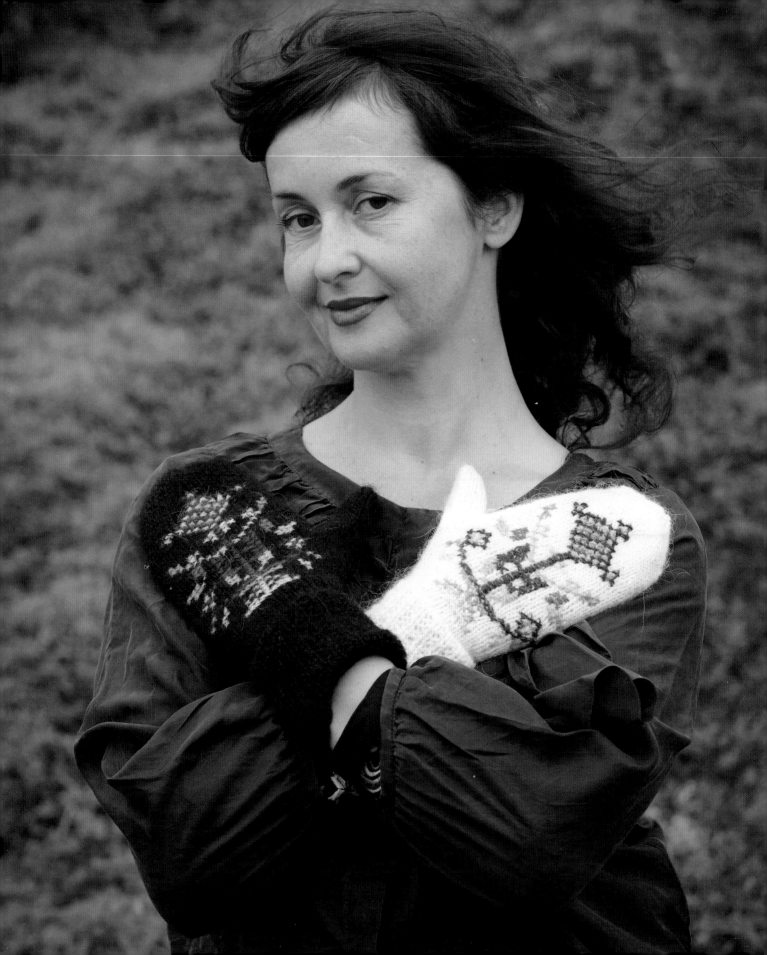

SKAGAFJÖRÐUR MITTENS

The mittens are inspired by a pair of mittens in the Textile Museum. They are decorated with an Old Icelandic cross-stitch flowerpot motif, typical from the fjord of Skagafjörður. I had to simplify and reduce the motif considerably to fit my mittens since they are knit with a much thicker yarn. My motif would probably fit on the thumb of the original pair! I did keep the same construction, however: they are knitted from the cuff up with a gusset and a star top. There is no left or right mitten, so keep this is mind when deciding on the placement of the embroidery.

Sizes
Women S (M)

Finished Measurements
Hand circumference: 7 ¾ (8 ¾)"/19.5 (22)cm
Length of hand (without the cuff): 7 (8)"/18 (20.5)cm

Materials
◆ Ístex *Léttlopi*, 100% pure Icelandic wool (light spun, medium weight), 50g/1.75 oz, 109 yds/100m per skein: #0059 for black or #0051 for white (MC), 2 skeins

◆ Ístex *Einband-Loðband*, 70% Icelandic wool, 30% wool (fine laceweight, 1-ply worsted), 50g/1.75 oz, 246 yds/225m per skein: Scrap lengths in the color of your choice (CC) or see chart for suggestions.

◆ Size US 4 (3.5mm) circ needle or double-pointed needles

◆ Stitch markers

◆ Tapestry needle

Gauge
22 sts and 29 rows = 4"/10cm in St st using size US 4 (3.5mm) needle
Adjust needle size as necessary to obtain correct gauge.

Pattern Stitch
Broken rib (multiple of 2)
Rnd 1: *K1, p1*.
Rnd 2: Knit all sts.
Rep Rnds 1 and 2.

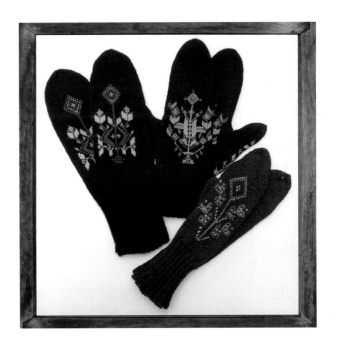

A collection of mittens, embroidered with a flowerpot motif in Old Icelandic cross-stitch, is typical of the embroidery from the fjord Skagafjörður. The Textile Museum in Blönduós

CROSS-STITCH MITTENS

Rósavettlingar, literally "rose mittens," were traditionally women's mittens knitted very fine with only one thumb and decorated on the back of the hand with a rose pattern or any other motif like a diamond or a flowerpot. *Rósavettlingar* are sometimes referred to as *ísaumaðir* (embroidered) to set them apart from stranded patterned mittens. They are knit in stocking stitch in a single color and decorated with embroidered patterns on the back of the hand, the thumb, and the cuff.

The mittens are embroidered in what is called Old Icelandic cross-stitch in Icelandic but known as long-armed cross-stitch in English. The motifs come in many varieties; eight-petal roses and various flower patterns were common, as were the embroidered initials of the mitten's owner and animal patterns, such as reindeer or birds. The flowerpot motif, where leaves and flowers are mirrored around a stem that stretches along the back of the hand, can be traced to Skagafjörður, a fjord in the North of Iceland, and is typical from this particular area. The mittens embroidered with a flowerpot motif are called *Skagfirskir rósavettlingar*— Skagafjord rose-mittens.

In 2003, Elísabet Steinunn Jóhannsdóttir published a book called *Skagfirskir rósavettlingar*, which displays a collection of Skagafjörður-style mittens that belong to her family. The book is in Icelandic but shows many beautiful color pictures of all the mittens that have survived, along with the charts of the embroidered motifs. The women in her family were known for their beautiful mittens. The mittens were knit with fine Icelandic wool and embroidered with the flowerpot motif typical of the family on the back of the hand, the thumb, and the cuff.

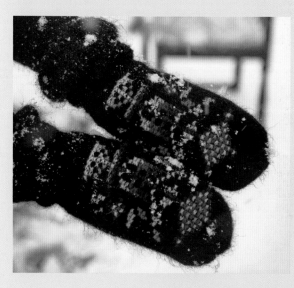

INSTRUCTIONS

Mittens (Make two)
With MC and size US 4 circ needle, CO 32 (34) sts. Join, taking care not to twist sts; pm EOR (end of rnd). Work in around broken rib for about 2.5"/6.5cm:

Rnd 1: *k1, p1* around

Rnd 2: K all sts.

Rep rnds 1 and 2.

Cont in St st: K2, pm, knit to EOR, then work inc for thumb gusset on both sides of markers as follows: *M1 on left side of EOR marker, knit to next marker, M1 on right side of it, knit to EOR, knit next 3 (4) rnds* 5 times—40 (44) sts.

Thumb Opening
Next rnd: K1, then k8 (10) sts with contrasting scrap yarn, place sts back on left needle and knit them again with MC, knit to EOR.

Cont knitting until mitten measures 4 (4 ½)"/10 (11.5)cm from thumb or 1"/2.5cm short of fingertips, then start dec:

Rnd 1: *K8 (9), k2tog* 4 times—36 (40) sts.

Rnd 2: *K7 (8), k2tog* 4 times—32 (36) sts.

Rnd 3: *K6 (7), k2tog* 4 times—28 (32) sts.

Rnd 4: *K5 (6), k2tog* 4 times—24 (28) sts.

Rnd 5: *K4 (5), k2tog* 4 times—20 (24) sts.

Rnd 6: *K3 (4), k2tog* 4 times—16 (20) sts.

Rnd 7: *K2 (3), k2tog* 4 times—12 (16) sts.

Rnd 8: *K1 (2), k2tog* 4 times—8 (12) sts.

Rnd 9 (Size S only): *K2tog* 4 times—4 sts.

Rnd 9 (Size M only): *K1, k2tog* 4 times—8 sts.

Rnd 10 (Size M only): *K2tog* 4 times—4 sts.

Break yarn and draw it through the sts.

Thumb
Remove scrap yarn and place the sts on the needle. Pick up an extra st on each of the outer corners of the thumb opening and k2tog with next st in next rnd—16 (20) sts. Work in St st for 18 (20) rnds, then start dec:

Rnd 1: *K2, k2tog* around—12 (15) sts.

Rnd 2 and every even rnd: Knit all sts.

Rnd 3: *K1, k2tog* around—8 (10) sts.

Rnd 5: *K2tog* around—4 (5) sts.

Break yarn and draw it through the sts.

Finishing

Weave in loose ends. Close the gaps at the outer corners of the thumb if needed. With CC, embroider the pattern in the middle of the back of the hand (when doing so, make sure to have a right-hand mitten and a left-hand mitten). Position the top of the embroidery at the 10th row from the top of the mitten and work your way down the center line of the motif, then out from center.

SKAGAFJÖRÐUR MITTENS CHART A1

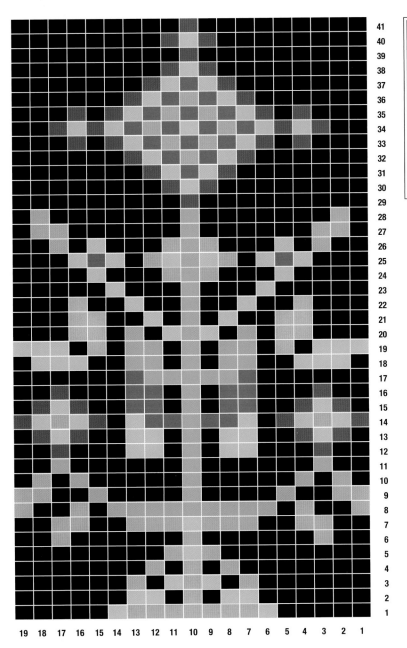

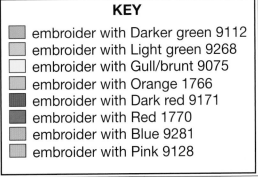

KEY

- embroider with Darker green 9112
- embroider with Light green 9268
- embroider with Gull/brunt 9075
- embroider with Orange 1766
- embroider with Dark red 9171
- embroider with Red 1770
- embroider with Blue 9281
- embroider with Pink 9128

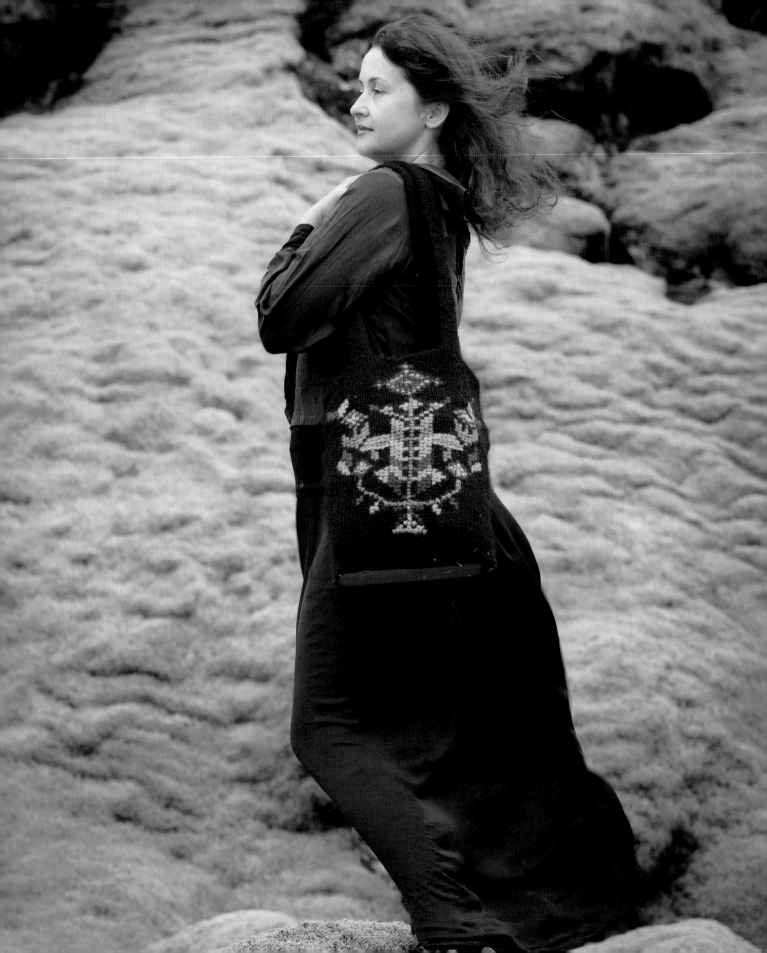

SKAGAFJÖRÐUR TOTE BAG

The tote bag is inspired by the same pair of mittens I used to design the Skagafjörður mittens except the motif on the bag is an exact reproduction of the embroidery on the original mittens. The bag is spacious enough for a laptop with an inside pocket, a key chain, and a magnetic closure. It is knitted in the round in one piece and sewing is kept to a minimum. The bottom is knit as a tube with a sheet of plastic placed inside to make it sturdier. Stiches are picked up around the bottom and the bag is knitted in the round. Handles are marked in the same manner as mitten thumbs, knitted in the round, and then grafted together.

Finished Measurements
9 ½ by 1 ½ by 14"/24 by 4 by 35cm

Materials
- Ístex *Álafosslopi*, 100% pure Icelandic wool (light spun), 3.5 oz/100g, 109 yds/100m per skein: #0059 black, 3 skeins; #0047 red (CC1), 1 skein
- Ístex *Léttlopi*, 100% pure Icelandic wool (light spun, medium weight), 1.75 oz/50g, 109 yds/100m per skein: Scrap lengths in the colors of your choice (CC2) or see chart for suggestions.
- Size US 6, 9, and 10.5 (4, 5.5, and 7.5 mm) circ needle or double-pointed needles
- Pair of magnets
- Metal ring for key chain
- Grosgrain ribbon about 1 ½"/4cm wide and 63"/160 cm long
- Piece of sturdy plastic sheet about 1 ½"/4cm wide and 9 ½"/24cm long
- Embroidery needle
- Sewing needle

Gauge
14 sts and 19 rows = 4"/10cm in St st using size US 9 (5.5 mm) needle
12 sts and 14 rows = 4"/10cm in St st using size US 10.5–11 (7.5mm) needle
Adjust needle size as necessary to obtain gauge.

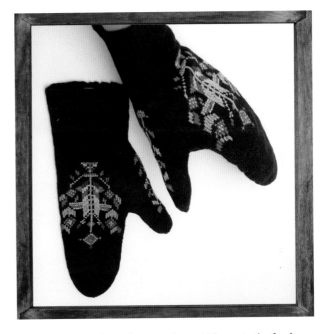

Guðrún Símonardóttir from Hvalsnesi á Skaga, in the fjord of Skagafjörður, knitted these beautiful mittens typical of the area, but Halldóra Bjarnadóttir doesn't say when they were made. The hand-spun yarn is extremely fine, and the work is particularly delicate. Above the cuff is a gusset thumb, and starlike decreases enclosed the fingers. The fit is so snug that they feel almost like a second skin. The Textile Museum in Blönduós, Reference HB649

RÚGBRAUÐ

Rúgbrauð is the smooth, dark, and rather sweet rye bread that is served as part of the Icelandic *Þorramatur*. There are many varieties of *rúgbrauð*, but my favorite one is the *hverabrauð*, or "hot spring bread." Traditionally, *hverabrauð* is steam-cooked in a special pot buried in the hot ground at the edge of a hot spring. Here is a modernized recipe for your oven using 1-quart (1 l) cardboard milk cartons.

2 ½ c. (600 g) sugar	
1 ¾ c. (400 g) whole-wheat flour	
4 ½ lbs. (2 kg) rye flour	
1 tsp. salt	
¼ c. (50 g) dry yeast	
4 ⅓ c. (1 l) hot water	
2 c. (½ l) warm milk (don't allow to boil)	

Preheat the oven to 210°F (100°C). In a large mixing bowl, combine sugar, whole-wheat flour, rye flour, salt, and dry yeast. Add hot water and warm milk and mix well. Pour dough mixture into two half-gallon cardboard milk cartons, filling each halfway. Close cartons and bake at the bottom of the oven for about 12 hours.

INSTRUCTIONS

Bottom

With CC and size US 10.5–11 (7.5mm) needle, CO 12 sts. Join, taking care not to twist sts, pm EOR (end of rnd). Work in St st for 34 rnds (9.5"/24cm), adapt needle size as necessary. BO.

Flattened, the tube makes a double-layered rectangle inside which the piece of plastic sheet will be inserted later.

Body

With MC and size US 9 (5.5mm) needle, pick up and k34 sts along the length of the rectangle (go under two legs of each st), 6 sts along the width (catch the two layers of the tube opening together), 34 sts from the other length, 6 sts along the other width (catch only the lower layer of the tube, in order to keep the tube opened from the inside of the bag), pm EOR—80 sts.

Knit around in St st for about 14"/36.5cm.

Mark the handles as follows: k5, *knit next 6 sts with contrasting scrap yarn, place sts on left needle and knit them again with main color, k12, k6 next sts with contrasting scrap yarn, place sts on left needle and knit them again with MC,* knit next 16 sts, rep between * and *, knit rem 11 sts.

Cont knitting straight for 4"/10cm from handles (folding edge).

BO 6 sts, knit next 22 sts, and BO rem sts. Set live 22 sts aside.

Pocket

With CC1 and US 9 (5.5mm) needle, CO 22 sts.

Keeping continuity, purl the 22 sts that were set aside from the WS—44 sts. Join in the rnd, pm EOR. Work 4 rnds in garter st (*knit 1 rnd, purl 1 rnd* twice), then cont in St st until pocket is 7"/18cm long. Divide sts on 2 needles and BO using 3-needle method.

Handles

Remove scrap yarn and place sts on needle; pick up an extra st on each of the outer corners of the handle hole and k2tog with next st in next rnd—12 sts. Pm EOR. Knit in the rnd for 15"/38cm. Set live sts aside on spare needle. Do the same for each of the four handles, and then graft the first two and the last two together, being careful not to twist.

Key Chain

With any CC2 color and using size US 4 (3.5mm) needle, CO 3 sts. Work an I-cord for about 6"/15cm. BO.

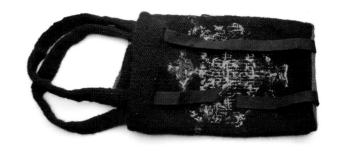

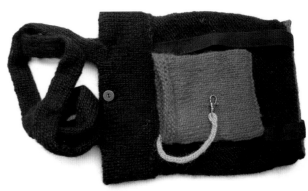

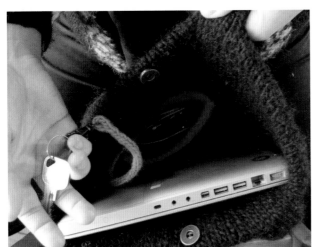

Finishing

Weave in loose ends. Insert the piece of plastic sheet inside the tube at the bottom (inside the bag) and close the opening.

The grosgrain ribbon runs inside the handles and around the bag from the inside to avoid the knit fabric from distorting with heavy objects. Attach a safety pin to one end of the grosgrain ribbon and draw it inside one handle, being careful not to twist it, wrap it around the bottom of the bag, then draw it inside the 2nd handle. Wrap it around the bottom of the bag and sew both ends together. Secure the ribbon in place, especially at the bottom of the bag, with a few sts. Fold the top edge inside the bag and sew it down. Sew the pocket down inside the bag. Be careful that the sewing doesn't show on the RS. Sew one end of the key chain inside the pocket, just below the opening at a corner, and attach a metal ring at the other side. Sew the magnets inside the bag between the handles, about ½"/1cm from edge, facing. You may also choose to line the bag.

With CC2, embroider pattern A2 in the middle of one face. Position the center of the embroidery at the center of the bag; work your way down and up the centerline of motif, then out from center.

Tip: Insert a newspaper inside the bag to make sure you don't catch both layers of fabric while sewing.

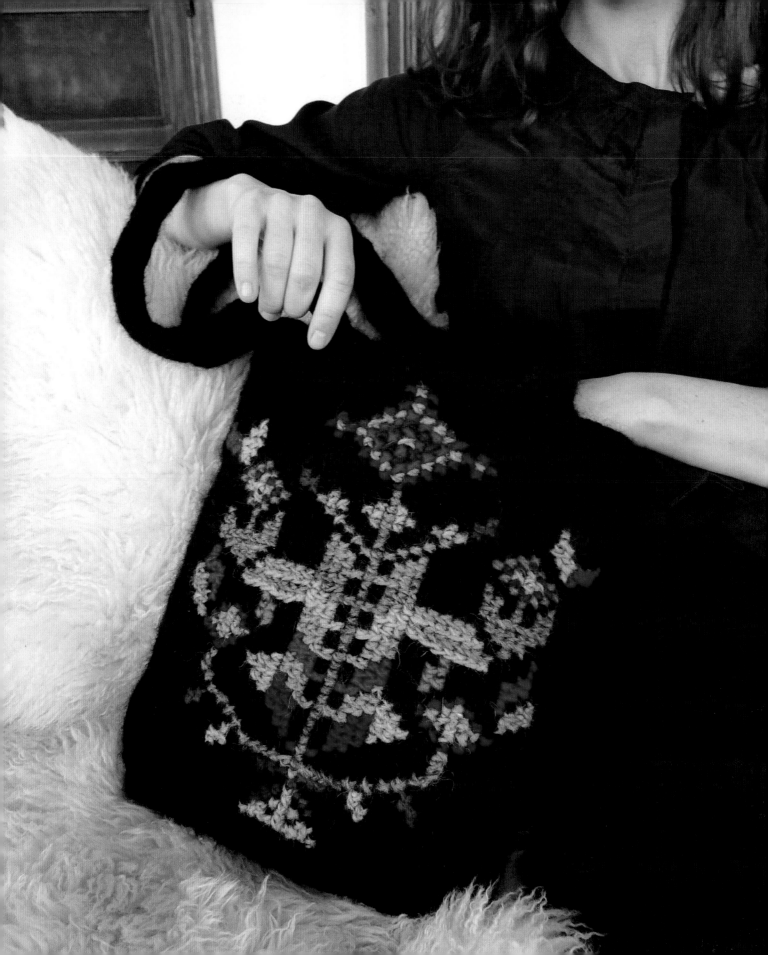

SKAGAFJÖRÐUR TOTE BAG CHART A2

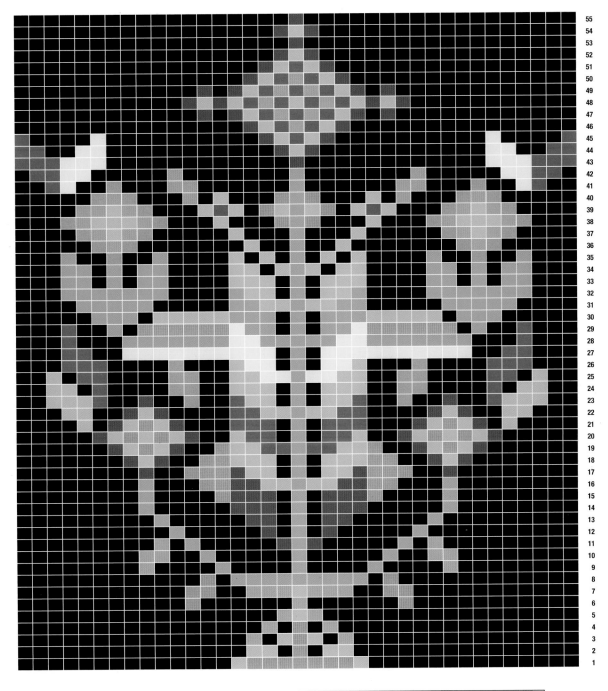

55
54
53
52
51
50
49
48
47
46
45
44
43
42
41
40
39
38
37
36
35
34
33
32
31
30
29
28
27
26
25
24
23
22
21
20
19
18
17
16
15
14
13
12
11
10
9
8
7
6
5
4
3
2
1

KEY

- embroider with Darker green 9421
- embroider with Light green 1406
- embroider with Gull/brunt 9264
- embroider with Orange 1410
- embroider with Dark red 9414
- embroider with Red 9434
- embroider with Blue 1403
- embroider with Pink 1412

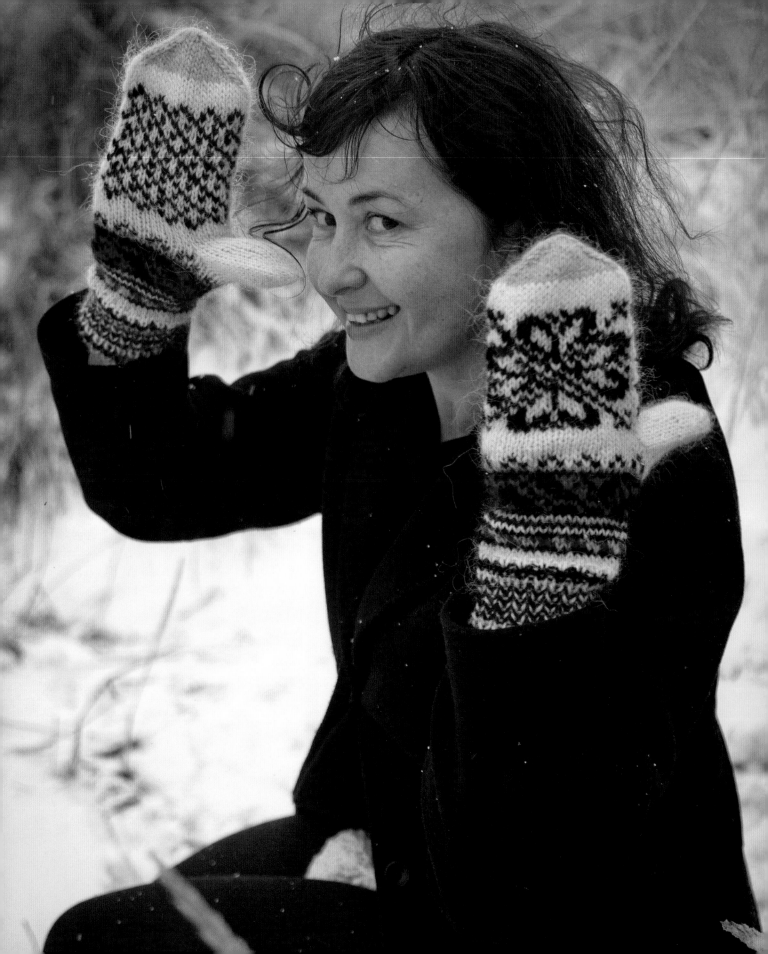

NORDIC LEAF MITTENS

Many mittens found in Iceland are clearly inspired by—if not mere reproductions of—Nordic or Baltic mittens. Some, however, have an "Icelandic touch": band motifs above and under the main motif on the back of the hand. Those bands resemble the bands from the traditional Icelandic leaf mittens. Mittens like those didn't have a gusset that would interrupt the band pattern.

With my mittens, I took that idea and ran with it. Drawing inspiration from a pair of Selbu-style gloves and a pair of traditional leaf mittens, both from the Textile Museum collection, I designed mittens with a recognizable white and black patterning as the main motif and a leaf band in vivid colors on both sides. The cuff is very long, which was common with traditional leaf mittens. If you prefer, you can work just a few rounds in rib and start the patterning right away. Be sure to work a jogless join when knitting the stranded band to avoid unsightly jogs when changing colors.

Sizes
Women S (M)

Finished Measurements
Hand circumference: 7 ¼ (8, 8 ¾)"/18.5 (20.5, 22)cm

Materials
- Ístex *Léttlopi*, 100% pure Icelandic wool (light spun, medium weight), 1.75 oz/50g, 109 yds/100m per skein: #0051 white (MC), 1 skein; #0059 black (CC1), 1 skein (about half a skein used); #9434 red (CC2), 1 skein (less than 5g used); #1406 green (CC3), 1 skein (just a few lengths used); #1411 yellow (CC4), 1 skein (less than 10g used)
- Size US 4 (3.5 mm) circ needle or double-pointed needles
- Stitch markers
- Darning needle

Gauge
22 sts and 29 rows = 4"/10cm in St st using size US 4 (3.5mm) needle
Adjust needle size as necessary to obtain correct gauge.

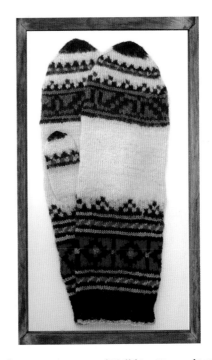

These leaf mittens were part of Halldóra Bjarnadóttir's belongings. The wool to knit them was hand spun and worked in the village of Vigur in the Westfjords, but there is no information on when that was or who knitted the mittens.
The Textile Museum in Blönduós, Reference HB650

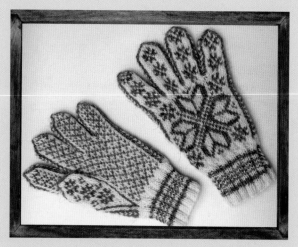

Björg Þorgilsdóttir (born 1954) knit these gloves and gave them to the museum in 2009. She explained that they were a reproduction of finger gloves from Jónsina Jónsdóttir (1883–1976), a housemother in Sveinsstadar. Jónsina had knitted such mittens all her life with Icelandic wool. The main pattern on the back of the hand can be found in Norwegian Knitting Design *by Annichen Sibbern Bohn and is specifically a star from Selbu; so are all the featured constructions such as the cuff, the thumb gusset, and the pointed fingertip and thumb. The Textile Museum in Blönduós, Reference HIS2206*

INSTRUCTIONS

Mittens (Make two)

With MC and size US 4 (3.5mm) needle, CO 36 (40, 44) sts. Join, taking care not to twist sts, pm EOR (end of rnd). Work around in *k1, p1* rib for 17 (19, 19) rnds, alternating 2 rnds MC; 2 rnds CC1; 2 rnds MC; *1 rnd CC1, 1 rnd MC* 2 (3, 3) times; 1 rnd CC1; 2 rnds MC; 2 rnds CC1; 2 rnds MC.

Cont in St st and MC, inc 4 sts evenly spaced on first rnd: *k9 (10, 11), M1* 4 times—40 (44, 48) sts.

Work 1 (2, 3) rnds with MC. Follow Twist Pattern B1 chart for 4 rnds, 1 rnd with MC, Leaf Pattern A1 (A2, A3) chart for 11 (12, 13) rnds, and Little Leaf Pattern B2 chart for 2 rnds.

Cont with MC, work 2 rnds.

Thumb Opening

Mark thumb in next rnd:

Right Thumb: K1, k7 (8, 9) sts with contrasting scrap yarn, place sts back on left needle and knit them again with MC, knit to EOR.

Left Thumb: K32 (35, 38), k7 (8, 9) sts with contrasting scrap yarn, place sts back on left needle and knit them again with MC, knit rem st to EOR.

Cont with MC, work 1 (2, 3) rnds. Work Rose Pattern C chart from right to left (right mitten) or from left to right (left mitten).

With MC, work 3 (4, 5) rnds.

Next rnd: K20 (22, 24) sts, pm, knit to EOR.

Change to CC4 and work dec in every rnd:

K1, ssk, k to 2 sts before next m, k2tog until 8 sts rem on needle.

Break off yarn. Turn mitten inside out and BO on WS using 3-needle method.

Thumb

Remove scrap yarn and place the sts on the needle. Pick up 2 extra sts and k2tog (work a double-lifted dec, see Technique on page 133) at each of the outer corners of the thumb hole—16 (18, 20) sts. Place the EOR m at the outer corner on palm side. Work in St st with MC for 14 (16, 18) rnds.

Next rnd: K8 (9, 10) sts and pm, knit to EOR, then work dec in every rnd:

K1, ssk, k to 2 sts before next m, k2tog until 8 (6, 8) sts rem.

Break off yarn. Turn thumb inside out and BO on WS using 3-needle method.

Finishing

Darn in all ends.

Hand wash delicately in lukewarm water with gentle wool soap. Leave flat to dry.

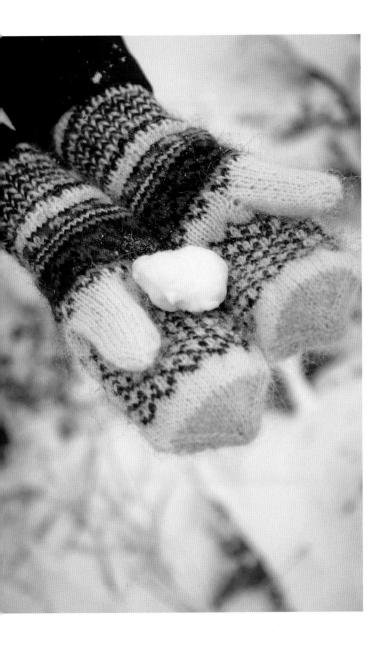

ÞORRAMATUR

Þorramatur is traditional Icelandic food served at Þorri, a mid-winter feast with origins in ancient pagan folklore. *Þorri* is an Old Icelandic month from the lunar calendar; it always begins on a Friday, between the 19th and the 25th of January, and ends on a Saturday between the 18th and 24th of February. *Þorramatur* consists mostly of lamb, mutton, and a bit of fish and is traditionally served with flatbread and rye bread (*rúgbrauð*) in deep wooden trays. It was prepared after the slaughtering to make use of everything and preserve the food by either pickling it in whey (*mysa*), smoking it, or letting it dry. A typical Þorri menu might consist of the following foods:

Hákarl, rotten or cured shark

Brennivín, also called Black Death, a vodka made of potatoes and perfumed with cumin

Sviðasulta, singed sheep's head and sheep's head jam or headcheese

Fótasulta, sheep's legs and sheep's leg jam

Svínasulta, spiced pig's head jam

Hrútspungar, ram testicles in sour whey

Hvalspik, sour whale blubber

Lundabaggar, made from all the meat leftovers, such as colons, which are rolled up then boiled and pickled in whey

Bringukollar, made from fat breast meat

Slátur (The Slaughter), liver sausages (*Lifrarpylsa*), and blood sausages (*Blóðmör*), preserved in skyr-whey

Hangikjöt (literally "hung meat"), made from lamb or mutton, traditionally smoked with sheep excrement (This is the most popular dish, also served outside the Þorri season.)

Harðfiskur, dried fish, such as cod or catfish, eaten with a little bit of butter

Potatoes and rutabaga mash

Whey, served as a refreshing drink

NORDIC LEAF MITTENS CHARTS

LEAF PATTERN A1: FIMMTEKINN

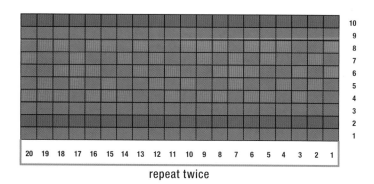

20 19 18 17 16 15 14 13 12 11 10 9 8 7 6 5 4 3 2 1

repeat twice

KEY

☐	MC
▨	CC 1
▨	CC 2
▨	CC 3
☐	CC 4

LEAF PATTERN A2: SEXTEKINN

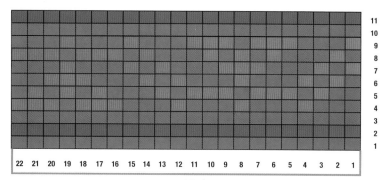

22 21 20 19 18 17 16 15 14 13 12 11 10 9 8 7 6 5 4 3 2 1

repeat twice

TWIST PATTERN B1

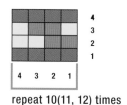

4 3 2 1

repeat 10(11, 12) times

LEAF PATTERN A3: SJÖTEKINN

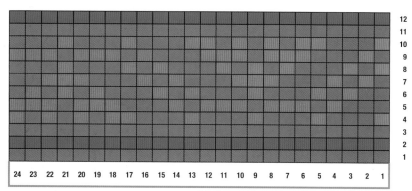

24 23 22 21 20 19 18 17 16 15 14 13 12 11 10 9 8 7 6 5 4 3 2 1

repeat twice

LITTLE LEAF PATTERN B2

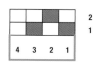

4 3 2 1

repeat 10(11, 12) times

ROSE PATTERN C

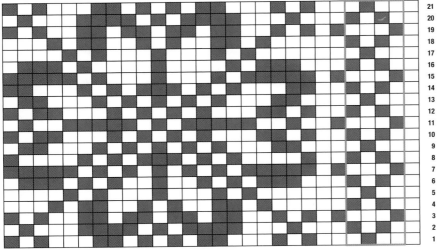

21
20
19
18
17
16
15
14
13
12
11
10
9
8
7
6
5
4
3
2
1

repeat 4(5, 6) times

28 27 26 25 24 23 22 21 20 19 18 17 16 15 14 13 12 11 10 9 8 7 6 5 4 3 2 1

KJÖTSÚPA

Icelandic meat soup is traditionally served during the sheep round-up, when sheep have been herded from the mountains where they grazed freely during the summer and are gathered in *réttir*—round-up—where they are sorted out among the farmers from the area. Every home or farm has its own recipe, and here is mine. *Kjötsúpa* is very popular outside the round-up season too. It can be reheated and tastes even better the next day, so we always make a big pot of it and eat it through the week.

2 lbs. (1 kg) lamb or mutton stew meat

1 tsp. salt

Bouquet garni (five birch leaves, dry thyme branch)

12 peppercorns

1 ¼ c. (300 g) onions, chopped into big cubes

1 ¼ c. (300 g) carrots chopped into big cubes

1 ¼ c. (300 g) rutabagas or turnips, chopped into big cubes

1 ¾ c. (400 g) potatoes, chopped into big cubes

¾ c. (200 g) leeks, sliced

½ c. (113 g) oatmeal

Milk, to serve

In a large soup pot, cover lamb or mutton with water and bring to a boil. Add salt, birch leaves and thyme, and peppercorns, and allow to cook for about 45 minutes. Skim fat from top with a spoon. Add onions, carrots, rutabagas or turnips, potatoes, and leeks to the stew. Cook for 30 minutes more or until vegetables are well cooked. At the very end of the cooking time, add oatmeal to thicken the soup.

We serve it at my home with a dish on the side so you can cut the meat then return it to your soup dish. My children usually add a splash of milk to cool it down.

PERLUSMOKKAR
BEADED WRIST WARMERS

Recycled wrist warmers were worn often in the fields by men, women, and children. Women typically wore three-cornered shawls rather than sweaters. They crossed them over the chest and binded them at the back, and the wrist warmers were their "sleeves." They were commonly made by cutting off a pair of socks at the ankles once the heel and the toes could no longer be mended, or by cutting the arms from an old sweater. More refined wrist warmers with patterning or lace stitches were worn by women and were considered Sunday best. Decorating wrist warmers with beads became fashionable in Iceland in the nineteenth century. The Textile Museum has many different kinds of wrist warmers, but I particularly like the quiet simplicity of the beaded pair made by Olöf. I simply adapted it to our modern yarn and added a little crocheted picot edge.

Size
One size

Finished Measurements
Circumference about 6 ¼"/16cm
Length about 4 ¼"/11cm
Note: You can achieve more sizes by changing needle size and/or yarn or adding/removing a pattern repeat.

Materials
- Ístex *Kambgarn*, 100% new Merino wool (3-ply worsted), 1.75 oz/50g, 164 yds/150m per ball: #1210 green, 1 ball
- Size US 3 (3mm) double-pointed needles
- Size US 5 (2 mm) steel crochet hook
- Golden seed beads 2 mm: 252 (less than 25"/63.5cm)
- Thread and sewing needle
- 2 buttons about ½"/1cm diameter
- Darning needle

Gauge
26 sts and 52 rows = 4"/10cm in garter st using size US 3 (3mm) needle
Adjust needle size as necessary to obtain correct gauge.

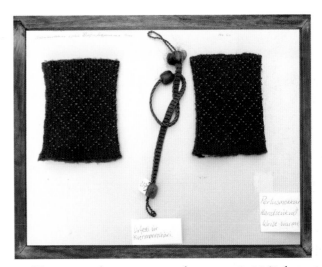

Halldóra Bjarnadóttir mentions in her register in 1961 that such beaded wrist warmers were often worn with the peysuföt, *the traditional costume used for decoration purposes. The wrist warmers were given to her by Olöf Þorbjarnardóttir. The Textile Museum in Blönduós, Reference HB213*

WHO'S THE KNITTER?

"She was Olöf, the daughter of Þorbjörn, from the valley of Mýrdal. She was a crafter and a spinner. She was the sister of Guðmundur from Stóra-Hofi," writes Halldóra Bjarnadóttir in 1961 about the woman who made the beaded wrist warmers now in the Textile Museum.

There are very few family names in Iceland. You are simply the son (*son*) or the daughter (*dóttir*) of your father. That is why Olöf is Þorbjarnardóttir, whereas Halldóra Bjarnadóttir is the daughter of Bjarni ("Bjarnar" being the genitive case of "Björn," and "Bjarna" of "Bjarni"). Of course, that means that many people can be called the same name, so it is common to also explain where you come from and who the other members of your family are. When introducing a new character, the old Icelandic sagas always start with a thorough description of the whole family: he was the son of this man and this woman who where themselves the son or the daughter of those people, they lived there, moved there, their brothers and sisters were these people who did that, etc. These introductions can last for many pages, then you can finally go on with the story. Even today, it is Icelandic cultural tradition that as soon as you meet someone, the task at hand is to discover if you have anyone in common, be it a relative, acquaintance, or friend.

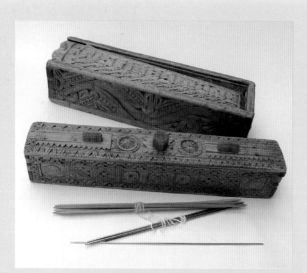

Knitting needles were kept into carved wooden boxes called Prjónastokkur. You can decipher the name Kristin on the one at the back and the date 1819 on the one at the front. The Textile Museum in Blönduós, Reference 618 and 619

INSTRUCTIONS

Beaded Wrist Warmers (Make two)

Thread needle, make a loop, secure it, draw the end of the yarn through the loop, leaving a 4"/10cm-long tail and slide beads on yarn.

With a provisional cast-on, using size US 3 (3mm) needle, CO 30 sts. Work in garter st, placing beads as indicated on chart. Always slip first st in row. Note that only uneven rows are charted; even rows are always knit.

When motif is complete, leave sts in needle. Remove provisional cast-on, fold in two with beads on the inside, and join the edges by binding off with 3-needle method.

With crochet hook, work an edge of picot around one of the openings:

1 sc in edge (between 2 ridges on garter st), 2 sl sts, 1 sc in first sc around.

Finishing

Darn in all ends.

PERLUSMOKKAR:
BEADED WRIST WARMERS CHART

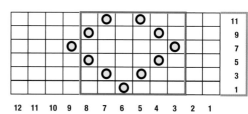

repeat 7 times upward

12 11 10 9 8 7 6 5 4 3 2 1

repeat 4 times across

Notes: Only uneven rows are charted.
Even rows are always k without any bead.
Always slip first st in row.

KEY

- ☐ k
- ⊙ place bead and knit st
- ☐ repeat

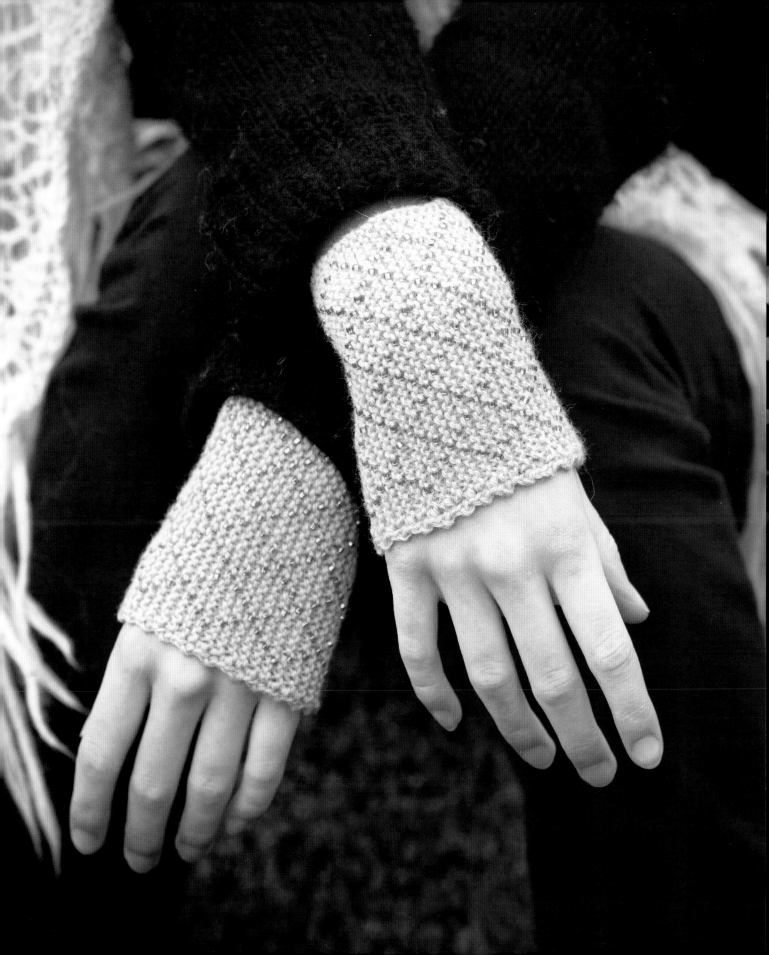

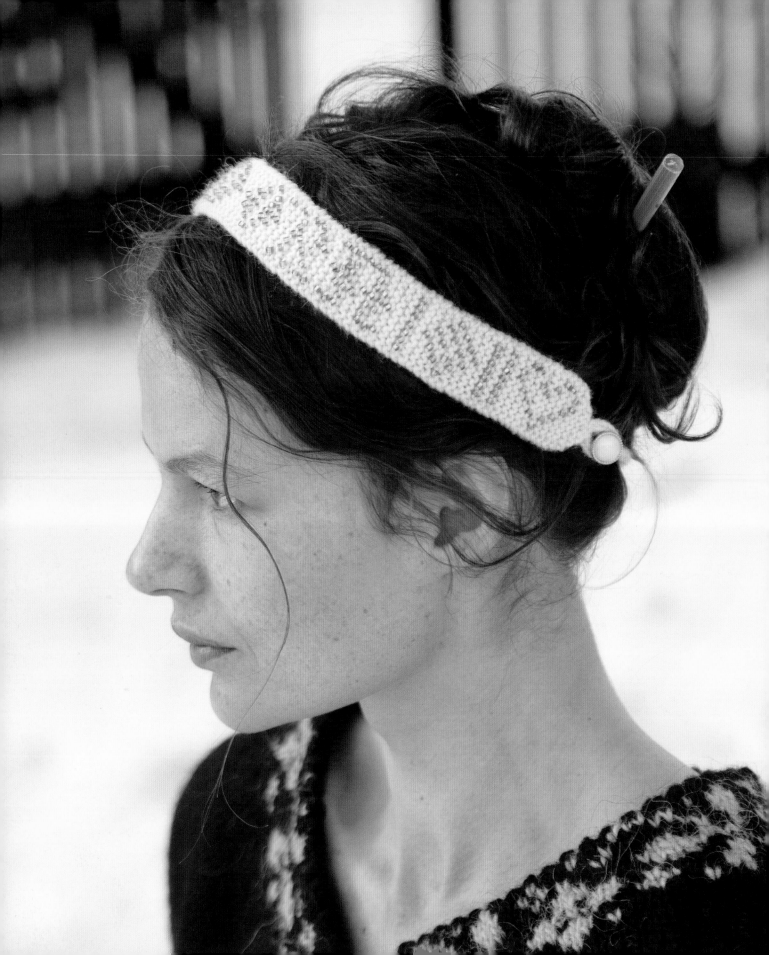

PERLUBAND
BEADED HAIRBAND & ARMBAND

This armband is my new take on wrist warmers. Despite its jewelrylike appearance, the band still provides warmth when wrapped around the wrist. It also doubles as a lovely hair band thanks to a clever I-cord design. The motif is inspired by the names and motifs inscribed on the tablet-woven bands in the Textile Museum collection. You can customize your band with the name of its intended recipient and use the little motifs to fill up the band. I've provided an alphabet, taken from an Icelandic pattern manuscript (called *Sjónabók*) from the seventeenth century. In order for the letters to appear correctly when knitting with the beads, the alphabet is reversed. You can play with the little motifs to make the band longer or shorter.

Size
One size, adjustable, customizable

Finished Measurements
About 13" by 1" (33 x 2.5cm)

Materials
◆ Ístex *Kambgarn*, 100% new Merino wool (3-ply worsted), 1.75 oz/50g, 164 yds/150m per ball: #0051 white, ½ ball

◆ Size US 0 (2mm) double-pointed needles

◆ Golden seed beads, 2mm, about 290 (29"/73.5cm long)

◆ Thread and sewing needle

◆ 2 buttons about ½"/1cm diameter

◆ Darning needle

Gauge
31 sts and 62 rows = 4"/10cm in garter st using size US 0 (2mm) needle
Gauge not essential.

THE SJÓNABÓK TRADITION

A *Sjónabók* is a manuscript pattern book filled up with hand drawings and charts meant for handiwork, such as stitching, weaving, and knitting. Only nine such books are known to exist, dating from the seventeenth through the nineteenth centuries. One is in private possession, another one belongs to the National Museum of Denmark, and the remaining seven are owned by the National Museum of Iceland. The Skaftatfell book, which dates from the eighteenth century and belongs to the National Museum of Iceland, has been the subject of a book titled *Handíðir horfinnar aldar—Sjónabók frá Skaftafelli*. One can admire the colorful pictures of the book's wooden and brown leather cover and the beautiful squared designs that fill up the book's pages, more than a third of which are decorated in many colors. There are runic characters, eight alphabets, narrow and wide border designs, and floral patterns.

More recently, the Handicraft Association of Iceland, the Iceland Academy of the Arts, and the National Museum published a compilation of the patterns from all the manuscript pattern books in the National Museum (*Íslensksjónabók*, Reykjavik 2009). There are no color pictures of the original books, but all the patterns have been redrawn and shown in different colors. A CD compilation for use by designers is included with the book.

INSTRUCTIONS

Tip
With size US 0 (2mm) needle, CO 2 sts. Work in garter st, inc 1 st on each side every other row:

Row 1: Knit all sts.

Row 2: K1, M1, knit to 1 st before EOR, M1, knit rem st.

Rep those 2 rows until there are 10 sts on needle.

Beaded Band
Work beaded pattern. Always slip first st at the beginning of the row. Customize the armband using the alphabet provided. In order for the letters to appear right, the alphabet is mirrored. You can play with the little motifs to make the band longer or shorter.

Other Tip
When beaded motif is complete, work 2 rows in garter st, then dec 1 st on each side every other row:

Row 1: Ssk, knit to 2 sts before EOR, k2tog.

Row 2: Knit all sts.

Rep these 2 rows until 2 sts rem on needle.

I-cord Loop
Next row: K1, M1, k1—3 sts
Work I-cord: *At the EOR, don't turn, slide sts to the right of your left needle and knit the sts with yarn lying at the back* for 1 ½"/4cm (you can make it longer/shorter depending on your button size). Break yarn and draw it through the sts. Make a loop and secure at the top of the tip.

I-cord for Hairband Loop
With size US 0 (2mm) needle, CO 3 sts. Work I-cord for about 6"/15cm or desired length. Add an extra 1 ½"/4 cm for the loop. Break yarn and draw it through the sts. Make a loop and secure on the I-cord.

Finishing
Darn in all ends. Sew a button at the top of first tip. Sew a button at the other end of the cord.

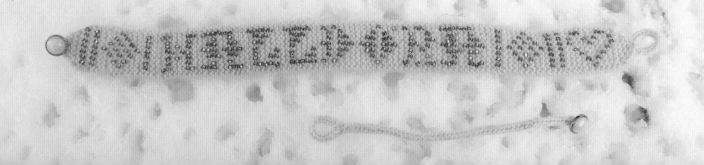

PERLUBAND: BEADED ARMBAND AND HAIRBAND CHARTS

KEY

☐ white

▨ Place bead and knit st
(bead sits at the back
of the work between 2 sts)

Notes: Only uneven rows are charted.
Even rows are always k without any bead.
Always slip first st in row. In order for the letters to appear
correctly when knitting with the beads, the alphabet is
reversed on the chart.

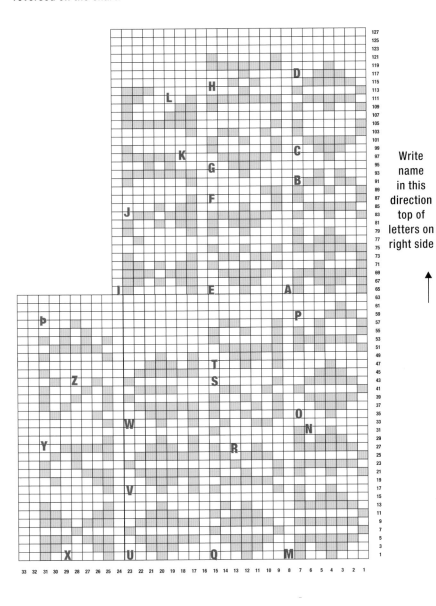

Write
name
in this
direction
top of
letters on
right side

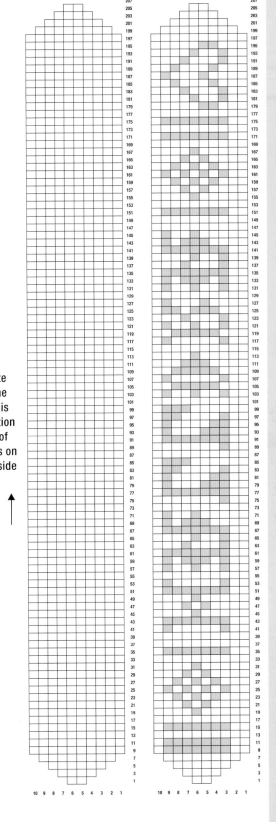

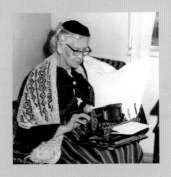

CHAPTER

2

INSPIRED BY TRADITIONAL COSTUMES

The designs in this chapter are influenced by the beautiful collection of traditional Icelandic costumes on display at the Textile Museum. The costumes are a mix of those intended for everyday use and more festive costumes with golden embroidery, mostly for women. Most of the costume jackets on display are from the late nineteenth century or early twentieth century and are sewn out of woolen fabric, but there are two rare, knitted pieces that were a source of great inspiration for me: a jacket belonging to Halldóra Bjarnadóttir and a man's sweater, both knitted by Halldóra's mother.

Opposite: *New-fallen snow on an idyllic Icelandic village.*
Jeremy Reddington/Shutterstock

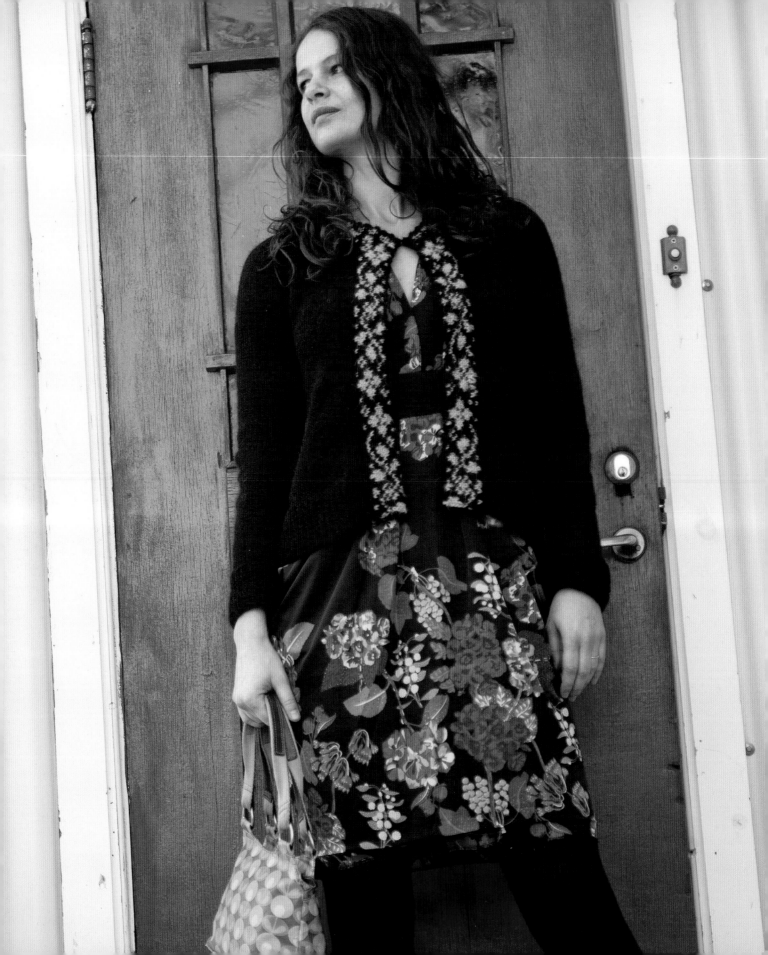

SKAUTBÚNINGUR SWEATER

Borrowing from the construction of the contemporary lopi sweater, this is my take on the festive costume *Skautbúningur*. I interpreted the metallic embroidery that decorates the costume as a leaf motif in stranded knitting. The body and the sleeves are knit in the round in stockinette stitch. The body has a thrilled hem at the back and a slightly darted waist; the elbows are shaped with short rows. At the armhole,

the stitches of the body and the sleeves are combined on one needle and the yoke is knit in the round. The neckline is lowered at the front with short rows. The sweater is steeked, then stitches are picked up along the edge and the neckline. As a true Icelandic knitter, I didn't want to knit the stranded motif band back and forth, so I came up with a little trick involving more steeking to allow me to work it in the round.

Sizes
Women XS, S, (S/M, M, ML), 1X, 1X/2X, 2X
To fit bust: 30, 32 (34, 36, 38) 40, 42, 44"/ 76, 81.5 (86.5, 91.5, 96.5) 101.5, 106.5, 112cm

Finished Measurements (slim fit)
Bust: 30, 31½, (34 ½, 37, 38), 40 ½, 43, 44 ½"/ 76, 80, (87.5, 94, 96.5), 103, 109, 113cm
Waist: 25, 25 ½, (31 ½, 33, 35), 37, 38, 39"/63.5, 65, (80, 84, 89), 94, 96.5, 99cm
Body length to underarm: 16 ½, 17, (17 ½, 18, 18 ½), 19, 19, 19"/42, 43, (44.5, 45.5, 47), 48.5, 48.5, 48.5cm
Sleeve length to underarm: 17, 17 ½, (18, 18, 18 ½), 18 ½, 18 ½, 18 ½"/43, 44.5, (45.5, 45.5, 47), 47, 47, 47cm

Materials
♦ Ístex *Léttlopi*, 100% pure Icelandic wool (light spun, medium weight), 1.75 oz/50g, 109 yds/100m: #0059 black (MC), 6, 6, (7, 7, 8), 8, 9, 9 skeins; #1411 yellow (CC), 1 skein

♦ Size US 7 (4.5mm) circ needle. Magic loop is used for smaller diameters (you can also use double-pointed needles).

♦ Stitch markers

♦ Darning needle

♦ 5, 5 (5, 5, 5) 6, 6, 6 pairs of black eyes and hooks

Gauge
18 sts and 24 rows = 4"/10 cm in St st using size US 7 (4.5.mm) needle
Adjust needle size as necessary to obtain correct gauge.

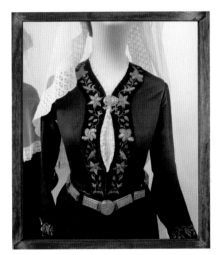

This Skautbúnigur costume, embroidered with golden threads in bouldering, belongs to Ingibjörg Guðmundsdóttir (1887–1974) and was made by her mother, Ingibjörg Guðrún Sigurðardóttir (1848–1922) from Mjóadal in East Húnnavatnasýsla county. The origins of the Skautbúningur costume date back to 1857, when painter Sigurður Guðmundsson (1833–1874) wrote a long article about the national costume and how it could be adapted and modernized. As a result of Guðmundsson's suggested changes to the old Faldbúningur costume, the first Skautbúningur was born in Reykjavík in 1859. Ingibjörg's costume is possibly one of the first costumes made that followed Sigurður's instructions and motifs. The Textile Museum in Blönduós, Reference HIS1605

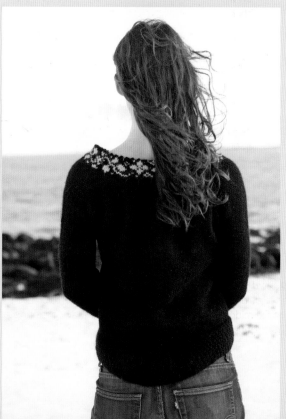

Pattern Stitch

Broken rib (multiple of 2)

Rnd 1: *K1, p1*.

Rnd 2: Knit all sts.

Rep Rnds 1 and 2.

INSTRUCTIONS

Sleeves

With an Old Norwegian cast-on also known as German twisted cast-on (known as *silfur fit*—"silver cast-on"—in Icelandic), using MC and size US 7 (4.5mm) needle, CO 34, 36, (38, 40, 42), 46, 50, 52 sts. Join, taking care not to twist sts, pm EOR (end of rnd). Work in broken rib for 2.75"/7cm.

Work in St st, inc 0, 0, (0, 1, 1), 1, 0, 1 st(s) anywhere in the first rnd—34, 36, (38, 41, 43), 47, 50, 53 sts.

*Work 12, 12, (13, 13, 13), 13, 13, 13 rnds in St st.

Next rnd: K1, M1, knit to 1 st before EOR, M1, knit rem st*.

Rep from * to * 6 times in all—46, 48, (50, 53, 55), 59, 62, 65 sts.

At the same time, after the 3rd inc rnd, when sleeve length reaches the elbow (try the sleeve on), work elbow shaping with short rows as follows:

K29, 30, (32, 33, 36), 37, 40, 41, turn, yo, k18, 18, (20, 20, 22). 22, 24, 24, turn, yo, *knit to 3 sts before gap, turn, yo, purl to 3 sts before gap, turn, yo* twice.

Next rnd: Close all the gaps (see Technique on page 132): work the first 3 yo's with the next st as k2tog, and the next 3 yo's with the st before as ssk.

When sleeve measures 17, 17 ½, (18, 18, 18 ½), 18 ½, 18 ½, 18 ½"/43, 44.5, (45.5, 45.5, 47), 47, 47, 47cm, or when reaching desired length, knit to 4, 4, (4, 4, 4), 4, 5, 5 sts before EOR and place next 8, 8, (8, 9, 9), 9, 10, 11 underarm sts on a st holder or length of yarn—38, 40, (42, 44, 46), 50, 52, 54 sts. Break off a good length of yarn later used to graft the underarms. Set sleeve aside and knit the 2nd sleeve the same way.

Body

With a German twisted cast-on, using MC and size US 7 (4.5mm) needle, CO 139, 147, (161, 173, 179), 191, 205, 211 sts. Work broken rib for 18, 18, (20, 20, 20), 20, 20, 20 rows.

Next rnd: K45, 49, (54, 58, 61), 65, 70, 73 sts, *k2tog* 25, 25, (27, 29, 29), 31, 33, 33 times, knit rem sts to EOR—114, 122, (134, 144, 150), 160, 172, 178 sts.

CO 2 extra sts, which are always purled (central front sts used for steeking) and are not included in the stitch count. Join in the rnd and cont in St st.

Work 1 rnd.

Short rows to lower the back:

K60, 64, (70, 76, 79), 84, 90, 93 sts, turn, yo, p6, 6, (6, 8, 8), 8, 10, 10, turn, yo, k6, 6, (6, 8, 8), 8, 10, 10, k2tog, k2, 2, (2, 3, 3), 3, 4, 4, turn, yo, p9, 9, (9, 12, 12), 12, 15, 15, ssp, p2, 2, (2, 3, 3), 3, 4, 4, turn, yo, k12, 12, (12, 16, 16), 16, 20, 20, k2tog, k2, 2, (2, 3, 3), 3, 4, 4, turn, yo, p15, 15, (15, 20, 20), 20, 25, 25, ssp, p2, 2, (2, 3, 3), 3, 4, 4, turn, yo, k18, 18, (18, 24, 24), 24, 30, 30, k2tog, knit to EOR.

Next rnd: Knit to 1 st before gap, ssk, knit to EOR.

Work even for 1, 3, (3, 5, 5), 7, 7, 7 rnds.

In next rnd, place four markers, two in the front, two in the back:

K6, 7, (8, 10, 11), 12, 14, 14, pm, k39, 42, (46, 48, 50), 53, 56, 59, pm, k24, 24, (26, 28, 28), 30, 32, 32, pm, k39, 42, (46, 48, 50), 53, 56, 59, pm, k6, 7, (8, 10, 11), 12, 14, 14.

Waist shaping
Decreases

Rnds 1–10: Work in St st.

Rnd 11: *K to 3 sts before marker, ssk, k2, k2tog* 4 times, knit to EOR.

Rep these 11 rnds 3 times in all—90, 98, (110, 120, 126), 136, 148, 154 sts.

Work 3, 3, (3, 3, 4), 4, 4, 4 rnds even.

Increases

Rnd 1: *Knit to 1 st before next marker, M1, k2, M1* 4 times, knit to EOR.

Rnds 2–13: Work in St st.

Rep these 13 rnds 3 times in all—114, 122, (134, 144, 150), 160, 172, 178 sts.

Remove back markers but not front markers and cont even for 1, 2, (3, 4, 5), 5, 6, 6 rnds.

Yoke
Combine body and sleeves on needle:

K19, 21, (24, 26, 27), 30, 32, 33 sts of right front, set next 8, 8, (8, 9, 9), 9, 10, 11 sts on a st holder (underarm sts), with yarn from body k38, 40, (42, 44, 46), 50, 52, 54 sts of left sleeve, k60, 64, (70, 74, 78), 82, 88, 90 sts of back, set next 8, 8, (8, 9, 9), 9, 10, 11 sts on a st holder (underarm sts), k38, 40, (42, 44, 46), 50, 52, 54 sts of left sleeve, k19, 21, (24, 26, 27), 30, 32, 33 sts of left front—174, 186, (202, 214, 224), 242, 256, 264 sts.

Knit 1 rnd.

Short rows to work the back and shoulders longer:

Knit to left front marker, turn, yo, purl back to right front marker, turn, yo, *knit to 3 sts (2 sts and a yo) before gap, turn, yo, purl to 3 sts (2 sts and a yo) before gap, turn, yo* rep between * and * 4, 4, (4, 4, 5), 5, 5, 5 times.

Next rnd: Close gaps (see Technique on page 132): Knit the 5, 5, (5, 5, 6), 6, 6, 6 left front yo's with the next st as k2tog and the 5, 5, (5, 5, 6), 6, 6, 6 right front yo's with the st before as ssk.

K1, 1, (2, 2, 3), 3, 4, 4 rnds.

Yoke decreases
Dec Rnd 1: K2, *k2tog, k4* 28, 30, (32, 34, 36), 39, 41, 43 times, k2tog, knit rem sts—145, 155, (169, 179, 187), 202, 214, 220 sts.

Work even for 9, 10, (10, 12, 13), 14, 15, 16 rnds.

Dec Rnd 2: *K1, k2tog* 48, 50, (56, 58, 62), 67, 71, 73 times, knit rem sts—97, 105, (113, 121, 125), 135, 143, 147 sts.

Work even for 4 rnds.

BO the two extra purled sts. Don't break off yarn.

Steek yoke (see Techniques)
With sts still on needle, machine-sew one or two seams into each of the purled sts at the center front using a small, straight stitch. Cut between seams.

Pattern band
From RS, working with yarn from yoke, pm, pick up and k1 st at left corner, pm, then pick up and knit 2 out of 3 sts down the left edge, CO 5 extra sts (used for steeking), pick up and knit up the right edge the same number of sts as on left edge, pm, pick up and k1 st at right corner, pm new EOR. Work motif band in the rnd: first chart A (corner st, yoke sts and other corner st), then left edge (Chart B1), the 5 extra sts, and finally right edge (Chart B2).

Chart A: Work right corner sts, then work yoke sts between appropriate marks according to size [central motif is repeated 2, 2, (2, 2, 2), 3, 3, 3 times], work left corner sts.

Chart B1: Work a complete motif of 48 sts, then rep for X sts (X = number of picked-up sts at edge minus 48).

Chart B2: Start working motif after Y sts (Y = 48 – X): Work last X sts of motif then work a complete 48 sts motif.

Corners are turned by inc between markers on Rows 2, 4, 6 and 8: *Knit to first m, M1 on left side of m, knit to 2nd m, M1 on right side of m* twice. When motif is complete = 9 sts at each corner.

Example: Sample size M: 78 sts were picked up on each edge. Chart B1: work a complete rep of 48 sts then X = (78 - 48) 30 first sts of chart. Chart B2: Start working motif after Y = 48 – 30 = 18 sts. Work 30 last sts of motif (from st 19 to 48), then work a complete rep of 48 sts.

When motif is complete, work 1 rnd with MC:

K9 right corner sts, k17, 21, (22, 23, 25), 30, 31, 33 yoke sts, *k2tog, k1* 21, 21, (23, 25, 25), 25, 27, 27 times, knit rem yoke sts—76, 84, (90, 96, 100), 110, 116, 120 yoke sts.

K9 left corner sts, knit left edge sts, BO the 5 extra sts, knit to EOR. Break off yarn.

Steek band
With sts still on needle, machine-sew one or two seams on each side of the middle st of the 5 extra sts between the edges using a small, straight stitch. Cut between seams.

Cont working band back and forth with MC (starts at bottom of right edge).

Row 1 (eyelet row): K1, yo, *k2tog, yo* across, end with knit or k2tog. Arrange the corner markers so that there are still 9 sts in between at each corner on next row.

Row 2 and all even rows: Purl all sts.

Row 3: Knit all sts.

Row 5: Knit to 2nd marker, k17, 21, (22, 23, 25), 30, 31, 33 yoke sts, *M1, k1* 21, 21, (23, 25, 25), 25, 27, 27 times, knit to EOR—97, 105, (113, 121, 125), 135, 143, 147 yoke sts.

Rows 7, 9, and 11: Turn corners by dec sts between markers: *Knit to first m, k2tog, knit to 2 sts before next m, ssk* twice, knit to EOR—3 sts at each corner.

Row 13: Knit to first m, s2sk, knit to third m, s2sk, knit to EOR—1 st at each corner

Row 14: Purl.

BO.

Finishing
Graft underarm sts. Darn in loose ends.

Fold the steeked band at bottom of edges toward the inside, fold the picot edge toward the inside, and sew down loosely, thus hiding the steeked edges. Hand wash the sweater delicately in lukewarm water with gentle wool soap. Leave flat to dry.

Sew eyes and hooks inside, facing, at equal distances.

SKAUTBÚNINGUR SWEATER CHARTS

CHART B1: LEFT EDGE

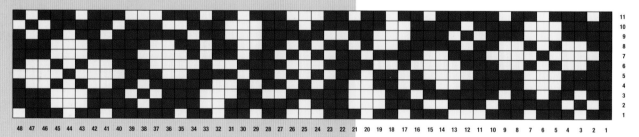

CHART A: CORNERS AND YOKE

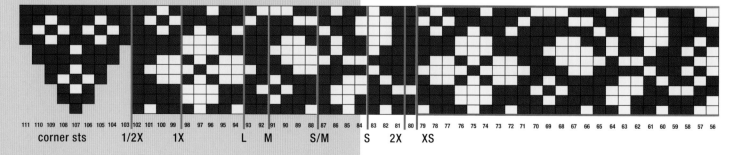

64

SKAUTBÚNINGUR SWEATER SCHEMATIC

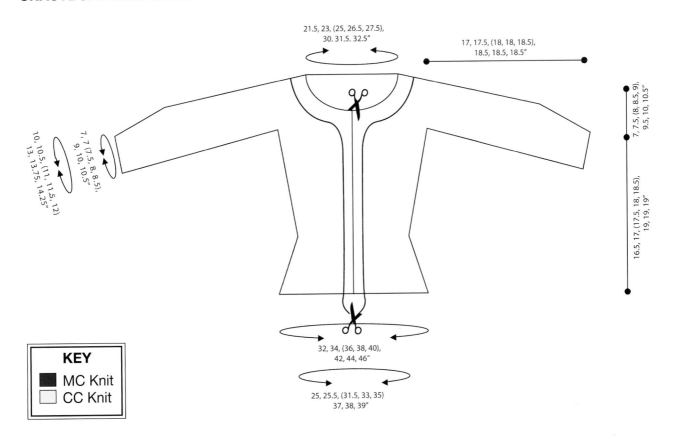

21.5, 23, (25, 26.5, 27.5), 30, 31.5, 32.5"

17, 17.5, (18, 18, 18.5), 18.5, 18.5, 18.5"

7, 7.5, (8, 8.5, 9), 9.5, 10, 10.5"

7, 7 (7.5, 8, 8.5), 9, 10, 10.5"

10, 10.5, (11, 11.5, 12), 13, 13.75, 14.25"

16.5, 17, (17.5, 18, 18.5), 19, 19, 19"

32, 34, (36, 38, 40), 42, 44, 46"

25, 25.5, (31.5, 33, 35), 37, 38, 39"

KEY

■ MC Knit
□ CC Knit

CHART B2: RIGHT EDGE

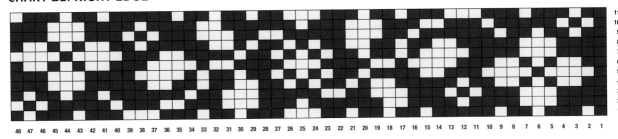

48 47 46 45 44 43 42 41 40 39 38 37 36 35 34 33 32 31 30 29 28 27 26 25 24 23 22 21 20 19 18 17 16 15 14 13 12 11 10 9 8 7 6 5 4 3 2 1

11 10 9 8 7 6 5 4 3 2 1

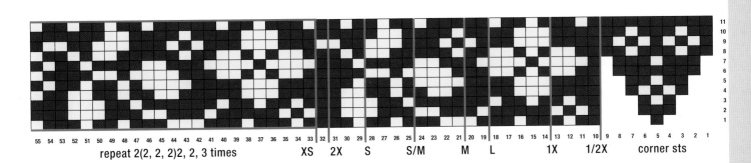

55 54 53 52 51 50 49 48 47 46 45 44 43 42 41 40 39 38 37 36 35 34 33 32 31 30 29 28 27 26 25 24 23 22 21 20 19 18 17 16 15 14 13 12 11 10 9 8 7 6 5 4 3 2 1

repeat 2(2, 2, 2)2, 2, 3 times XS 2X S S/M M L 1X 1/2X corner sts

11 10 9 8 7 6 5 4 3 2 1

MÖTULL CAPELET

The *Mötull* is a cape made of woolen fabric, usually flannel, but sometimes silk. The length varied with time, but it often reached the mid-calf. Sigurður Guðmundsson made a shorter version to go with the *Skautbúningur* and even drew a special motif to decorate it. My version is more like a capelet, and I used a leaf pattern similar to my *Skautbúningur* sweater.

Sizes
Women XS (S, M, L), 1X, 2X, 3X

Finished Measurements
At lower edge: 45 ½ (47, 50 ½, 54), 58, 61, 69"/115.5 (119.5, 128.5, 137), 147.5, 155, 175.5cm at the lower edge
Around neck: 15 (15, 18 ½, 18 ½), 22, 22, 25 ¾"/38 (38, 47, 47), 56, 56, 65.5cm
Height: 15 ¾ (15 ¾, 16 ½, 16 ½), 17, 18, 18"/ 40 (40, 42, 42), 43, 45.5, 45.5cm

Materials
◆ Ístex *Álafosslopi*, 100% pure Icelandic wool (light spun), 3.5 oz/100g, 109 yds/100m per skein: #0484 green (MC), 4 (4, 4, 4), 5, 5, 5 skeins; #0059 black (CC) 2 skeins

◆ Size US 15 (10mm) circ needle

◆ 3 pairs of black eyes and hooks

◆ Darning needle

Gauge
9 sts and 12 rows = 4"/10 cm in St st using size US 15 (10mm) needle yarn held double
Adjust needle size as necessary to obtain correct gauge.

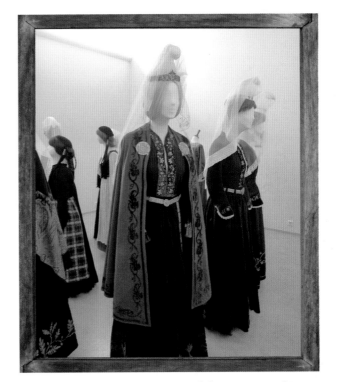

This Skautbúningur costume was made by Kristín Jónsdóttir (1850–1937) probably in 1870. It was given to the museum by her great grand daughters, the daughters of Kristín Sigurðardóttir—who was named after her grandmother—to honor her memory. The green cape, or mötull, has big appliqué flannel black leaves, outlined with a golden thread. The Textile Museum in Blönduós

PEYSUFÖT COSTUME

In the nineteenth-century Iceland, women wore the traditional *peysuföt* costume everyday. It consisted of a black knitted jacket that was closed at the front with a gap through which the shirt underneath could be seen. It was knitted on very fine needles in a rather intricate manner and was shaped to fit the wearer's body snuggly. It had a pleated knitted piece at the hem, and the cuffs and front edges were trimmed with black velvet. A woven apron, with checks or vertical stripes, was worn over the skirt. A silk neckerchief and a black tasseled cap called a *skotthúfa* completed the costume. The cap was knitted, and the tassel was decorated with a sleeve of silver or lattenbrass. Women wore black or red socks and traditional soft shoes made of lamb skin or fish skin with knitted inserts inside. They also wore shawls to keep warm, usually a very simple garter-stitch shawl for everyday, but sometimes they wore beautiful lace shawls to show off their spinning and knitting skills.

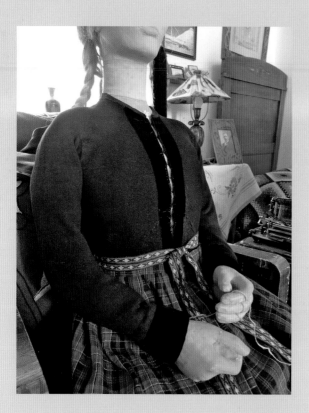

INSTRUCTIONS

With MC held double and size US 15 (10mm) needle, CO 90 (98, 106, 114), 122, 130, 138 sts. Work in garter st for 6 rows.

Following chart, work stranded motif in St st according to sizes with a 4-st garter st border on each side.

Note that each square represents 2 sts and 2 rows.

Row 1: K4, knit stranded charted motif, knit last 4 sts.

Row 2: K4, purl stranded charted motif, knit last 4 sts.

Rep these 2 rows until motif is complete, then begin working decs according to sizes beginning with Row 13 (11, 9, 7), 5, 3, 1 and ending at Row 25 (25, 23, 23), 21, 21, 19 (RS).

Row 1: K4, *k13, ssk* 4 times, k10, *k2tog, k13* 4 times, k4.

Row 2 and all even rows: K4, purl to 4 sts before EOR, k4.

Row 3: K4, *k12, ssk* 4 times, k10, *k2tog, k12* 4 times, k4.

Row 5: K4, *k11, ssk* 4 times, k10, *k2tog, k11* 4 times, k4.

Row 7: K4, *k10, ssk* 4 times, k10, *k2tog, k10* 4 times, k4.

Row 9: K4, *k9, ssk* 4 times, k10, *k2tog, k9* 4 times, k4.

Row 11: K4, *k8, ssk* 4 times, k10, *k2tog, k8* 4 times, k4.

Row 13: K4, *k7, ssk* 4 times, k10, *k2tog, k7* 4 times, k4.

Row 15: K4, *k6, ssk* 4 times, k10, *k2tog, k6* 4 times, k4.

Row 17: K4, *k5, ssk* 4 times, k10, *k2tog, k5* 4 times, k4.

Row 19: K4, *k4, ssk* 4 times, k10, *k2tog, k4* 4 times, k4.

Row 21: K4, *k3, ssk* 4 times, k10, *k2tog, k3* 4 times, k4.

Row 23: K4, *k2, ssk* 4 times, k10, *k2tog, k2* 4 times, k4.

Row 25: K4, *k1, ssk* 4 times, k10, *k2tog, k1* 4 times, k4.

Work 6 rows in garter st (knit all rows) on rem 34 (34, 42, 42), 50, 50, 58 sts.

Next row (WS): BO loosely: K1, *k1, insert left needle through the 2 sts and k2tog through the back loops* to EOR (end of row).

Finishing

Darn in all ends. Hand wash in lukewarm water with wool soap. Squeeze excess water and lay flat to dry. Sew on eyes and hooks, facing each other, with about 4"/10cm between.

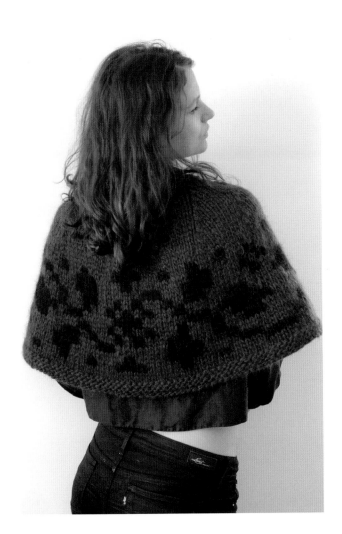

MÖTULL CAPELET CHART

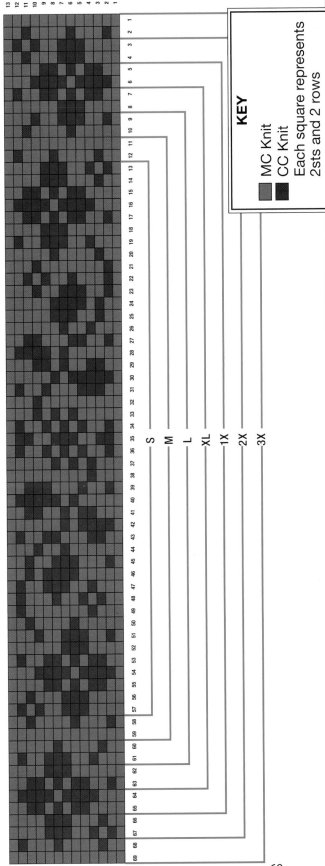

KEY

- ▨ MC Knit
- ◼ CC Knit

Each square represents 2sts and 2 rows

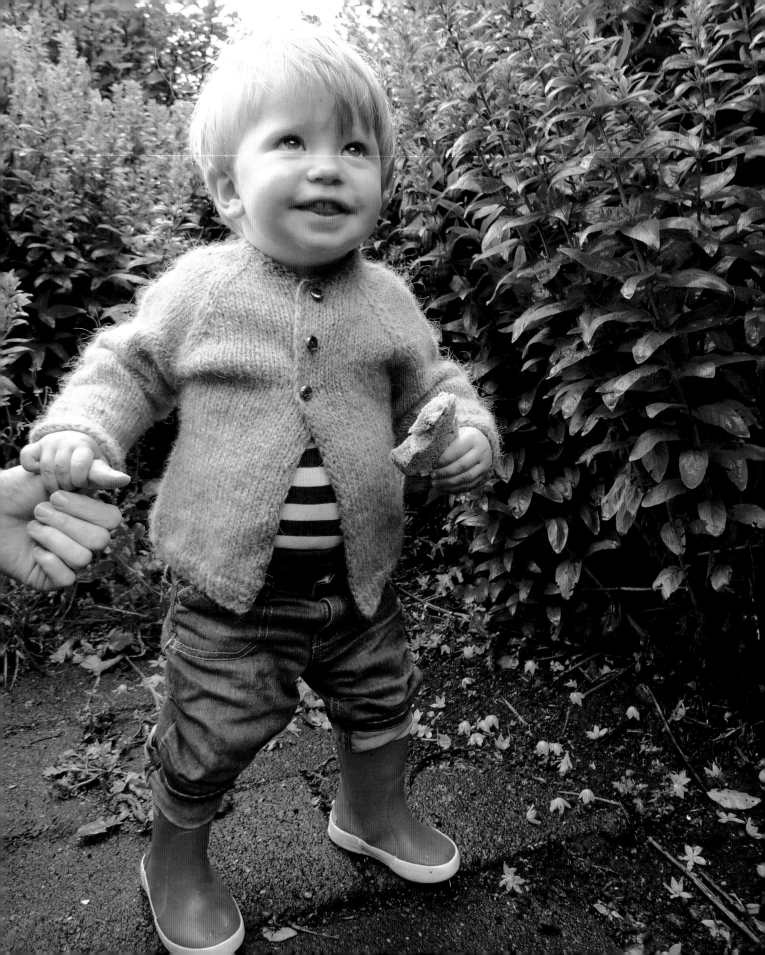

A PERFECT LITTLE ICELANDIC SWEATER

This book is certainly not the place for an accurate historical pattern, but I hope you will have fun knitting this little sweater inspired by the original styles. *Íslensk Karlmannaföt 1740–1850*, a book by Fríður Ólafsdóttir researching men's costumes, was very helpful for some shaping features. The sweater is knitted in the round with waist shaping (at the sides and in the back) up to the armholes; stitches are set aside for the underarms, the back and the front are knitted separately back and forth, and the back is knit a little longer than the front. Extra stitches are cast-on for the sleeves, then the yoke is knitted with raglan decreases. Stitches are picked up around the armholes, and the sleeves are knitted from the top down. The elbows are shaped with short rows. The sweater is steeked at the front and the neckline and edged with single crochet. The edges are lined in the inside with a piece of fabric.

Sizes
Child 1 (2, 3, 4) years

Finished Measurements
Bust: 22 (24, 25 ¾, 27 ½)"/ 56 (61, 65.5, 70)cm
Body length to underarm: 7 (8, 9, 10)"/ 18 (20.5, 23, 25.5)cm
Sleeve length to underarm: 8 (9, 9 1/2, 10 ½)"/20.5 (23, 24, 26.5)cm

Materials
◆ ístex *Léttlopi*, 100% pure Icelandic wool (light spun, medium weight), 1.75 oz/50g, 109 yds/100m per skein: #1402 blue heather (MC), 3 (3, 4, 5) skeins; #1406 green (CC), less than 0.75 oz/10g

◆ Size US 7 (4.5mm) circ needle

◆ Magic loop is used for smaller diameters or double-pointed needles

◆ Crochet hook size US G/6 (4mm)

◆ Stitch markers

◆ Darning needle

◆ Fantasy ribbon, three times the length of the cardigan opening

◆ 3 snap buttons

◆ 3 little sliver buttons

Gauge
18 sts and 24 rows = 4"/10cm in St st using size US 7 (4.5mm) needle
Adjust needle size as necessary to obtain correct gauge.

Man's sweater knitted by Björg Jónsdóttir, Halldóra's mother, for Eirik Briem in 1880–1890. Halldóra considered this sweater to be one of the most important pieces in her collection of handknits. She mentions in her biography that "the men sweaters were knitted in stocking stitch like the women ones, with a similar determined shape, out of a good 2-ply band, often dark blue, the arms reached under the hips. (…) They were buttoned up all the way, often with silver buttons." The elbows are shaped with short rows, possibly to avoid holes from forming with use; as a matter of fact, the sweater is mended in many places, but the elbows are like new.

SKÚLI FOGETI'S PERFECT SWEATER

There are very few written knitting instructions for Icelandic knitting, however, as the techniques and traditions were typically passed down at home, from one generation to the next. Instructions do exist, for example, for the perfect man's sweater, written by Skúli Magnússon sometime between 1760 and 1770. Skúli was the first bailiff (*fogeti*) of Iceland and a knitter too, obviously. No one has ever been able to follow his instructions. Here is an attempt to translate the pattern.

"It has to be wide at the cast on, 1 alin* and 1 kvartél*, and the underarm length almost the same; cast on at the bottom about 54 per kvartil*, the measure will say how much. This with a medium band. If the men want to avoid it pouching at the front, are decreased under the waist about 14 times on the middle needle, and in the back, if you want, may decrease 8 times, and for the decreases at the sides you will have 4 in between; would it be still too wide, then 3 in every other of the last ones under the waist. The width under the waist is 3 kvartél and 3 fingers, but the arms width is 1 alin and 2 fingers (...)." After that, instructions are really confusing and many bits I don't understand at all.

Note: These are units of measures. An alin *is about 19.7–23.6" (50–60 cm); a* kvartél *or* kvartil *is 1/4 of an* alin, *or about 4.7–5.5" (12–14 cm). So, if I understand correctly, you cast-on at the bottom about 540 stitches. Finer sweaters would require even more stitches; the jacket for which Fríður gives instructions in her book* Íslensk karlmannaföt 1740– 1850, *begins with a cast-on of 840 stitches.*

INSTRUCTIONS

Body

With MC and size US 7 (4.5mm) circ needle, CO 99 (107,115, 123) sts; CO 2 extra sts that are always purled and that are not included in the sts count (sts used to steek later). Join, taking care not to twist sts. EOR (end of rnd) is at the front between the 2 purled sts.

Work in rib (*k1, p1*, end with k1) for 4 (4, 5, 5) rnds.

Work in St st, inc 1 st in first rnd—100 (108, 116, 124) sts.

Place markers: K25 (27, 29, 31), pm right side, k25 (27, 29, 31), pm middle of the back, k25 (27, 29, 31), pm left side, k rem sts.

Work until 7 (8, 9, 10) rnds from ribbing, then work dec on each side every 7 (8, 9, 10) rnds:

Decreases
Rnd 1 (dec rnd): Knit to 3 sts before right-side m, k2tog, k2, ssk; knit to 3 sts before left-side m, k2tog, k2, ssk—98 (106, 114, 122) sts.

Rnds 2–7 (8, 9, 10): Knit all sts.

Repeat these 7 (8, 9, 10) rnds 3 times in all—88 (96, 104, 112) sts.

Work inc on each side and at the back every 7 (8, 9, 10) rnds:

Increases
Rnd 1 (inc rnd): Knit to 1 st before right-side m, M1R, k2, M1L; knit to 1 st before back m, M1R, k2, M1L; knit to 1 st before left side m, M1R, k2, M1L, knit to EOR.

Rnds 2–7 (8, 9, 10): Knit all sts.

Repeat these 7 (8, 9, 10) rnds twice in all—100 (108, 116, 124) sts.

Work even until body measures 7 (8, 9, 10)"/18 (20.5, 23, 25.5)cm.

Next rnd: Set underarm sts on a st holder and work front and back separately back and forth:

K22 (24, 25, 27) right front sts, turn, *p44 (48, 50, 54) front sts (plus the 2 extra sts that are now knit on the WS), turn, k44 (48, 50, 54) (plus the 2 extra sts)* 2 (3, 3, 4) times—4 (6, 6, 8) rows at the front. Don't break off yarn.

Set 5 (6, 6, 7) underarm sts on both sides of the front on a st holder, and with a new strand of yarn, work 46 (48, 52, 56) back sts in St st, back and forth, for 8 (10, 10, 12) rows. Break off yarn.

Raglan Yoke
In the continuity of front, pm, then CO 31 (32, 35, 35) sts (right shoulder), pm, k46 (48, 52, 56) back sts, pm, CO 31 (32, 35, 35) sts (left shoulder), pm, knit to EOR at center front—162 (172, 186, 194) sts.

Cont to work St st in the rnd and work raglan dec:

Rnd 1: Knit all sts.

Rnd 2: *Knit to 3 sts before next m, k2tog, k2, ssk* 4 times, knit to EOR.

Repeat these 2 rnds 14 (15, 16, 16) times—50 (52, 58, 58) sts rem.

BO loosely.

Right Sleeve
With MC, place the 5 (6, 6, 7) underarm sts on the needle, pick up and k4 (5, 5, 6) sts along the back, pick up and k31 (32, 35, 35) shoulder sts, pick up and k2 (3, 3, 4) sts along the front—42 (46, 50, 52) sts; k2 (3, 3, 3) sts and pm EOR.

**Work St st in the rnd and dec on both sides of marker every 7 (7, 8, 9) rnds:

Rnds 1—6 (6, 7, 8): Knit all sts.

Rnd 7 (7, 8, 9) (dec rnd): Knit to 3 sts before m, ssk, k1, k2tog, knit to EOR.

Repeat these 7 (7, 8, 9) rnds 5 (5, 6, 6) times in all—32 (36, 38, 40) sts.

At the same time, after 24 (26, 29, 31) rnds in all (between the 3rd and the 4th dec rnds), shape elbow with short rows:

K27 (30, 33, 34), turn, yo, p18 (20, 22, 23), turn, yo, knit to EOR closing gap (k2tog yo with next st), k27 (30, 33, 34) closing gap

(ssk yo with previous st), turn, yo, p18 (20, 22, 23), turn, yo, knit to EOR closing gap (k2tog yo with next st).

Next rnd: Close gap (ssk yo with previous st).

When sleeve measures about 7 (8, 9, 9 1/2)"/18 (20.5, 23, 24)cm, work rib (*k1, p1*) for 4 (4, 5, 5) rnds.

BO loosely in rib pattern.

Left Sleeve
With MC, place the 5 (6, 6, 7) underarm sts on the needle, pick up and k2 (3, 3, 4) sts along the front, pick up and k31 (32, 35, 35) shoulder sts, pick up and k4 (5, 5, 6) sts along the back—42 (46, 50, 52) sts; k3 sts and pm EOR.

Cont as Right Sleeve from ** to end.

Finishing
Graft underarm sts and darn in all ends.

Open up the cardigan: Machine-sew one or two seams into each of the purled sts at the center front using a small straight st. Cut between seams (see Techniques).

Mark the V-neck opening 1/4"/1.5cm from raglan dec on front side and 1/2"/5cm down at the center front, on both sides of the neckline. Mark a straight line between these marks, machine-sew one or two seams using a small straight st. Cut away excess material. With crochet hook and CC, crochet an edging of single crochet along the sides and around the neckline.

Hand wash the sweater delicately in lukewarm water with gentle wool soap. Leave flat to dry.

Sew down by hand the ribbon on the inside of the sweater along the edges and around the neckline. Sew 3 snap buttons facing with about 1 1/2"/4cm between.

Sew silver buttons above the snap button for decoration.

A PERFECT LITTLE ICELANDIC SWEATER SCHEMATIC

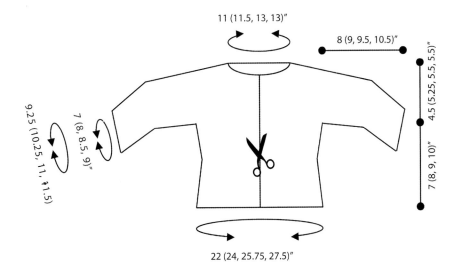

11 (11.5, 13, 13)"

8 (9, 9.5, 10.5)"

4.5 (5.25, 5.5, 5.5)"

9.25 (10.25, 11, 11.5)

7 (8, 8.5, 9)"

7 (8, 9, 10)"

22 (24, 25.75, 27.5)"

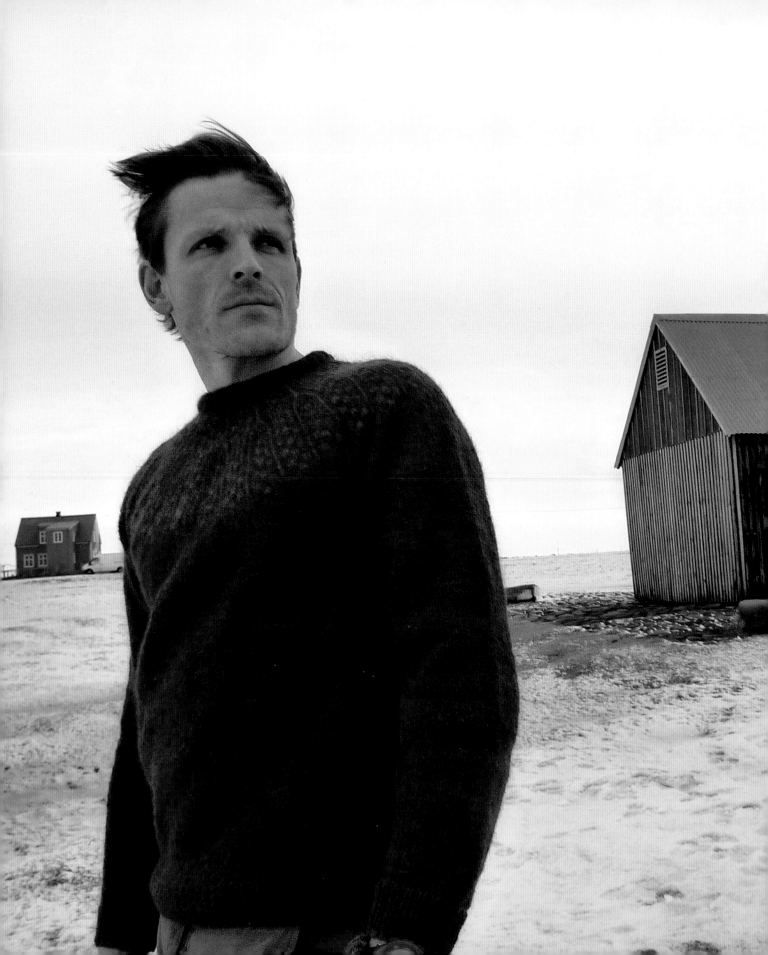

THE MISSING LOPI SWEATER

The so-called *lopapeysa*—literally "made with lopi sweater," with its recognizable yoke patterning— is probably the most prominent representation of Icelandic knitting today. But you won't find any in the Textile Museum nor in other Icelandic museums, because this "traditional" sweater is actually fairly new. In the 1950s, yoke sweaters became fashionable in the Western world. Nobody really knows how and when exactly the first *lopapeysa* came to be, but there are a few Icelandic women who claim to have knitted the first. What is certain is that by the 1970s, the *lopapeysa* had become so popular that it was probably one of the most sought-after sweaters in the world. The first

yoke patterns were made of geometrical motifs with decreases between the motif bands. Then women began to include decreases within the motif and started to invent or adapt countless motifs, seeking inspiration in Icelandic nature, paintings, and old pattern manuscripts. Even today, one could say the *lopapeysa* is in constant state of evolution.

My design is for a rather fitted sweater that remains fairly traditional in shape, with the exception of a few short rows that I added to lift the back and lower the front, creating a more natural neckline. The motif is inspired by the same pair of mittens that I drew upon to create the Checkered Mittens and Beanie (see pages 18–23).

Sizes
Men S (M, L, 1X), 2X, 3X, 4X

Finished Measurements
Bust: 35 (39, 42, 47), 49, 54, 57"/89 (99, 106.5, 119.5), 124.5, 137,145cm
Body length to underarm: 16 (16 ½, 17, 17 ½), 18, 18, 18 ½"/ 40.5 (42, 43, 44.5), 45.5, 45.5, 47cm
Sleeve length to underarm: 19 (19 ½, 20, 20 ½), 21, 21, 21 ½"/ 48.5 (49.5, 51, 52), 53.5, 53.5, 54.5cm

Materials
- ístex *Léttlopi*, 100% pure Icelandic wool (light spun, medium weight), 1.75 oz/50g, 109 yds/100m per skein: #9420 navy (MC), 10 (10, 10, 11), 11,12, 12 skeins; #0053 acorn (CC), 2 (2, 2, 2), 2, 3, 3 skeins
- Sizes US 6 and 7 (4 and 4.5mm) circ needle
- Magic loop is used for smaller diameters or double-pointed needles
- Stitch markers
- Darning needle

Gauge
18 sts and 24 rows = 4"/10cm in St st using size US 7 (4.5mm) needle
Adjust needle size as necessary to obtain correct gauge.

This sweater, made by Ragna Ágústsdóttir (pictured in photo) is among the first lopapeysa *made in Iceland.*

UNSPUN LOPI

Lopi or *lyppa* means "roving band" in Icelandic. Knitting with unspun lopi is a relatively new phenomenon dating back to the early 1900s, when a few women experimented with knitting on a machine directly from the roving band without spinning it into yarn first. In a 1923 issue of the popular *Hlín* journal, edited by Halldóra Bjarnadóttir, Elín Guðmundsdóttir Snaehólm wrote about how she knitted a scarf with unspun roving on her knitting machine. Knitting with unspun roving later became popular with handknitters as well. The unspun lopi is the most popular yarn in Iceland today. *Plötulopi* comes in plates or cakes of one single strand of lopi, *Léttlopi* is made of two strands slightly twisted together, *Álafoss* lopi of four strands. Mixing *tog* (the outer coarser hair) and *þel* (the soft inner air) together creates a wool that is extremely light, warm, and water-repellent. The yarn is also highly insulating due to the vast amount of air trapped between the fibers and works well both in very cold climates and warmer ones. Water repellent also means that the wool repels dirt, so finished knitted items rarely require cleaning aside from the first wash to soften the fibers.

INSTRUCTIONS

Sleeves
With CC and size US 6 (4mm) circ needle, CO 42 (44, 46, 48), 50, 52, 54 sts. Join, taking care not to twist sts, pm EOR (end of rnd), change to MC and work rib in *k1, p1* for 2"/5cm.

Change to size US 7 (4.5mm) circ needle.

Work around in St st, inc 1 st after first st and 1 st before last st every 9 (9, 9, 9), 8, 8, 8 rnds 12 (12, 12, 12), 13, 13, 13 times:

K1, M1, knit to 1 st before EOR, M1, knit rem st.

Cont even in St st on 66 (68, 70, 72), 76, 78, 80 sts until sleeve measures 19 (19 ½, 20, 20 ½), 21, 21, 21 ½"/48.5 (49.5, 51, 52), 53.5, 53.5, 54.5cm or when reaching desired length.

Knit to 5 (5, 6, 6), 6, 7, 7 sts before EOR and place next 10 (10, 10, 12), 12, 14, 14 underarm sts on a st holder—56 (58, 60, 60), 64, 64, 66 sts. Break off yarn, leaving enough tail to later graft the underarms. Set sleeve aside and knit the other sleeve the same way.

Body
With MC and size US 6 (4mm) circ needle, CO 158 (174, 188, 210), 220, 242, 256 sts. Join, taking care not to twist sts, pm EOR, and work in rib in *k1, p1* for 2"/5cm.

Change to size US 7 (4.5mm) circ needle.

Work around in St st until body measures 16 (16 ½, 17, 17 ½), 18, 18, 18 ½"/40.5 (42, 43, 44.5), 45.5, 45.5, 47cm.

Yoke
Combine body and sleeves on size US 7 (4.5mm) circ needle (EOR is at the juncture between back and left sleeve):

With MC yarn from the body, join in and k56 (58, 60, 60), 64, 64, 66 sts of left sleeve, set next 10 (10, 10, 12), 12, 14, 14 sts of the body on a st holder (underarm sts), knit next 70 (77, 84, 93), 98, 107, 114 body front sts, knit 56 (58, 60, 60), 64, 64, 66 sts of right sleeve, set next 10 (10, 10, 12), 12, 14, 14 sts of body on a st holder (underarm sts), knit rem 70 (77, 84, 93), 98, 107, 114 body back sts—252 (270, 288, 306), 324, 342, 360 sts.

Knit 1 rnd.

Short Rows
Work back and shoulders longer with short rows to lower the neckline at the front:

K73 (77, 81, 83), 88, 90, 94, turn, yo, purl back on 216 (231, 246, 259), 274, 287, 302 sts [which means purl to 36 (39, 42, 47), 50, 55, 58 sts before gap] turn, yo, *knit to 3 sts (2 sts and the yo) before gap, turn, yo, purl to 3 sts before gap, turn, yo* repeat from * to * 3 times; cont to knit in the rnd to EOR.

Next Rnd: Close gaps (see also Technique on page 132):

Knit the first 4 yo's with the next st as k2tog and the 4 last yo's with the st before as ssk.

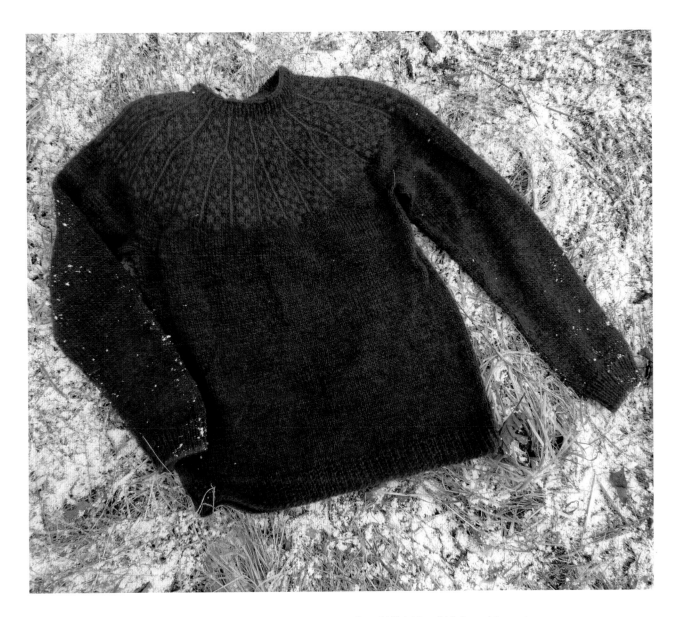

Yoke Pattern

Follow chart until Rnd 42 has been completed—70 (75, 80, 85), 90, 95,100 sts rem.

Cont with MC and dec 0 (1, 4, 7), 10, 13, 16 sts on rnd as follows:

Size M: Dec 1 st anywhere in the rnd.

Size L: *K18, k2tog* 4 times.

Size 1X: *K10, k2tog* 7 times, knit rem st.

Size 2X: *K7, k2tog* 9 times.

Size 3X: *K5, k2tog* 13 times, k4 rem sts.

Size 4X: *k4, k2tog* 16 times, k4 rem sts.

70 (74, 76, 78), 80, 82, 84 sts rem.

Work 4 rnds in *k1, p1* rib. BO loosely in rib pattern:

Work 1 st, *work 1 st, insert left needle in the 2 sts on right needle and work them together* across.

Finishing

Graft underarm sts and darn in all ends.

Hand wash the sweater delicately in lukewarm water with gentle wool soap. Leave flat to dry.

FJALLAGRASASÚPA OR FJALLAGRASAMJÓLK

The main ingredient for this soup or milk is *fjallagras*, Icelandic moss, which is not, as the name would suggest, a moss but a lichen. It is excellent for coughs and digestive problems. Most of the lichen's bitterness is removed by cooking it in milk. This soup takes on a very nice, mild green color.

4 ¼ c. (1 l) milk
½ c. fjallagras, carefully washed
1 tsp. brown sugar
Pinch of salt

Bring milk to the boil. Add fjallagras, brown sugar, and a pinch of salt. Let simmer for about 10 minutes. Makes four 1-cup servings.

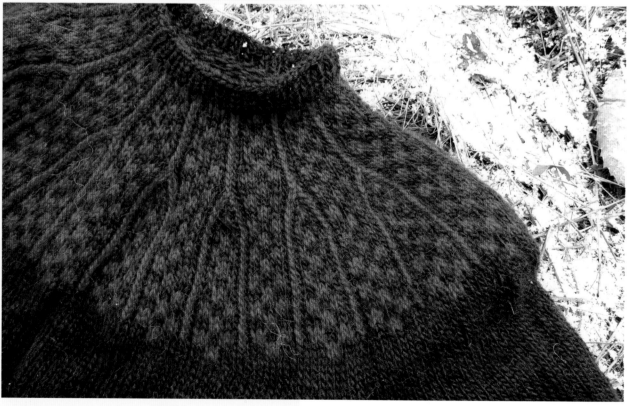

MISSING LOPI SCHEMATIC

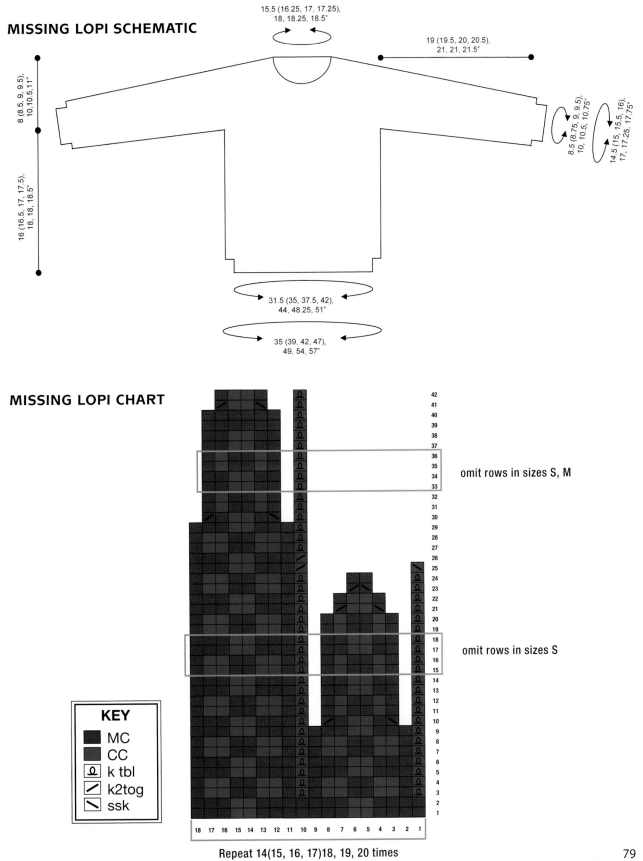

15.5 (16.25, 17, 17.25), 18, 18.25, 18.5"

19 (19.5, 20, 20.5), 21, 21, 21.5"

8 (8.5, 9, 9.5), 10,10.5,11"

8.5 (8.75, 9, 9.5), 10, 10.5, 10.75"

14.5 (15, 15.5, 16), 17, 17.25, 17.75"

16 (16.5, 17, 17.5), 18, 18, 18.5"

31.5 (35, 37.5, 42), 44, 48.25, 51"

35 (39, 42, 47), 49, 54, 57"

MISSING LOPI CHART

42
41
40
39
38
37
36
35 omit rows in sizes S, M
34
33
32
31
30
29
28
27
26
25
24
23
22
21
20
19
18
17 omit rows in sizes S
16
15
14
13
12
11
10
9
8
7
6
5
4
3
2
1

KEY

- ■ MC
- ■ CC
- ⌀ k tbl
- ╱ k2tog
- ╲ ssk

18 17 16 15 14 13 12 11 10 9 8 7 6 5 4 3 2 1

Repeat 14(15, 16, 17)18, 19, 20 times

79

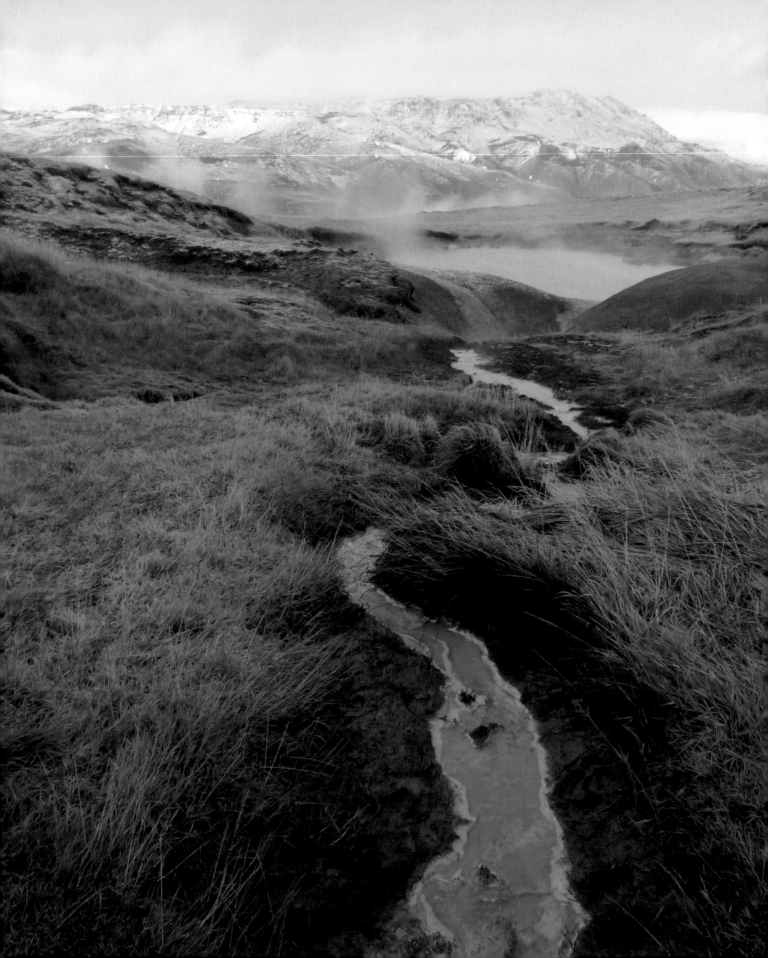

CHAPTER

3

INSPIRED BY FOOTWEAR

As you can imagine, socks have long been a very practical item in Iceland, where they are worn year-round. To fend off the cold, socks were often worn two together; the outer ones, much thicker and heavily felted, were actually worn over the shoes. Those were soft shoes made of sheepskin or fish skin, and they were used with knitted shoe inserts. As much as socks were very plain—single-colored with barely any decoration at all—shoe inserts were extremely colorful. The Textile Museum has a great collection of beautiful striped inserts for everyday use, but also many inserts that are decorated with all sorts of colorful patterns knitted in Icelandic intarsia. It was these artifacts that inspired many of the designs in this chapter.

Opposite: *When a river crosses a geothermal area, blue mud pots form. You may also bathe in the hot, clear river like we do during my Knitting in the Magical Night tour. This photo was taken during the tour.*

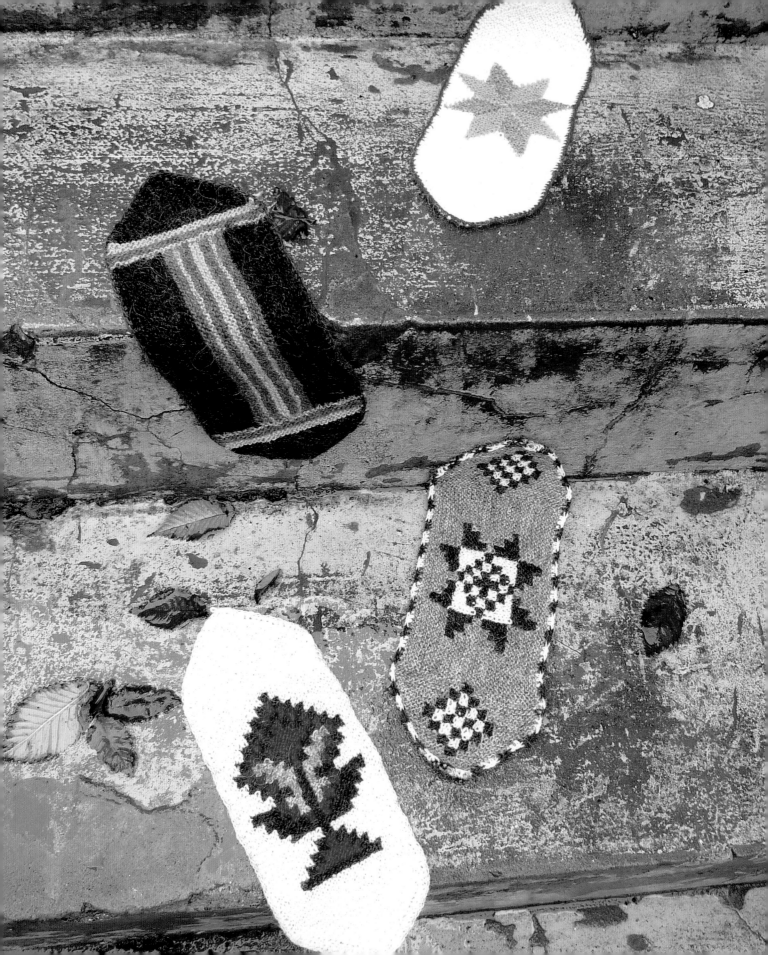

ICELANDIC SHOE INSERTS

Many inserts were knitted in Icelandic intarsia, intarsia made using garter stitch. The tradition is unique to Iceland and was used to knit mostly shoe inserts. In fact, the technique is called *rósaleppaprjón*, literally meaning "rose-pattern insert knitting." It was most common to knit inserts in three pieces using garter stitch to ensure the inserts would retain their shape. An insert knitted in one piece tends to stretch and become too long. The middle section is knitted first, and then stitches are picked up at the edge and the tips knitted. There were no knitting patterns for inserts, nor specific instructions, because the inserts had to be tailored to fit the person for whom they were made and adjusted to accommodate the type of yarn used, among other things. Please feel free to adapt this basic shoe insert pattern to any yarn, needle size, or foot.

Size
Women's foot size US 7–9 (EU 36–40)

Finished Measurements
Width: 4 ¼"/11cm
Length: 9 ½"/24cm
Note: You can achieve more sizes by changing yarn/needle size or adding/removing rows/stitches.

Materials
- Ístex *Einband-Loðband*, 70% Icelandic wool, 30% wool (fine lace-weight, 1-ply worsted), 1.75 oz/50gr, 246 yds/225m per skein: color of choice (MC), 1 skein; contrasting colors (CC), remnants in the colors of your choice
- Size US 0/2mm double-pointed needles
- Sizes US C-2/2.75mm crochet hooks
- Darning needle

Gauge
32 sts and 64 rows = 4"/10cm in garter st using size US 0 (2mm) needle
Adjust needle size as necessary to obtain correct gauge.

Note: In the intarsia motif, each square represents 1 st and 2 rows (= 1 garter ridge).

Pattern Notes
Inserts are often knitted in garter stitch in one piece from heel to toe or in three stages: First the rectangle middle piece is knitted, then stitches are picked up at the selvedge on both sides and the tips worked. An Icelandic intarsia motif is positioned in the center of the foot. Tips are often decorated with stripes or a smaller intarsia motif, especially in the inserts knitted in three stages.

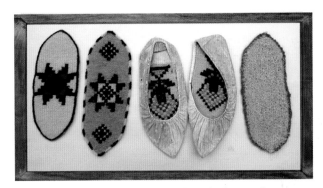

Here are a few shoe insert samples from the large collection at the Textile Museum. All were used inside the shoes except for the one on the right. It was knitted with horse hair and was used between the shoe and an outer leather sock—the boot of those times. You would therefore wear two pair of inserts at once.

NEW PATTERNS FROM AN OLD TRADITION

Soft shoes were common all over the world. Beyond Iceland, soft shoes were worn by the native people of North America and by peasants in Russia and the Baltic countries, to name a few examples. These shoes all needed some kind of insert. Straw was commonly used in Lapland, the Aran Isles, or in Ukraine. Often, wool or wool mixed with straw was used.

Knitted inserts in soft shoes, however, appear to be unique to Iceland. It is remarkable how beautiful many of these inserts were and how much care and time was taken in making them, considering what a short lifespan most of them could be expected to have. The striped inserts were used everyday, and the patterned ones were saved for Sunday-best. What makes them truly unique is not the motifs themselves but the use of Icelandic intarsia—intarsia made using garter stitch.

I conducted extensive research on Icelandic shoe inserts and Icelandic intarsia. My goal was to preserve the Icelandic intarsia tradition that was quickly disappearing. The result was my book *Icelandic Knitting: Using Rose Patterns*. Along with a complete history of the knitted inserts, the book contains 26 contemporary knitting projects, all based on traditional insole motifs. The patterns, which are inspired by the designs and color schemes evident in the old inserts, give a new, innovative twist to an old knitting tradition. The book won an award at the Women Literary Festival of Iceland in 2007 and a grant from the Icelandic Literature Fund in 2008. It is available in Icelandic (published by Salka, 2006), English (published by Search Press, 2008), and French (published by Tricoteuse d'Islande, 2009).

INSTRUCTIONS

Inserts knitted in one piece from heel to toe. (Make two the same.)
With MC, CO 4 sts.

Knit 2 rows in garter st.

Following chart of choice, inc 1 st on both sides 14 times: kfb at the beginning of each row until there are 32 sts.

Knit 116 rows (= 58 garter ridges).

Dec 1 st on both sides 14 times: k2tog at the beginning of each row until 4 sts rem. BO.

Inserts knitted in three stages. (Make two the same.)
With MC, CO 46 sts.

Stage #1:

Following chart of choice, knit 64 rows (= 32 garter ridges) and BO.

Stages #2 and #3:

Pick up 32 sts from the selvedge (between each garter st ridge) and work 12 rows (6 garter ridges).

Cont to follow chosen chart, dec 1 st on both sides 14 times: K2tog at the beginning of each row until 4 sts rem. BO.

Work the 2nd tip the same way, picking up sts on the other selvedge.

Finishing
With a CC, crochet an edge of sc around the insert. Hand wash with wool soap and slightly felt by rubbing. Leave flat to dry.

ROSE-PATTERNED PIPARKÖKUR

The tradition of *piparkökur*—Icelandic ginger bread—came to Iceland from Denmark at the end of the nineteenth century. It is very popular at Christmas, especially among the children.

The design of the Icelandic rose-patterned cookie cutters brings together my interest in both Icelandic textiles and traditional food. The cutters are made of fine copper, and the biggest cutter is in the shape of an eight-petal rose. The smallest cutter is used to make petals or a central diamond. With these cutters, I'm able to prepare all sorts of colorful food in the same style as the roses used on the knitted shoe inserts. Cookies with icing sugar are most traditional, but with the cutters, I also make colorful toasts from Icelandic flatbread, salmon, or smoked lamb.

2 ¼ c. (500 g) flour	1 c. (200 g) butter, softened
1 c. (200 g) sugar	1 c. (200 g) honey or maple syrup
½ tsp. ground cloves	2 eggs
½ tsp. baking soda	About ¼ c. (57 g) water

Preheat oven to 350°F (180°C). In a large mixing bowl, blend together flour, sugar, cloves, and baking soda. Add softened butter and work with a fork or your fingertips until the mixture is the consistency of sand. Add syrup, eggs, and enough water to make a smooth dough. Knead well for 1 minute and flatten to about ⅛" (0.5cm) thick. Cut out roses with the biggest cutter. Press the smallest cutter gently on the dough to make the inside pattern outlines. Cook in the oven on a baking sheet for about 10–15 minutes, or until golden brown. After baking, paint the cookies along the outlines with royal icing.

ROYAL ICING

2 egg whites
2 tsp. fresh lemon juice
1 ¼ c. (300 g) confectioner's sugar
1 or 2 drops food coloring

In a small bowl, beat egg whites with lemon juice until foamy. Add confectioner's sugar and beat until smooth. Add food coloring. Cover any leftover icing with plastic wrap and refrigerate for later use.

ICELANDIC SHOE INSERT CHARTS

CHART A: STRIPES

CHART B: DIAMOND ROSE

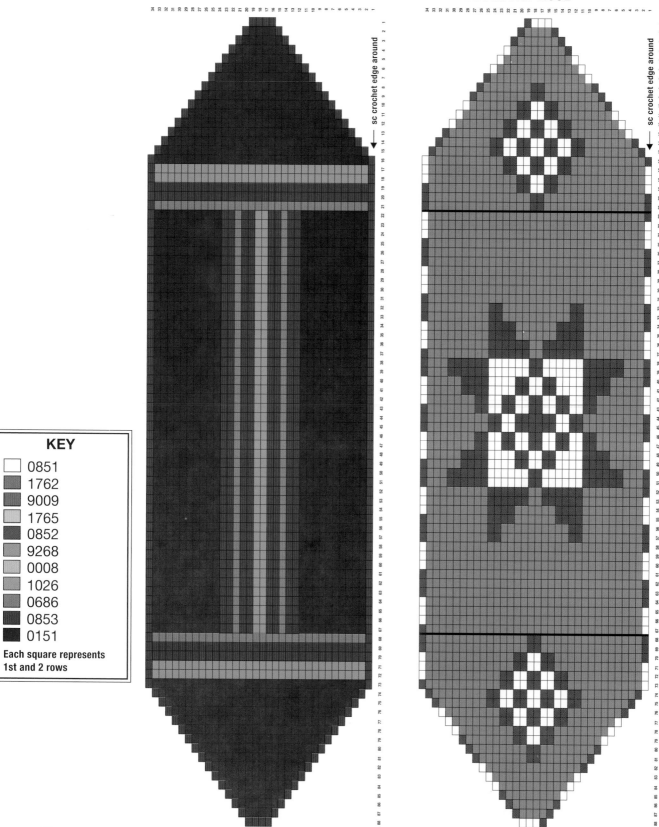

KEY

☐	0851
	1762
	9009
	1765
	0852
	9268
	0008
	1026
	0686
	0853
	0151

**Each square represents
1st and 2 rows**

sc crochet edge around

CHART C: FLOWER POT

CHART D: WINDROSE

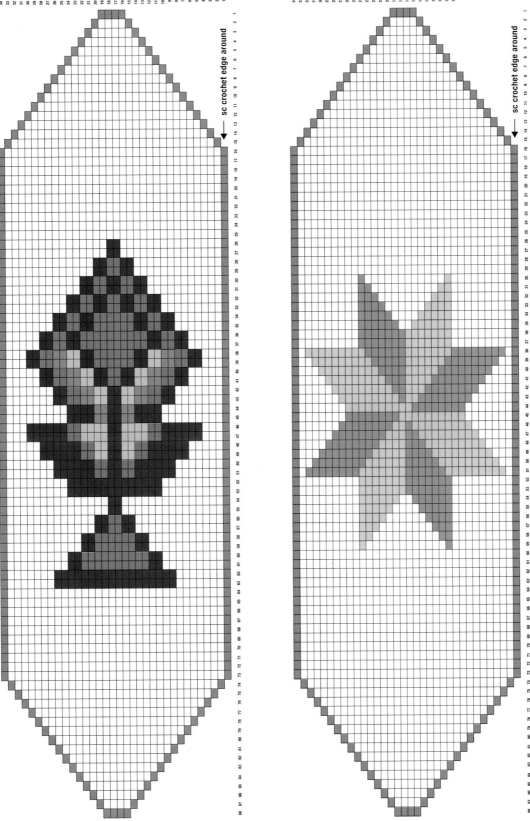

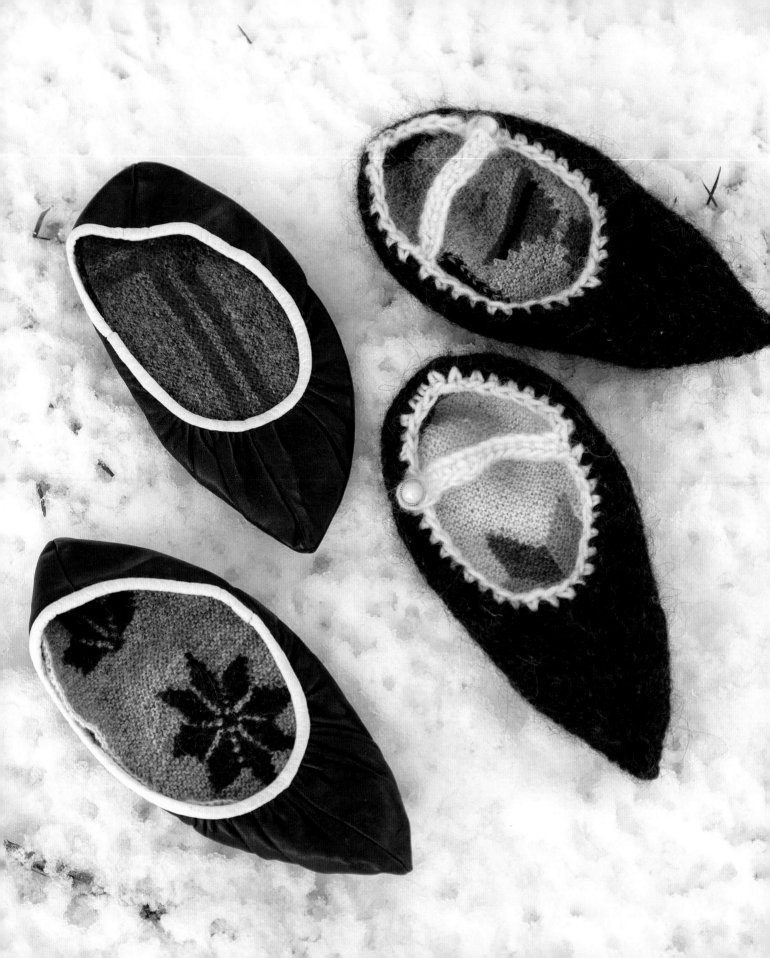

ICELANDIC SOFT SHOES

I couldn't help but design a knitted soft shoe to go with the shoe inserts. As a matter of fact, there are a few knitted slippers in the Textile Museum, but I wanted mine to replicate the traditional skin shoes. I more or less kept the proportions of the cut leather, but made use of clever shaping to avoid the sewing that is normally involved in such shoes. Instead of the string that was often braided around the foot to prevent the shoes from falling off, I added a crocheted strap with a little button. And mind you, with a knitted insert inside, those shoes are the most comfortable and warm slippers I have ever worn!

Sizes
One size fits all, adjustable in length where indicated in instructions

Finished Measurements
Length: 10"/25.5cm
Height: 3"/7.5cm

Materials
- ístex *Álafosslopi*, 100% pure Icelandic wool (light spun), 3.5 oz/100g, 109 yds/100m per skein: #0005 black heather, 1 skein (MC)
- #0051 white (CC), less than .20 oz/5g
- Size US 8 (5mm) circ needle (or double-pointed needles)
- Size US G-6 (4mm) crochet hook
- Stitch marker
- Darning needle

Gauge
14 sts and 21 rows = 4"/10cm in St st using size US 8 (5mm) needles
Adjust needle size as necessary to obtain gauge.

Shoes made of fish skin were for everyday use and were worn with striped inserts, whereas Sunday-best shoes were made of skin with rose-patterned inserts. The Textile Museum in Blönduós, Reference HIS668

THE ICELANDIC SHEEP

One of the main reasons for the popularity of knitting in Iceland is without any doubt the abundance of raw material available: the wool provided by the numerous Icelandic sheep that graze here. Icelandic sheep are a rustic, Northern European short-tail breed that arrived in the country with the first colonists some 1,100 years ago and have remained almost pure until today. Attempts to introduce new breeds have been mostly unsuccessful, manly due to the diseases brought by the new animals, which have proven impossible to eradicate without culling. Icelandic sheep are allowed to graze freely in the mountains all summer. This lifestyle made it possible for a unique population of "leader-sheep" to develop. These sheep have an outstanding ability to help the shepherds manage the flock. A small population of 1,200 members still exists and this flock is probably most like the sheep that first came to the island more than 1,000 years ago. Although the breed itself has little changed, the sheep have evolved due to farming practices. Farmers have been raising the sheep for meat and the white color is much more dominant today than it once was.

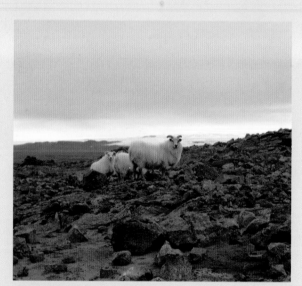

Icelandic sheep far inside the highlands. Unexpected barbed wire fences cross the Black Desert in the middle of the country to prevent sheep from the northern part of the country from going south and vice-versa.

INSTRUCTIONS

With a provisional cast-on, CO 20 sts with MC and size US 8 (5mm) needle, leaving a 12"/30cm tail (later used to graft heel sts).

Work back and forth in St st:

Row 1: Knit all sts.

Row 2 and all even rows: Purl all sts.

Row 3: K9, M1, k2, M1, k9—22 sts.

Row 5: K10, M1, k2, M1, k10—24 sts.

Row 7: K11, M1, k2, M1, k11—26 sts.

Row 9: K12, M1, k2, M1, k12—28 sts.

Row 11: Knit all sts.

Row 13: K2, k2tog, k2, k2tog, k12 , ssk, k2, ssk, k2—24 sts. Mark this row.

Cont even for 4"/10cm from marked row (this is for a foot length of 10"/25.5cm) or desired length (to decrease or increase sizes, add or deduct 1"/ 2.5cm per size).

Join in the rnd. Knit 1 rnd, pm EOR (end of rnd).

Inc in next rnd: K2, *M1, k1* 4 times, knit to 5 sts before EOR, *M1, k1* 4 times, k1—32 sts.

Work 1 rnd.

Dec in every rnd: *Knit to 6 sts before EOR, ssk, k2, k2tog* until 4 sts rem on needle.

Break off yarn and draw it through the sts.

Remove provisional cast-on, set live sts on needle, fold in two, and graft heel.

Finishing

With CC, crochet an edging of sc around: 1 sl st at the back of the shoe, 2 ch (count as a sc), 1 sc in every other st. Add a strap 3 1/2"/9 cm from back (on left side for right shoe and on right side for left shoe): Ch 20, sl 5 extra ch to make a loop, then crochet back to edge (1 sc in each ch), cont working sc edging to EOR, join rnd with a sl st in top chain.

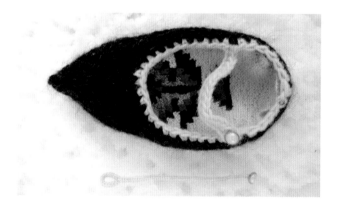

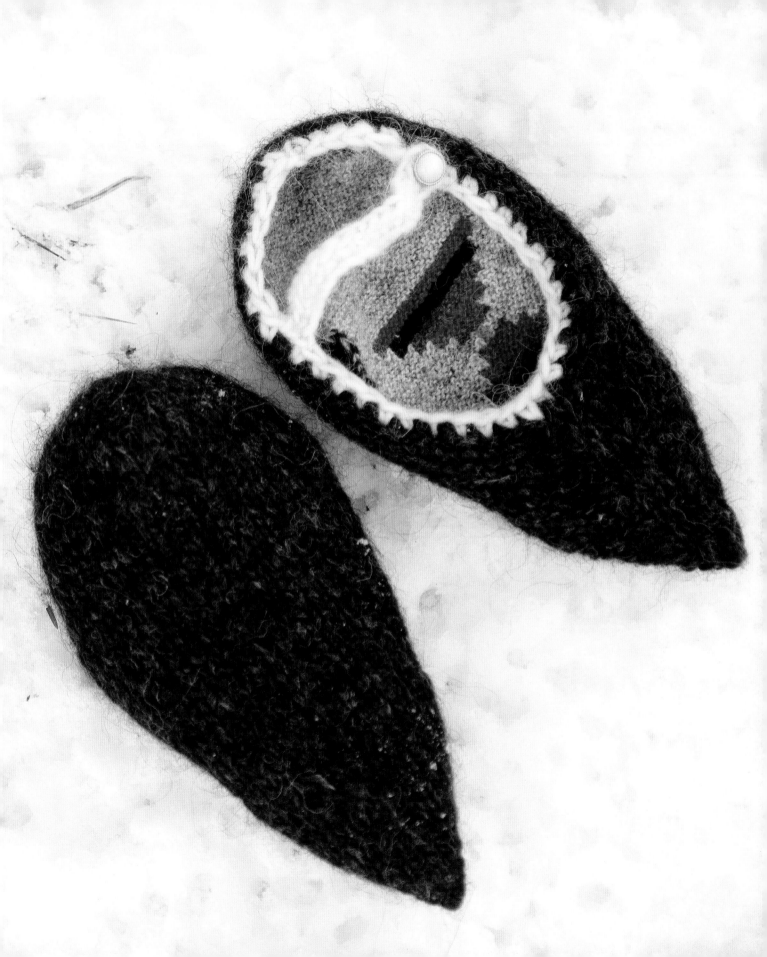

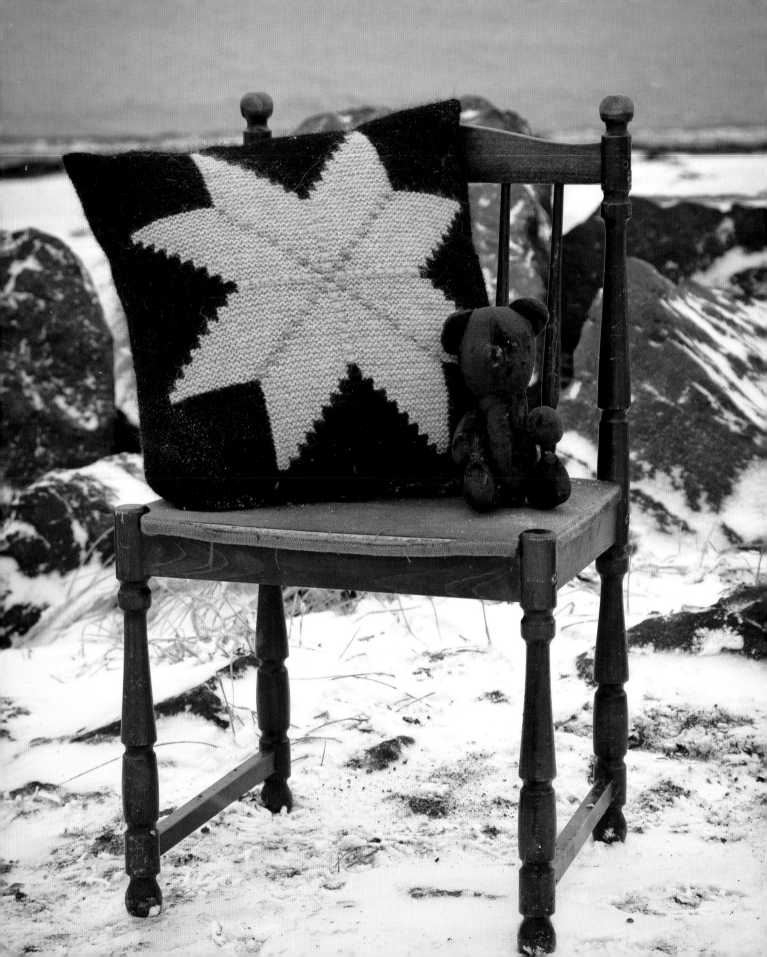

STEP ROSE CUSHION

Although most inserts were knitted in Icelandic intarsia, examples of other artifacts using the technique do exist. I reinterpreted the flat seat cushion into a big cuddly cushion. The center rose is knitted in Icelandic intarsia, but the two colorful crosses in each rose are later embroidered in the same manner, as some inserts from the Textile Museum were. It makes the intarsia work extremely easy, with only three blocks of color across the row.

Finished Measurements
16 (24)"/40.5 (61)cm square

Materials
- ístex *Léttlopi*, 100% pure Icelandic wool (light spun, medium weight), 1.75 oz/50g, 109 yds/100m per skein: #0059 black (MC), 2 skeins; #1411, yellow (CC1), 1 skein and 10g; #1418 chair (CC2), 1 skein; #1402 blue (CC3), 10g; #9434 red (CC4), 10g
- Size US 4 (3.5mm) needles
- Cushion to fit dimensions
- Darning needle

Gauge
20 sts and 40 rows = 4"/10cm in St st with 4 rows in garter st using size US 4 (3.5mm) needle
Adjust needle size as necessary to obtain correct gauge.

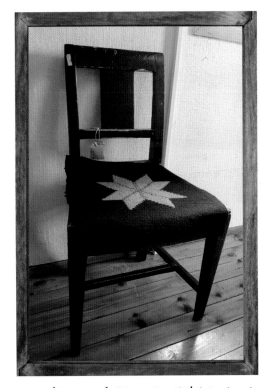

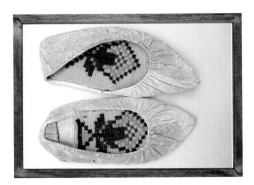

The motif on these inserts is not worked in Icelandic intarsia but embroidered with start cross-stitches. The Textile Museum in Blönduós

These seat cushions were knit in garter stitch intarsia using plant-dyed yarn on a black background. The motif is based on an eight-petal rose from the National Museum of Iceland. The rose was knit by the Unnur, the weaver's foster. She worked the wool very well and was the sister of Bogi Þórðarson from Lágafell, who was known for his artistic skills. Halldóra's room, The Textile Museum in Blönduós, Reference HB174

INSTRUCTIONS

With MC, CO 82 sts.

Note: Each square in the chart pattern represents 2 sts and 4 rows in garter stitch.

Following chart, work pattern in Icelandic intarsia (intarsia in garter stitch) with colorway A (front cover).

Keeping the continuity, work pattern again, but with colorway B (back cover). BO.

Finishing

Secure ends inside the cushion (you don't necessarily have to darn them in).

Embroider the two crosses on each rose with a star st.

Fold cushion cover in two, sew sides with a flat seam leaving a hole big enough at the bottom. Insert cushion and sew down the hole.

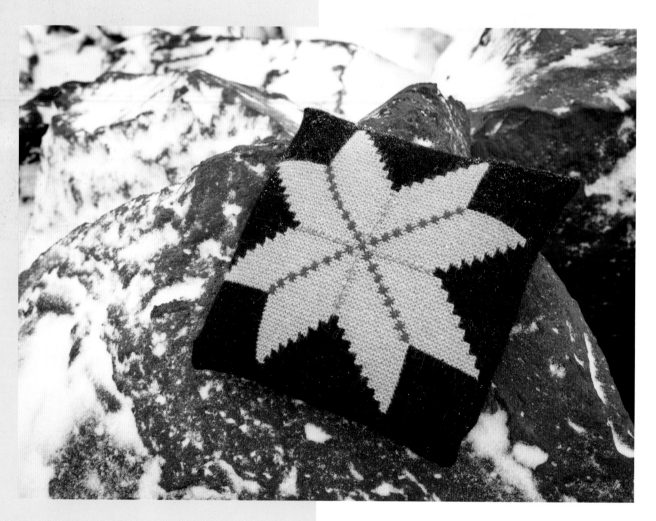

STEP ROSE CUSHION

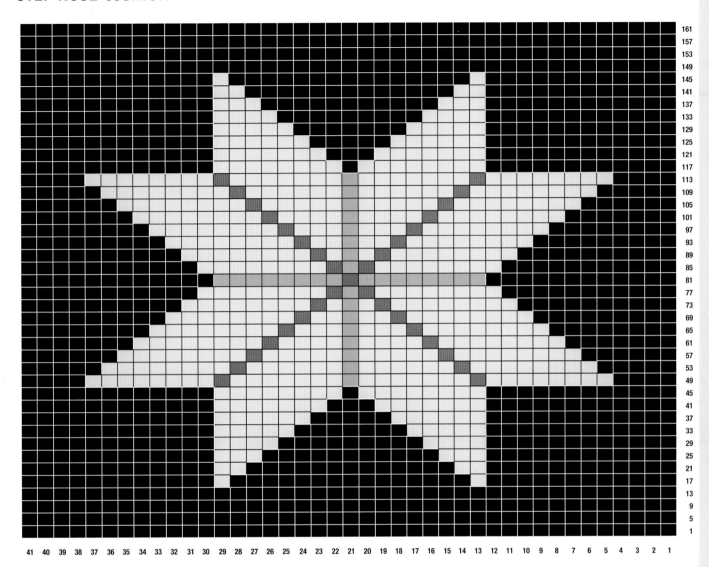

161
157
153
149
145
141
137
133
129
125
121
117
113
109
105
101
97
93
89
85
81
77
73
69
65
61
57
53
49
45
41
37
33
29
25
21
17
13
9
5
1

41 40 39 38 37 36 35 34 33 32 31 30 29 28 27 26 25 24 23 22 21 20 19 18 17 16 15 14 13 12 11 10 9 8 7 6 5 4 3 2 1

KEY

Colorway A
- ■ K MC
- ☐ K CC1
- ▨ K CC1, embroider with CC3
- ▧ K CC1, embroider with CC4

Colorway B
- ■ K MC
- ☐ K CC2
- ▨ K CC2, embroider with CC1
- ▧ K CC2, embroider with CC2

Each square is 2 sts and 4 rows.

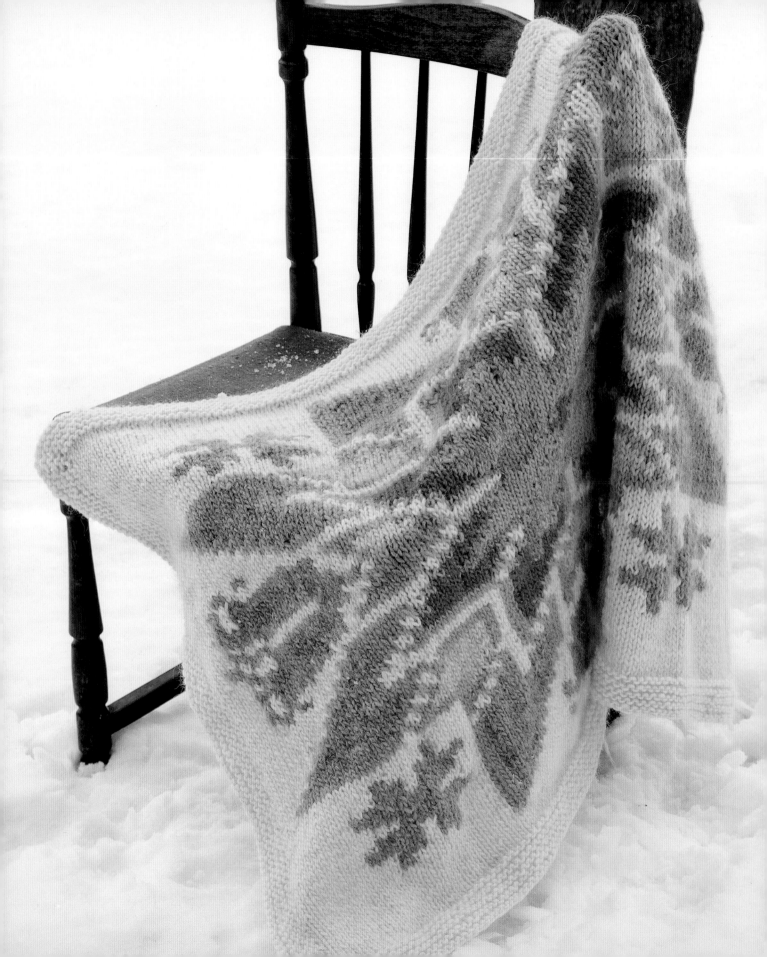

BROKEN ROSE BLANKET

I reinterpreted the broken rose frame in the Textile Museum as a blanket, but used intarsia in stockinette stitch instead of the Icelandic intarsia in garter stitch. The simple border in garter stitch is reminiscent of the original technique. The color combination is similar to the original colorway, but with a light background, giving it a very soft look that's more suitable for a baby.

Finished Measurements
31 by 41"/78.5 by 104cm

Materials
- ístex *Álafosslopi*, 100% pure Icelandic wool (light spun), 3.5 oz/100g, 109 yds/100m per skein: #0051 white (MC), 7 skeins; #9972 ecru heather (CC1), 1 skein; #9973 wheat heather (CC2), 2 skeins; #9984 fairy green (CC3), 3 skeins; #9983 apple green (CC4), 1 skein; #0008 light denim heather (CC5), 2 skeins
- Size US 10.5 (6.5mm) needles (for intarsia band) and circ needle (for border)

Note: Working intarsia with a circ needle is not recommended.

- Cushion to dimensions
- Stitch markers
- Darning needle

Gauge
14 sts and 17 rows = 4"/10cm in St st
Gauge not essential.

This piece of knitting is stretched on a wooden frame with pins and is about 22" by 22" (56 x 56 cm). Sigríður Þórðardóttir hand spun and dyed the yarn, then knitted the band. She was the foster parent of Vigdís Kristjansdóttir, who gave it to Halldóra Bjarnadóttir in 1925. It is knitted very loose in Icelandic intarsia (garter stitch) and has been a great source of inspiration for me in my book about shoe inserts. It inspired me to knit sweaters in loose garter stitch to produce a very fluid fabric, suitable for geometric shapes yet still flattering on the body. The motif represents a þríbrotin áttabladarós, literally a three broken eight-petal rose that, according to Elsa E. Guðjónsson, seems to be a motif unique to Iceland. It is, however, a common motif in Icelandic handwork, and you can find it charted in the Skaftatfell pattern manuscript book from the eighteenth century. The Textile Museum in Blönduós, Reference HB33

LUMMUR

Like Icelandic knitting designs such as the shoe inserts or the leaf mittens that make use of all the yarn scraps, *lummur*, traditional Icelandic pancakes, are made with whatever is left of the morning's oatmeal porridge. Rice pudding can also be used. An Icelandic truck driver gave me a recipe while I was guiding a hiking tour: "You just blend a little bit of everything together," he said. This is my recipe.

3 c. (680 g) cooked oatmeal porridge (or 1 c. oatmeal soaked in 1 c. milk/water overnight)
2 tbsp. flour
1 egg
½ tsp. salt
Sugar (optional and to taste)
½ c. (113 g) raisins (optional)
½ to 1 c. (113 to 227 g) milk

In a large mixing bowl, combine oatmeal, flour, egg, salt, sugar, and raisins. Add milk until the batter is thick, but still pourable. Heat a frying pan or griddle with a little bit of butter over medium heat. Using a tablespoon, pour batter in pan to form small, round pancakes. Brown one side for about 1 minute, or until bubbles form at the surface, and turn to cook the other side. This recipe makes about 20–25 pancakes.

INSTRUCTIONS

With a provisional cast-on, using MC and size US 10.5 (6.5mm) needle, CO 122 sts.

Following Chart, work motif in intarsia.

When motif is complete, knit a garter st border around:

Cont with MC and circ needle: Knit across, pm, pick up 1 st at the corner, pm, pick up 80 sts along the edge (about 2 sts out of 3), pm, pick up 1 st at the corner, pm, remove provisional cast-on and k122 live sts, pm, pick up 1 st at the corner, pm, pick up 80 sts along the other edge, pm, pick up 1 st at the corner, pm EOR (end of rnd)—408 sts.

Work in garter st and inc (with yo) 1 st on both sides of corner sts in every other rnd:

Rnd 1: Purl all sts.

Rnd 2: *Knit to marker, yo on right side of it, k1 (corner st), yo on left side of next marker* 4 times, knit rem sts to EOR.

Repeat these 2 rnds 3 times—432 sts.

BO as follows: P1, *place st back on left needle, p2tog* across.

Break off yarn and pull it through.

Finishing
Darn in all ends. Hand wash in lukewarm water with wool soap. Squeeze excess water and lay flat to dry.

BROKEN ROSE BLANKET

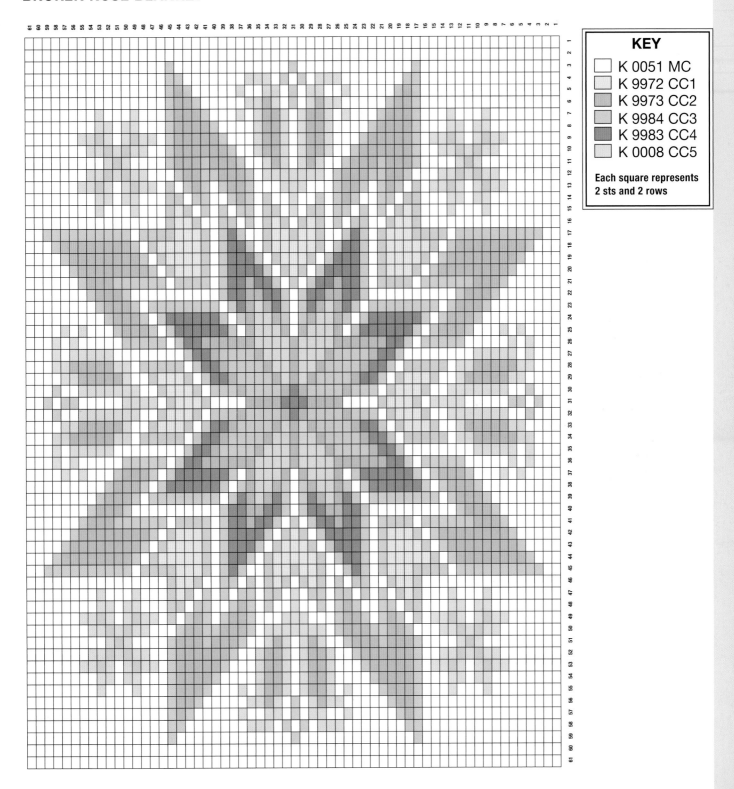

KEY

☐	K 0051 MC
	K 9972 CC1
	K 9973 CC2
	K 9984 CC3
	K 9983 CC4
	K 0008 CC5

Each square represents 2 sts and 2 rows

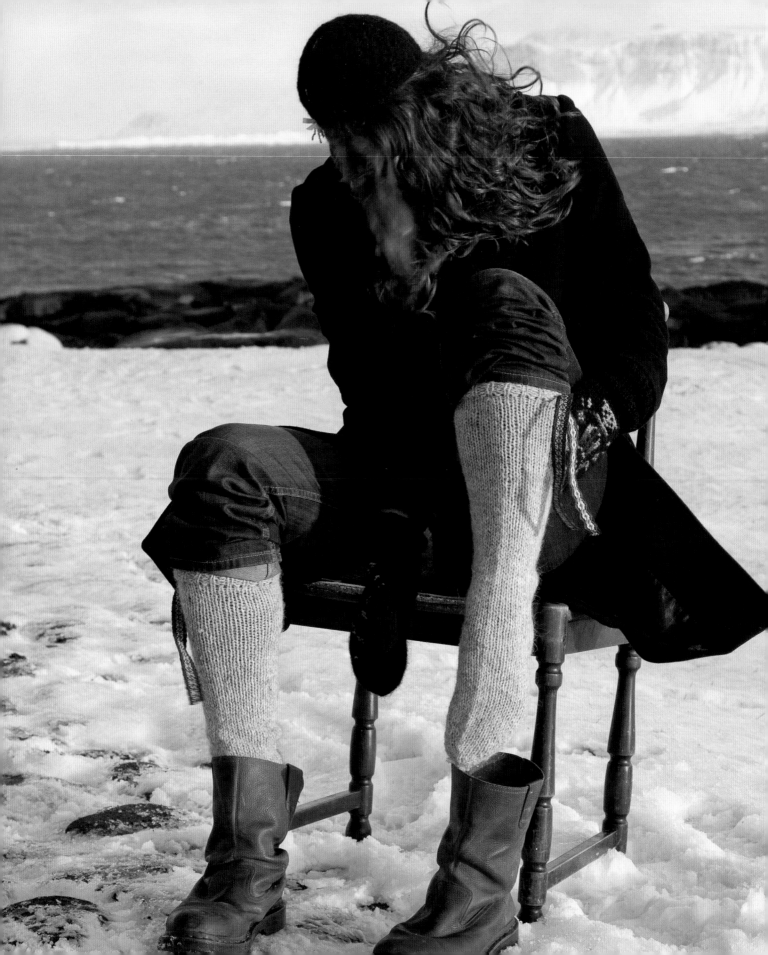

TOGARA SOCKS

The original socks that inspired this pattern were intended for mass production, so my pattern includes many sizes to fit everyone in the family. I used Hosuband, which is an Icelandic wool blended with nylon—an extremely hard-wearing blend that is suitable for socks. Hand-knitted knee socks tend to fall down to the ankles, which is why bands used to be braided in the tops of socks to hold them up. These days, elastic has taken the place of the braids. Rather than using elastic in my socks, the cuff is tubular with a little buttonhole through which you can draw a woven band or a nice ribbon. You can change the ribbon as often as you like for dramatically different effects. I like how the rather rough socks take on a feminine feel when laced with a delicate, transparent ribbon with golden threads.

Sizes
XS (S, M, L), XL for Child (Teen, Women, Women/Men) Men

Finished Measurements
Circumference: 6 (7, 8, 9), 9 3/4"/15 (18, 20.5, 23), 25cm
Length: 6 (8, 10, 11), 11 1/2"/15 (20.5, 25.5, 28), 29cm

Materials
- Ístex *Hosuband*, 80% new wool, 20% polyamide (worsted weight), 3.5 oz/100g, 142 yds/130m per skein; #0005 light gray, 2 skeins
- Sizes US 6 and 7 (4 and 4.5mm) circ needles
- Magic loop is used for smaller diameters or double-pointed needles
- Stitch markers
- Darning needle
- Thread and needle
- Fancy ribbon about 72"/183cm long and 1"/2.5cm wide

Gauge
18 sts and 22 rows = 4"/10cm in St st using size US 7 (4.5mm) needle
Adjust needle size as necessary to obtain gauge.

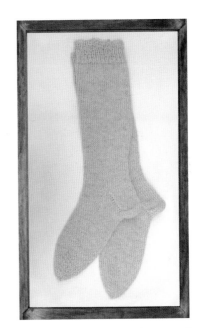

Halldóra Bjarnadóttir writes: "Made after Scottish socks that Captain Halldór Þorsteinsson came with from England. A lot of socks like those were produced in the difficult years 1930–40 were sold with a lot of sweaters and stockings in the fishing stores in Reykjavík. The material is tog or wool "upp med öllu saman (Note: with everything in, meaning unsorted wool, spring and autumn wool mixed together), four strands together, not twisted. Good socks that work their job well."
The Textile Museum in Blönduós, Reference HB238

SOCKS IN ICELAND

Traditionally, socks were knitted just after the slaughtering season in preparation for the coming winter. The wool for the socks was often spun during the day, and the socks were knitted from the just-spun wool in the evening. The process was very much like a speed-knitting competition. The socks made in this way were for everyday use or for export, and many hundreds of thousands of pairs were shipped from Iceland to other parts of the world each year. No time could be lost—men were expected to knit four to five pairs of socks per week, so they knitted while walking around the farm and to the fields. These socks were often gray and rather thick, whereas Sunday-best socks were knitted with finer wool in blue, red, brown, or darker colors. Knitted on very fine needles—barely 1 mm in the nineteenth century—the Sunday socks required more time and attention.

Socks were knitted to shape in stocking stitch. Not much is known about the heel and the toe, but the heel flap was very common for finer socks, as was the wedge toe or the star toe. Afterthought heels were common for the rougher socks. The rougher socks were most likely knitted from the top down. The cuff was often ribbed, and the calf shaped with increases and decreases. The sole was often knitted slightly longer than the instep with the help of a few short rows. Like most of the knits, socks were felted.

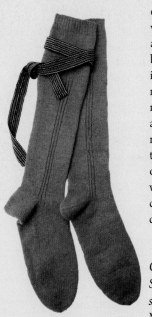

As far as I know, the socks were not decorated at all, with the occasional exception of a few colored stripes or vertical lines of purl stitches. Instead, all the embellishment went into the bands that were used to hold the socks in place. The sock bands were woven, mostly with tablet weaving, in many colors, with all sorts of motifs, and often included the initials or the name of their owner. They ended with a tassel and were braided around the leg or above or under the knee. Sock bands were also very useful. For example, one could be used to bind a horse when you didn't have a proper cord on hand.

Guðbjörg Baldvinsdóttir, from Sunnuhlíð í Vatnsdal, knitted these socks out of þel yarn. The Textile Museum Blönduós, Reference HIS776

INSTRUCTIONS

Cuff

With a provisional cast-on, using size US 6 (4mm) circ needle, CO 30 (34, 38, 42), 46 sts. Join, taking care not to twist sts, pm EOR (end of rnd).

Work in St st for 6 rnds.

Work in *k1, p1* rib for 6 rnds, making a buttonhole in the 3rd rnd:

Left sock: K7 (8, 9, 10), 11, BO 3 sts in rib pattern (CO 3 sts over BO sts in next rnd).

Right sock: K20 (23, 26, 29), 32, BO 3 sts in rib pattern (CO 3 sts over BO sts in next rnd).

Remove provisional cast-on, place sts on spare needle, fold cuff in two (rib facing, reverse St st inside the sock), and work the sts from each needle together—30 (34, 38, 42), 46 sts.

Alternatively, omit provisional cast-on, CO normally, fold cuff in two and sew down on the inside.

Leg

Change to size US 7 (4.5 mm) needle. Work in St st for about 4 (6, 7 1/2, 8 1/4), 9"/10 (15, 19, 21), 23cm or 4"/10cm short of ankle bone, inc 4 sts evenly spaced in first rnd:

K7 (8, 9, 10), 11, M1 4 times, knit rem sts—34 (38, 42, 46), 50 sts.

Dec at ankle:

Rnd 1: K1, k2tog, knit to 3 sts before EOR, ssk, knit rem st.

Rnds 2-6: Knit all sts.

Repeat these 6 rnds 3 times in all—28 (32, 36, 40), 44 sts. Work 4 more rnds.

Heel Flap

Next rnd: K7 (8, 9, 10), 11, turn and work 14 (16, 18, 20), 22 sts back and forth in St st for 10 (12, 14, 16), 18 rows. Always slip first st in row; end with a knit row (RS).

Heel Turn

Row 1 (WS): P9 (10, 11, 12), 13, p2tog, turn.

Row 2: Sl 1 pwise, k4, ssk, turn.

Row 3: Sl 1 pwise wyif, p4, p2tog, turn.

Rep Rows 2 and 3 until 6 sts rem, ending on a RS row. Cont working in the rnd.

Gusset

Rnd 1: Pick up and k5 (6, 7, 8), 9 sts along the edge of the heel flap, M1 at the gap (make a double lifted dec, see Technique on page 133), pm, knit across instep, pm, M1 at the gap, pick up and k5 (6, 7, 8), 9 sts along the other edge of the heel flap, knit to EOR (center back)—32 (36, 40, 44), 48 sts.

Rnd 2: K7 (8, 9, 10), 11, ssk, k14 (16, 18, 20), 22, k2tog, knit to EOR—30 (34, 38, 42), 46 sts.

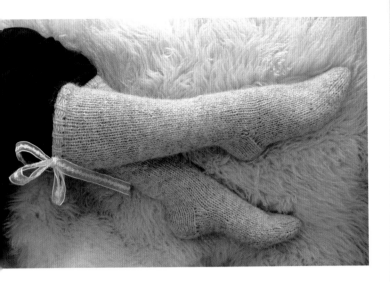

Rnd 3: Knit all sts.

Rnd 4: K6 (7, 8, 9), 10, ssk, k14 (16, 18, 20), 22, k2tog, knit to EOR—28 (32, 36, 40), 44 sts.

Foot

Work 8 (9, 10, 11), 12 rnds even in St st.

Instep-short-row rnd: K21 (24, 27, 30), 33, turn, yo, p14 (16, 18, 20), 22 sts, turn, yo.

Cont knitting in the rnd: Knit to first yo, k2tog (yo and next st), knit to EOR.

Next rnd: Knit to 1 st before yo, ssk (st and yo), knit to EOR.

Work 7 (8, 9, 10), 11 rnds, then rep Instep-short-row rnd and Next rnd.

Work even until foot measures 4 (5 1/2, 7, 7 3/4), 7 3/4"/10 (14, 18, 19.5), 19.5cm or about 2 (2 1/2, 3, 3 1/4), 3 3/4"/5 (6.5, 7.5, 8.5), 9.5cm short of tip of the toe.

Toe

Place side markers: K7 (8, 9, 10), 11, pm, k14 (16, 18, 20), 22, pm, knit to EOR.

Rnd 1: Knit to 3 sts before m, ssk, k2, k2tog, knit to EOR.

Rnd 2: Knit all sts.

Rep Rnds 1 and 2 until 8 sts rem on needle.

Graft back to front sts.

Finishing

Darn in all ends.

Cut ribbon in two. Draw it through the buttonhole at the cuff.

HALLDÓRA'S HEEL

What is referred in Iceland as "Halldora's heel" is, in fact, a so-called German square heel. It was not in Germany but in Scotland where Halldóra Bjarnadóttir learned about this technique. Knitting is the greatest traveler of all. She liked this method so much that she started to teach it all around Iceland. She thought it was much better than the afterthought heel commonly used at the time for the mass-knitted stocking intended for exportation.

SHORT ROWS WITHOUT TURNING OR PURLING

A few short rows were often made under the sole to make it longer than the instep and more comfortable. There are many different ways to work short rows. American knitters are most familiar with the "wrap and turn" method, the Japanese use safety pins, and in Europe and Iceland, the yarn over method seems to be the most popular. I describe the technique I use on page 137.

The short rows under the sole add two rows: you knit one short row, purl back, and then continue knitting in the round. Some Icelandic women didn't want to bother turning and purling, so they found another way. Instead of turning at the end of the short row, they calculated how much yarn would be needed for two more short rows (the return row and the knit row when you start working in the round again), left that amount of yarn lying at the back of the work, and knitted with it, but always from the right side and from the same stitch. They used their fingers to calculate how much yarn was going to be needed to complete the two rows without running short or having too much. It takes practice to get this just right!

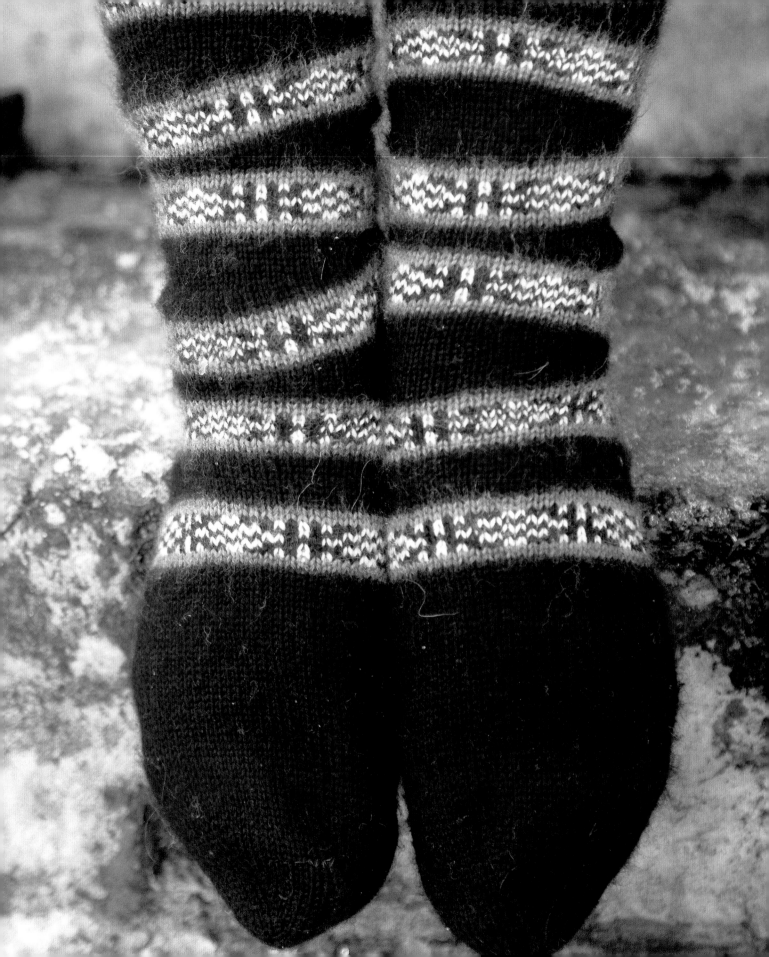

SOCK BAND SOCKS

This stranded pattern alternated with short rows gives the illusion of the woven bands that were braided around the legs to hold socks in place in the past. For a more striking effect, the socks are designed so they are not completely symmetrical.

They are knitted from the cuff down with an afterthought heel, a star toe, and a few short rows under the sole for comfort. When working the short rows, use the yarn over method described on page 137.

Sizes
Adult S (M, L)

Finished Measurements
Foot circumference: 6 1/2 (8, 9 3/4)"/16.5 (20.5, 25)cm
Foot length: 9 (9 1/2, 10 1/4)"/23 (24, 26)cm
Length from cuff to heel: 7"/18cm

Materials
- Knit Picks *Stroll Sock Yarn*, 75% superwash merino wool, 25% nylon (fingering weight), 1.75 oz/50g, 231 yds/211m per ball: Black (MC), 1 ball; Bare (CC1), 1 ball; Fedora Dark Brown (CC2), 1 ball; Jack Rabbit Heather medium brown (CC3), 1 ball; Cork light brown (CC4), 1 ball

- Size US 1 (2.25mm) circ needle or double-pointed needles

- Stitch markers

- Darning needle

Gauge
32 sts and 48 rows = 4"/10cm in St st using size US 1 (2.5mm) needle
Adjust needle size as necessary to obtain gauge.

Pattern Note
You can obtain more sizes by changing the needle size, using smaller or larger needle. For example, 26 sts and 36 rows = 4"/10cm in St st using size US 3 (3.25mm) needle.

Special Abbreviation
Central double dec s2sk (slip2, slip1, knit): Slip 2 together as if to knit, slip 1 as if to knit, insert left needle from back to front in the 3 sts and k3tog through the back loops.

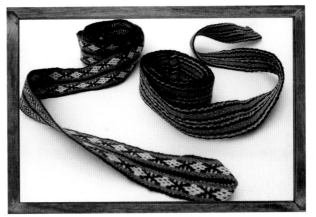

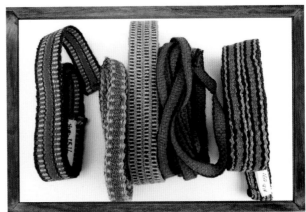

Þurídur Jónsdóttir from Sigurðarstödum í Bárðardal worked and weaved the bands that inspired me to create the pattern that runs around the socks. When the bands were made is not known. The Textile Museum in Blönduós, Reference HB569

SALKJÖT OG BAUNIR

Split pea soup with salt lamb is traditionally served on *Sprengidagur* (Bursting Day) in Iceland. Bursting day is the last day before Lent or the last day on which meat can be eaten until Easter. I prefer to cook the peas and the meat separately to prevent the soup from becoming too salty.

1 c. (200 g) yellow split peas	
	1 lb. (500 g) salt-cured lamb meat or mutton
1 c. chopped onion	
2 ¼ c. (400 g) potatoes, chopped into big cubes	
1 ¼ c. (300 g) rutabagas, chopped into big cubes	
1 ¼ c. (300 g) carrots, sliced thickly	

Soak yellow split peas overnight in water to cover. In a pot, cover salt-cured lamb meat or mutton with water, bring to a boil, then simmer for about 1 hour. In another pot, cover the soaked and rinsed peas with water. Add chopped onion, bring to a boil, and simmer for about 30 minutes. Add potatoes, rutabagas, and carrots, and cook for another 30 minutes, or until the peas are well cooked. Stir regularly, adding water from the salt lamb to salt the peas and prevent the soup from sticking to the bottom of the pot or getting too thick. Add the meat to the soup and serve. Serves four to six.

INSTRUCTIONS

Cuff
With MC and size US 1 (2.25mm) needle, CO 52 (64, 78) sts. Join, taking care not to twist sts, pm EOR (end of rnd).

Work in *k1, p1* rib for 6 rnds.

Cont with MC in St st for 2 rnds, inc 1 st in size M—52 (65, 78) sts.

Leg
Rnds 1–11: Work pattern band in stranded knitting with a jogless join.

Rnds 12–13: Work 1 rnd with MC, then short rows: turn, yo, p42 (49, 55), turn, yo, *knit to 5 sts (4 sts and a yo) before gap, turn, yo, purl to 5 sts before gap, turn, yo* 4 times, knit to EOR and knit next rnd closing all gaps (see Techniques).

Rnds 14–24: Work pattern band.

Rnds 25–26: Work 1 rnd with MC, then short rows: K10 (16, 23), turn, yo, p10 (16, 23), turn, yo, *knit to next yo, k2tog (yo and next st), k3, turn, yo, purl to next yo, ssp (yo and next st), p3, turn, yo* 4 times, cont to knit in the rnd, knit to next yo, k2tog, knit to 1 st before next yo, ssk, knit to EOR.

Repeat Rnds 1–26 once more.

Afterthought Heel
Cont with MC and in next rnd, work first (right foot) or last (left foot) 26 (32, 38) sts in rnd with a contrasting color scrap yarn, place sts back on left needle and knit them again with MC.

Foot
Work pattern band Rnds 1–11.

Work 3 rnds with MC, then short row across the sole: K26 (32, 38) sts (right foot) or knit to EOR (left foot), turn, yo, p26 (32, 38) sts, turn, yo. Cont knitting in the rnd, closing all gaps (see Techniques).

Work 2 more rnds with MC, then work pattern band Rnds 1–11.

Cont even with MC until foot measures 5 1/2 (6, 6 1/2)"/14 (15, 16.5)cm from scrap yarn or about 2"/5cm short of desired length.

Star Toe
Rnd 1: *K2tog, k11* to EOR—48 (60, 72) sts.

Rnd 2 and all even rows: Knit all sts.

Rnd 3: *K2tog, k10* to EOR—44 (55, 66) sts.

Rnd 5: *K2tog, k9* to EOR—40 (50, 60) sts.

Rnd 7: *K2tog, k8* to EOR—36 (45, 54) sts.

Rnd 9: *K2tog, k7* to EOR—32 (40, 48) sts.

Rnd 11: *K2tog, k6* to EOR—28 (35, 42) sts.

Rnd 13: *K2tog, k5* to EOR—24 (30, 36) sts.

Rnd 15: *K2tog, k4* to EOR—20 (25, 30) sts.

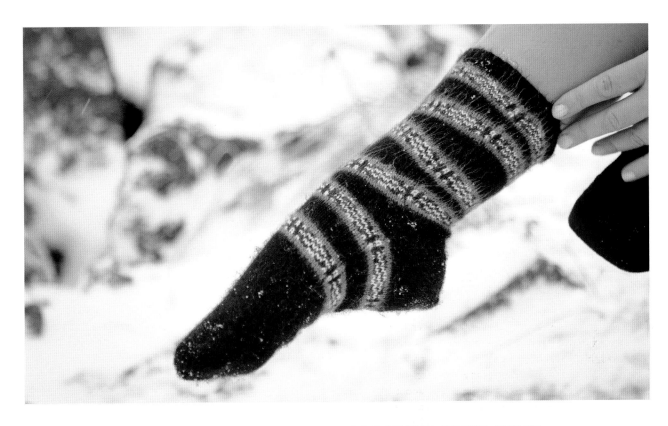

Rnd 17: *K2tog, k3* to EOR—16 (20, 24) sts.

Rnd 19: *K2tog, k2* to EOR—12 (15, 18) sts.

Rnd 21: *K2tog, k1* to EOR—8 (10, 12) sts.

Break yarn, draw it trough the sts.

Heel

Remove scrap yarn and place live sts on needles (see Techniques).

Work in the rnd with MC: pick up 2 extra sts and k2tog (make a double lifted dec, see Techniques) on each side—54 (66, 78) sts.

Work central double dec on each side in every other row; the extra picked up st is at the center of the double dec:

Rnd 1: *Knit to 1 st before extra st, s2sk* twice.

Rnd 2: Knit all sts.

Rnd 3: *Knit to 1 st before central dec st, s2sk* twice.

Rnd 4: Knit all sts.

Repeat Rnds 3 and 4 until 18 (22, 26) sts rem. Divide sts in two and graft together back to bottom to close the heel.

Finishing

Darn in ends and block.

SOCK BAND SOCKS CHART

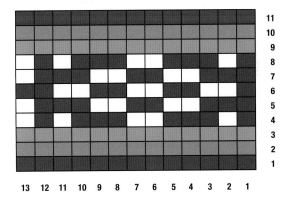

KEY

☐ K CC1
■ K CC2
■ K CC3
■ K CC4

CHAPTER

4

INSPIRED BY LACE

The Textile Museum has a great collection of lace patterns present in its artifacts, including the wrist warmers, mittens, and *klukka*, the Icelandic petticoat. But it is the amazing shawls attract the most attention. The Icelandic tradition of knitting intricate lace shawls likely dates back to the nineteenth century. Icelandic lace shawls are known around the world for the beauty of the handspun yarn and the array of colors used, from natural sheep tones to yarn that is hand-dyed using plants. Some shawls were so fine that they could be drawn through a wedding ring. The color variations were infinite, and the shift between shades almost imperceptible. The many beautiful triangular and long shawls in the Textile Museum collection inspired the designs in this chapter.

Opposite: *We get to see amazing Northern Lights during my knitting tours, which take us far away from the city lights.*
James Thew/Shutterstock

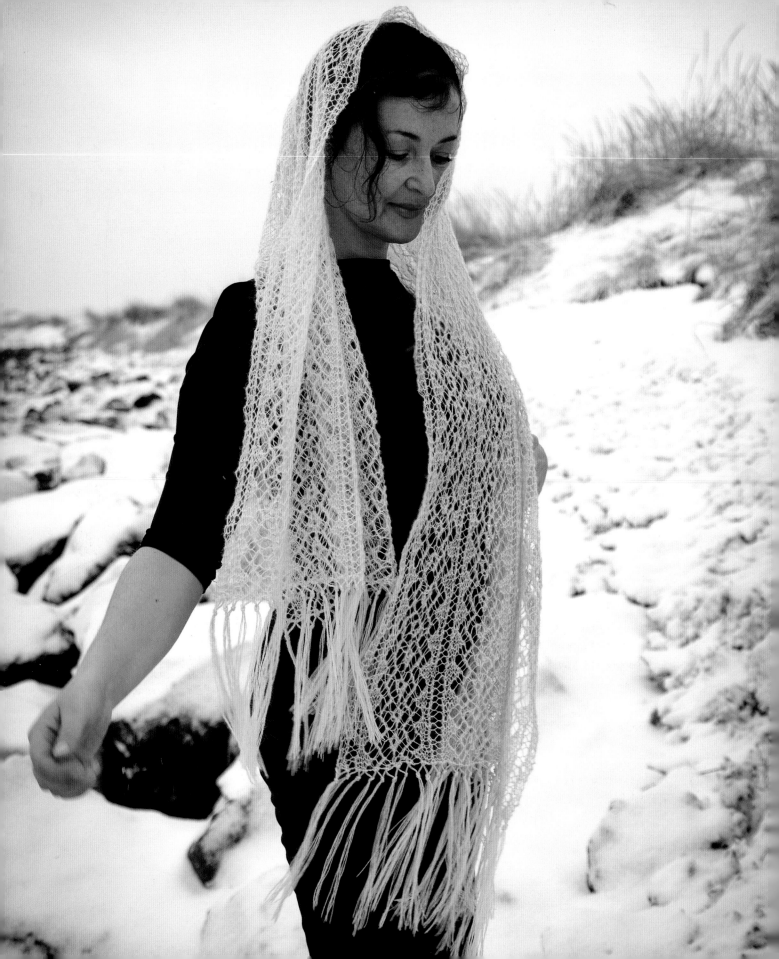

HALLDÓRA LONG SHAWL

It was probably just as challenging to knit this shawl as it was to figure out the true lace stitch pattern—an exciting openwork diamond with an eyebird in the center. Jóhanna Jóhannesdóttir knitted many similar versions of this shawl, including one for Halldóra Bjarnadóttir herself. Jóhanna was a prolific and amazing knitter who received an "acknowledgment of best in show" at Iceland's first public home industry exhibition in Reykjavík in 1921. She probably sought inspiration for this long shawl from the book *Kvennafræðarinn* by Elín Briem, as the motif appears in the oldest edition, which was published in 1888. *Kvennafræðarinn* was one of the first books about women handiwork and homework to be published in Icelandic.

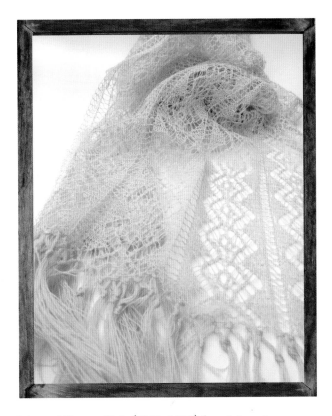

Finished Measurements
Width: 24"/61cm
Length: 63"/150cm

Materials
- Hélène Magnússon *Love Story*, icelandicknitter.com, 100% Icelandic wool (fine artisanal lace), .881 oz/25g, 230 yds/210m per skein: #01 natural sheep color white, 4 skeins
- Size US 6 (4mm) circ needle
- Crochet hook size US G-6 (4mm) for the fringe
- Markers
- Pins
- Darning needle

Gauge
19 sts = 4"/10cm unblocked using size US 6 (4mm) needle
Gauge is not essential.

Jóhanna Jóhannesdóttir (1895–1989) from Svínavatn, Húnavatnssýsla, has been spinning and knitting all her life. The long shawls in the Textile Museum collection are all of the same facture with a few variations in the details, such as a slightly different fringe or a few eyelet rows added at the edge. One shawl has one band of another lace pattern with dark colors. But what makes the shawls even more special is that some of them are knitted with the soft, fine þel and others with the tog for a dramatically different texture. The tog was hand spun by Vigdís Guðmundsdóttir from Akrafell in Akranes. The Textile Museum in Blönduós, Reference HB574

ICELANDIC WOOL, TOG, AND ÞEL

Icelandic wool is made of two types of fibers. The *þel* are the very fine, soft inner fibers that are highly insulating. The outer fibers, called *tog*, are much longer, shiny, and water repellent. Both fibers are considered wool.

Combining the two in different percentages allows for a vast array of yarns, from pure *tog*, which makes a strong, twisted yarn used for ropes, belts, or rugs; to pure *þel*, which makes the finest, softest shawls, Sunday-best mittens, or soft underwear; and all the yarns in the between for everyday use. The Textile Museum has wonderful samples of extra-fine, handspun *þel* yarn.

Pattern Note
All rows are charted. The gray line serves only to help visualize the lace and ease the knitting. It is a good idea to place a marker between pattern repeats. A lifeline between pattern repeats upward is also a good idea, at least to begin with.

INSTRUCTIONS

Using two size US 6 (4mm) needles, CO 113 sts.

Follow Chart, working Rows 5–8, then repeat Rows 1–8, 44 times, ending with Rows 1–5. BO loosely.

Finishing
Darn in all ends, but don't cut them off yet. Hand wash in lukewarm water with wool soap. Let soak in water for at least 20 minutes. Squeeze out excess water in a towel, pin to dimensions. Lay flat to dry. When it's dry, cut off the ends.

Fringe
Cut 12"/30.5cm lengths of yarn. Fold four strands in two and attach at each end of the shawl as shown on chart (even number). Knot them two by two about 1"/2.5 cm from edge.

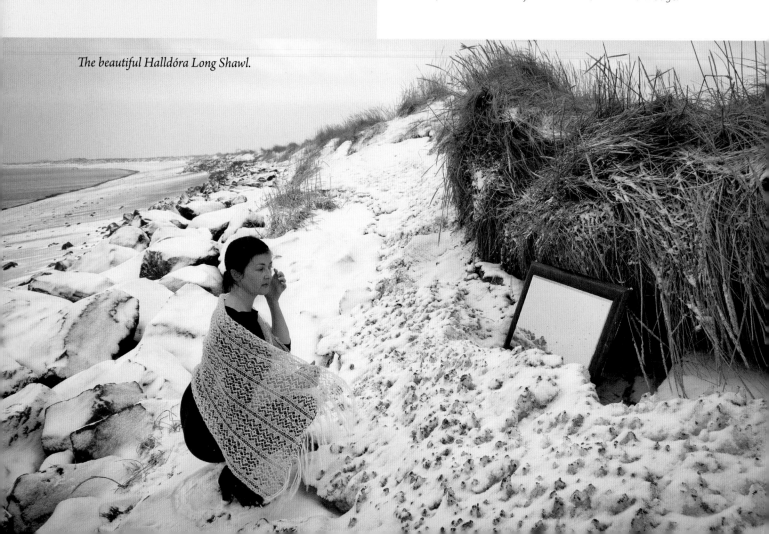

The beautiful Halldóra Long Shawl.

LOVE STORY YARN

Love Story is an artisanal lace-weight yarn made of 100 percent Icelandic wool that is much softer than the industrialized yarn on the market. Love Story mixes both *tog* and *þel*. It is my very own label, and I originally developed it to re-create old Icelandic lace dresses for my upcoming book, *The Icelandic Lace Dresses of Aðalbjörg Jónsdóttir* (Reykjavik 2013). The yarn used by Jónsdóttir didn't exist anymore, and the lace-weight yarn Einband-Loðband by Ístex, which is blended with up to 30 percent of another wool, lacks certain qualities inherent in the pure Icelandic wool needed for the dresses. I called the yarn "Love Story" because the story of its creation is really one of love and friendship—love for the raw product, the wool, which is treated gently and without any aggressive processes. Love Story is available in the natural colors of the sheep or dyed with plants or environmentally friendly dyes in an array of delicate colors. This was all made possible through collaboration with the lovely people who helped create the yarn and became my friends: the farmers, spinners, dyers, and mills.

HALLDÓRA LONG SHAWL CHART

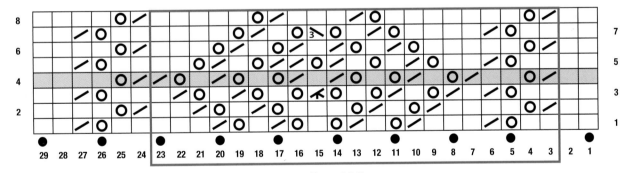

Repeat 5 times

All rows are charted.
The gray line is there simply to help visualize the lace and ease the knitting.

KEY
- ☐ k
- ╱ k2tog
- ⊼ k3tog
- ₃ sk2p
- O yo
- ● Attach fringe

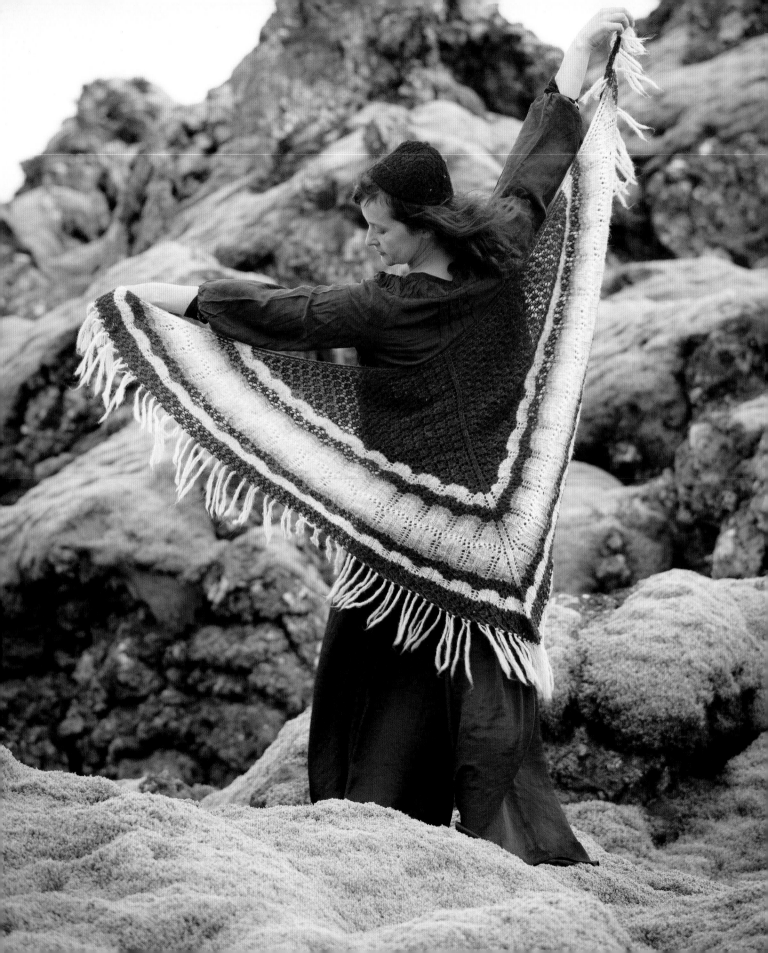

MARGRÉT TRIANGULAR SHAWL

I made very few changes to the shawl knitted by Margrét Jakobsdóttir, now in the Textile Museum, but I did add a garter tab cast-on to avoid having to sew the cast-on at the top. This design is not as fine as the original shawl, which was knitted with *þel* band that Margrét hand spun herself, and it has far fewer shades of gray. Margrét designed few shawls herself, but she made the first pattern for this shawl that was published in the magazine *Hugur og Hönd* in 1976, which is now out of print.

Finished Measurements
Triangle at widest: 67"/170cm
Triangle height: 3 ½"/85cm

Materials
- Ístex *Einband-Loðband*, 70% Icelandic wool, 30% wool (fine lace-weight, one-ply worsted), 1.75 oz/50gr, 246 yds/225m per skein: #0852 heather black (MC), 2 skeins; #9102 dark gray (CC1), 1 skein; #1027 medium gray (CC2), 1 skein; #1026 light gray (CC3), 2 skeins; #0851 white (CC4), 1 skein
- Size US 6 (4mm) circ needle
- Size US C2 (2.75mm) crochet hook
- Darning needle

Gauge
22 sts and 26 rows = 4"/10cm in St st using size US 6 (4mm) needle
Adjust needle size as necessary to obtain correct gauge.

Pattern Notes
- Follow the charts as indicated. Only RS rows (uneven rows) are charted. WS rows (even rows) are always purled except for the first 3 and last 3 sts that are worked in garter st (borders).
- The shawl is made of two identical triangles with one middle st and 3 garter st borders on both sides. The charts show only half the shawl; work the motif first from right to left, then repeat from the middle st from left to right.

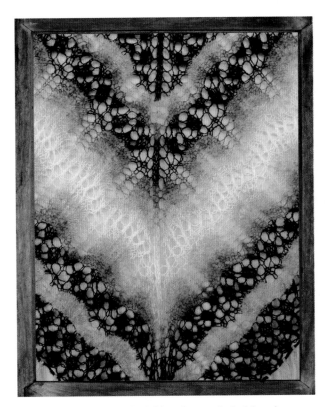

Margrét Jakobsdóttir Lindal hand spun the þel band in natural sheep colors and used it to knit the shawl. The Textile Museum in Blönduós, Reference HIS2176

MARGRÉT JAKOBSDÓTTIR LINDAL

Margrét Jakobsdóttir Lindal was born at Lækjamóti í Víðidal in 1920. Her father was Jakob H. Lindal, a farmer and geologist, and her mother was Jónína Sigurðadóttir, a handiwork teacher. Margrét learned at a young age the methods used to work the wool—spinning, dyeing, knitting, and weaving. At the time, a lot of home industry took place at the farm. The wool was washed, and the *tog* and *þel* were separated by hand. Then it was sent to the Gefjun mill in Akureyri for combing. The wool was sent back home to the farm, where it was spun both on a traditional Icelandic spinning wheel (a vertical one) and on a little spinning machine. The band was knitted into all sorts of clothing on a knitting machine.

This is how Margrét grew up, and it is not surprising that she became a handwork teacher. Margrét's mother was very much up-to-date with all the new technologies, but from a young age, Margrét was fascinated by the few women in the countryside who were still combing the wool themselves and spinning it into extremely fine band from which they knitted delicate and airy shawls. She thought it was a much more beautiful yarn than the one made by the machine at her home. Margrét followed in their footsteps and taught herself the old ways to work the wool. She learned a great deal from Hulda Á. Stefánsdóttir, director of the Women's College in Blönduós. To assist her with the spinning was her husband, Kristinn Gíslasson, who was always combing the wool for her. He had learned how to work with wool as a child at home, and he was also spinning on the Old Icelandic spindle. Many of Margrét's especially beautiful pieces can be seen at the Textile Museum. Beautiful shawls, knitted with a very thin handspun *þel* yarn in a wonderful array of natural sheep colors or delicate plant-dyed hues, were donated to the Museum in 2008 by her children, Jakob, Halldóra, Gísli, and JónínaVala (who are thus altogether Kristinsbörn, children of Kristinn).

Margrét was, without a doubt, among the best of Icelandic crafters. When she passed away on October 8, 2011, I had plans to meet her in just a couple of weeks. I contacted her daughter Halldóra to arrange for an interview. This book is dedicated to Margrét.

This article in the August 17, 1976 edition of the Icelandic newspaper Morgunblaðið *describes Iceland's participation in the United States of America's bicentennial celebration festival, which was organized by the Smithsonian Institute. Many countries were invited to participate, and Margrét, her husband, Kristinn Gíslasson, and Þórður Tómasson, director of the District Museum of Skógar, came to represent Iceland with a demonstration of the old ways to work the wool. Margrét spun wool on an Icelandic wheel while Kristinn combed the wool and showed how to use the Icelandic spindle. Þórður attracted a lot of attention spinning horsehair and making it into braids and ropes.*

INSTRUCTIONS

With provisional cast-on, using MC and size US 6 (4mm) circ needle, CO 3 sts.

Knit 5 rows in garter st. Pick up and k3 sts along the edge of the square. Remove provisional cast-on and knit the 3 live sts—9 sts.

Rows 1–26: With MC, work Chart A Rows 1–26—71 sts at end of Row 26.

Rows 27–82: With MC, repeat Chart A Rows 19–26 seven times—239 sts at end of Row 82.

Rows 83–90: Work Chart B Rows 1–8 (repeat red frame 9 times), working Rows 1–4 with CC3 and Rows 5–8 with CC2—263 sts at end of Row 90.

Rows 91–98: With MC, work Chart A Rows 19–26—287 sts at end of Row 98.

Rows 99–134: Work Chart B Rows 1–36 (repeat red frame 11 times), working Rows 1–4 with CC1, Rows 5–8 with CC2, Rows 9–14 with CC3, Rows 15–22 with CC4, Rows 23–28 with CC3, Rows 29–32 with CC2 and Rows 33–36 with CC1—371 sts at end of Row 134.

Rows 135–142: With MC, work Chart A Rows 19–26 (repeat red frame 28 times)—395 sts.

Rows 143–150: With CC3, work chart C rows 1–8 (repeat red frame 15 times)—415 sts.

Rows 151–164: With MC, work chart D rows 1–14 (repeat red frame 32 times)—457 sts.

BO with MC and a crocheted chain bind-off: Sl st 2 together (insert hook through loops of sts as if to knit them together through the back loops, yarn over hook and pull through all sts), *ch 5, sl st 3 together* ch 5, sl st 2 last sts—152 ch arches.

Finishing
Darn in all ends, but don't cut them off yet. Hand wash in lukewarm water with wool soap. Let it soak in water for at least 20 minutes. Squeeze out excess water in a towel, pin to dimensions. Lay flat to dry. When it's dry, cut off the ends.

Fringe
Cut 12"/30.5cm lengths of CC3. Fold three strands in two and attach in each arch with the crochet hook.

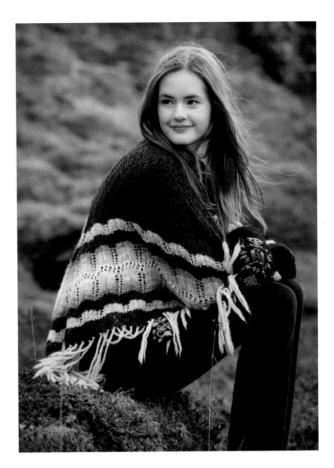

These examples of very fine handspun yarns are graded from the lightest to the darkest in an array of natural sheep colors and plant-dyed colors. The Textile Museum in Blönduós

MARGRÉT TRIANGULAR SHAWL CHARTS

CHART D

CHART C

KEY

- ☐ k
- ⌀ k tbl
- ○ yo
- ╱ k2tog (right-leaning dec)
- ╲ ssk (left-leaning dec)
- ⋏ left-leaning double dec: sl1, k2tog, psso
- ☐ repeat

CHART B

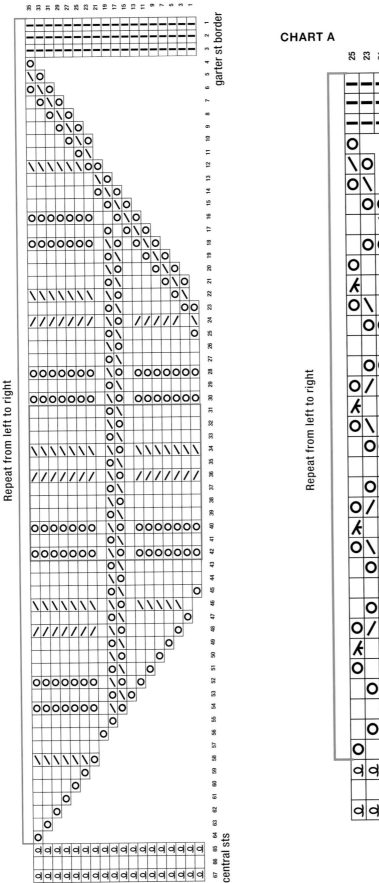

Repeat from left to right

central sts

CHART A

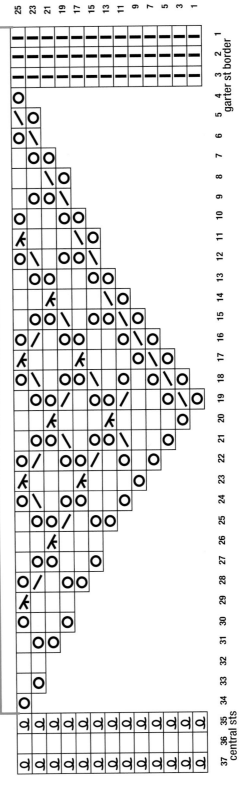

Repeat from left to right

central sts

119

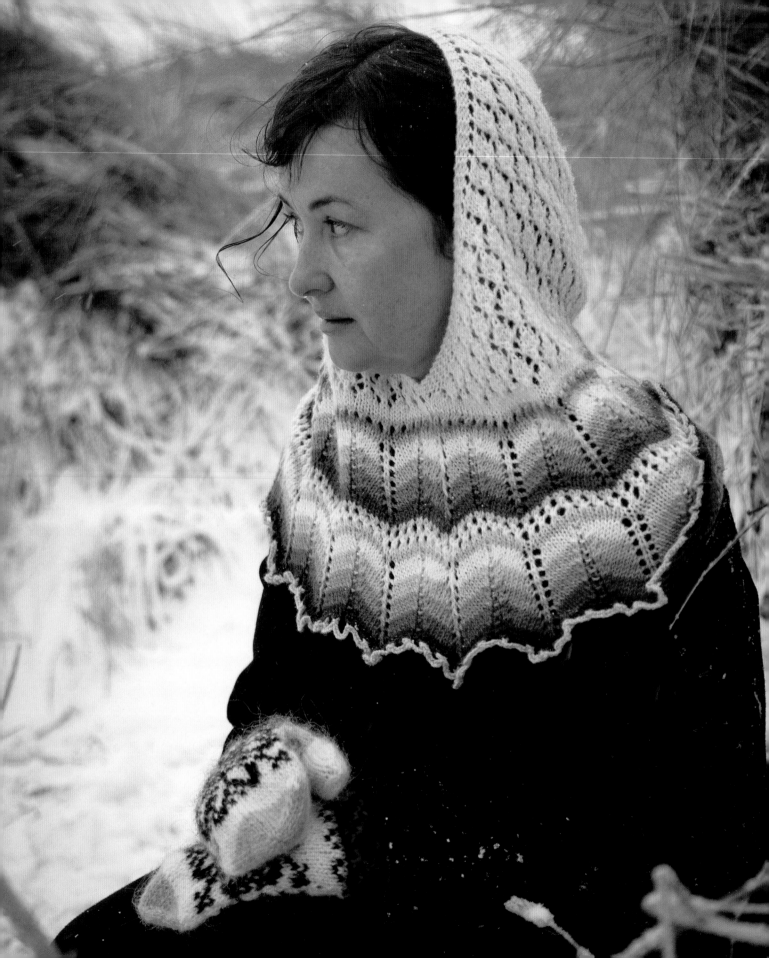

LACE HOOD

Hoods were a common and useful accessory for men in Iceland. There were two main types: the *lambhúshetta* and the *Mývatnshetta*, which was much wider over the shoulders and typically worn in North Iceland, near Lake Mývatn, from which it derives its name. My hood is sort of a feminine lacy version of a

Mývatn hood. It begins in the same way one would knit a triangular shawl: from the top down. It is shaped to conform to the head, then joined in the round, and the collar is knitted. The delicate patterning and subtle color grading was inspired by one of Þordís's wonderful shawls (see below).

Size
One size fits all

Finished Measurements
Circumference (around neck): 28"/71cm
Height: 18"/45.5cm

Materials
- Kambgarn from Ístex, 100% new Merino wool (3-ply worsted), 1.75oz/50g, 165yds/150m: #0051 white (MC), 2 balls; #1205 sandshell (CC1), 1 ball; #1204 beige (CC2), 1 ball; #1203 almond (CC3), 1 ball; #9652 chocolate (CC4), 1 ball; #1202 frost gray (CC5), 1 ball; #1201 dove gray (CC6), 1 ball; #1200 steel gray (CC7), 1 ball
- Size US 6 (4 mm) circ needle
- Magic loop is used for smaller diameters or double-pointed needles
- Size US D-3 (3mm) crochet hook
- Darning needle

Gauge
24 sts and 32 rows = 4"/10cm in St st using size US 6 (4mm) needle
Adjust needle size as necessary to obtain correct gauge.

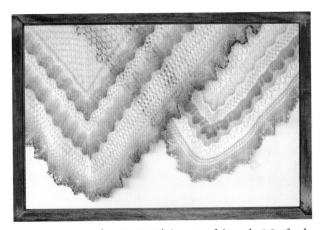

Þordís Egilsdóttir (1878–1961) from Ísarfirði in the Westfjords of Iceland knitted both shawls with yarn made of þel, the finest undercoat wool. They are very fine and hand spun in natural sheep colors (shawl on the left) or hand-dyed with Icelandic plants in subtle shades of green and brown (shawl on the right). You may recognize Þordís's style, as one of the shawls is from the book Three-cornered and Long Shawls after Sigriður Halldórsdóttir. This book has long become a classic, thanks to School House Press, which published the first English translation. I recently published a French translation as well. The Textile Museum in Blönduós

ÁBRYSTIR: A RECIPE FROM OLD ICELAND

This was a rich, thick pudding made from the first or the second milking after calving. Since it's nearly impossible to find the milk or colostrum at an obliging farm today, we've included this recipe for historical interest only.

4 ¼ c. (1 l) cow's colostrum	
4 ¼ c. (1 l) whole milk	
1 tsp. salt	

Thin 1 liter of cow's colostrum with about 1 liter of whole milk from the first milking or ½ liter whole milk from the second milking. Make a batch test to find the right mixture. Dissolve salt in ⅛ cup warm water. Pour milk/colostrum mix into a double boiler, add the dissolved salt, put a lid on it, and steam gently in hot water until the milk has the consistency of a solid but soft and smooth pudding. Makes six to eight 1-cup servings.

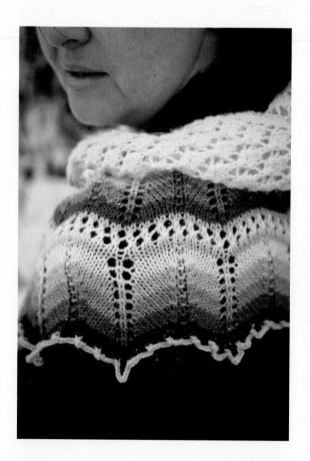

Pattern Notes

Only RS rows (uneven rows) are charted.

For Chart A (worked back and forth): WS rows (even rows) are always purled except the 3 border sts that are in garter st.

For Chart B (worked in the round): WS rnds (even rnds) are always k. They are worked in the same color of the uneven round they follow. Color changes occur only on uneven rounds.

INSTRUCTIONS

Garter Tab

With provisional cast-on method, using MC and size US 6 (4mm) needle, CO 3 sts.

K 3 rows (garter st). Pick up and k 1 st along the edge. Remove provisional CO and k the 3 sts—7 sts (3 border sts on each side and one middle st).

Lace Motif

With MC, work Chart A. Lace motif is repeated twice between the garter st borders with 1 middle st between.

Work Rows 1–18 = 3 garter sts + 23 sts + 1 central st + 23 sts + 3 garter sts—53 sts.

Repeat Rows 11–18, 4 times = 3 garter sts + 71 sts + 1 central st + 71 sts + 3 garter sts—149 sts.

Work Rows 19–26, twice = 3 garter sts + 83 sts + 1 central st + 83 sts + 3 garter sts—173 sts.

Set the 3 sts on each side (garter st borders) on a piece of scrap yarn—167 sts.

Join in the round and work Chart B, changing colors according to chart. In first rnd, inc one st anywhere in the rnd—168 sts.

Repeat 14 times between *-* —252 sts.

BO with CC1 and a crocheted chain BO: slip st 3 together (insert hook through loops of sts as if to knit them together through the back loops, yarn over hook and pull through all sts), *chain 8, slip st 3 together* chain 8, join in rnd with a sl st—84 chain arches.

Finishing

Graft together the sts from the two borders. Darn in all ends, but don't cut them off yet. Hand wash in lukewarm water with wool soap. Let it soak in water for at least 20 minutes. Squeeze out excess water in a towel, block to dimensions, pull out the scallops, and pin. Lay flat to dry. When it's dry, cut off the ends.

LACE HOOD CHART A

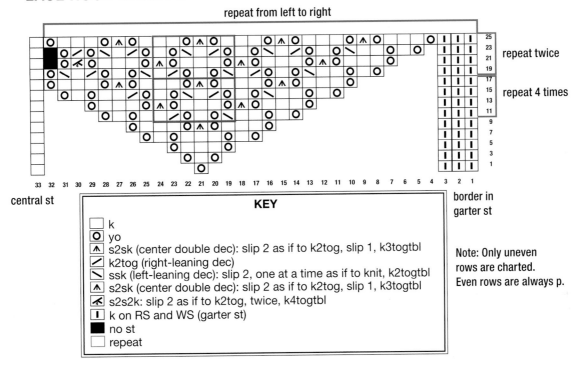

repeat from left to right

repeat twice

repeat 4 times

central st

border in garter st

KEY

- ☐ k
- Ⓞ yo
- Λ s2sk (center double dec): slip 2 as if to k2tog, slip 1, k3togtbl
- ╱ k2tog (right-leaning dec)
- ╲ ssk (left-leaning dec): slip 2, one at a time as if to knit, k2togtbl
- Λ s2sk (center double dec): slip 2 as if to k2tog, slip 1, k3togtbl
- ⋝ s2s2k: slip 2 as if to k2tog, twice, k4togtbl
- | k on RS and WS (garter st)
- ■ no st
- ☐ repeat

Note: Only uneven rows are charted. Even rows are always p.

LACE HOOD CHART B

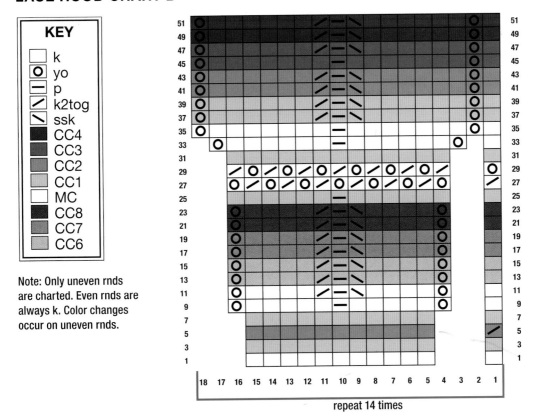

KEY

- ☐ k
- Ⓞ yo
- ─ p
- ╱ k2tog
- ╲ ssk
- CC4
- CC3
- CC2
- CC1
- MC
- CC8
- CC7
- CC6

Note: Only uneven rnds are charted. Even rnds are always k. Color changes occur on uneven rnds.

repeat 14 times

123

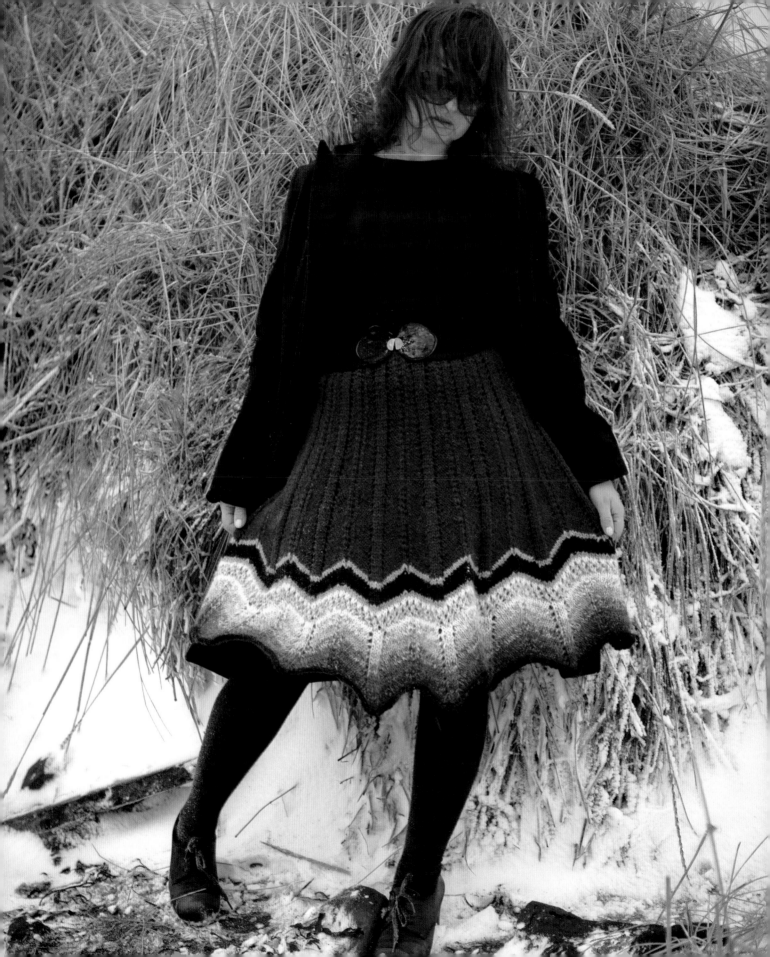

KLUKKA SKIRT

This skirt is inspired by the *klukka*, the Icelandic petticoat or slip. It was worn as an undergarment, close to the skin to keep warm. It was knitted out of lightweight wool, often with a wavy lace pattern in the skirt, such as a scallop lace stitch, enhanced with a few stripes of colors and a crocheted edge. The Textile Museum has many examples of *klukka*, and several are machine knitted but finished by hand.

The skirt, which is knitted from the top down, comes in many sizes and three lengths. You can easily add sizes or adjust the length. It is shaped with increases within the stitch pattern, but also by changing needle size. The shifts in shading, inspired by the lovely and subtle color shading found in shawls from the Textile Museum collection, are obtained by knitting different strands of yarn together.

Sizes
From Girl's to Woman's 3X (15 sizes)
Chose size according to waist measurements (zero or negative ease)

Finished Measurements
Waist: 17, 19, 21 ½ (23 ½ , 25 ½ , 27 ¾) 30, 32, 34 (36, 38 ½ , 40 ½) 42 ½ , 44 ¾, 47"/43, 48.5, 54.5 (59.5, 65, 70.5) 76, 81.5, 86.5 (91.5, 98, 104) 108, 113.5, 119.5cm
Height (before blocking): About 16, 16, 16 (18, 18, 18) 20, 20, 20 (22, 22, 22) 24, 24, 24"/40.5, 40.5, 40.5 (45.5, 45.5, 45.5) 51, 51, 51 (56, 56, 56) 61, 61, 61cm
Height (after blocking): Add about 1"/2.5cm

Materials
◆ Ístex *Plötulopi*, 100% pure Icelandic wool (unspun,) 3.5 oz/100g, 228 yds/200m per skein (always held doubled): #0484 forest green (MC), 2, 2, 2 (2, 2, 3) 3, 3, 3 (3, 4, 4) 4, 4, 4 skeins; #1424 golden yellow heather (CC1), 1 skein; #0059 black (CC2), 1 skein; #0014 forest heather (CC3), 1 roving plate; #0013 light forest heather (CC4), 1 skein; #0001 white (CC5), 1 skein

◆ Sizes US 7, 8, and 9 (4.5, 5, and 5.5 mm) circ needles

◆ Darning needle

◆ Elastic for waistband, about 0.6"/1.5cm wide

Gauge
15 sts and 21 rows = 4"/10cm in pattern st with size US 7 (4.5mm) needle
Adjust needle size as necessary to obtain correct gauge.

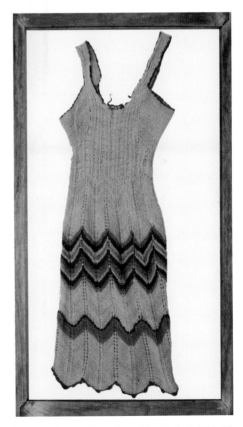

No one knows who made the hand-knitted pink klukka *or when. The Textile Museum in Blönduós, Reference HIS162*

THE ICELANDIC LACE DRESSES OF AÐALBJÖRG JÓNSDÓTTIR

Aðalbjörg Jónsdóttir is a 95-year-old Icelandic knitter of lace-knitted dresses that are reminiscent of the klukka—although infinitely more constricted and elaborate in their conception. She knitted about one hundred dresses in the 1970s, all one-of-a-kind. I interviewed Jónsdóttir in 2007 and again 2008 as part as a series of interviews I conducted with old knitters in Iceland. I found her work so extraordinary that in 2009, I decided to write an entire book about her and the dresses. Over three years, I studied her work and even developed my own special Icelandic yarn label, Love Story, to allow knitters to re-create the patterns included in the book in a yarn that was close to the original yarn used by Jónsdóttir. The book, *The Icelandic Lace Dresses of Aðalbjörg Jónsdóttir* (Reykjavík, Prjónakerling 2013), will be available in three languages: Icelandic, French, and English.

INSTRUCTIONS

With MC (held doubled) and size US 7 (4.5mm) circ needle, CO 64, 72, 80 (88, 96,104) 112, 120, 128 (136, 144, 152) 160, 168, 176 sts. Join, taking care not to twist sts, pm EOR (end of round).

Work around in St st for 5 rnds.

Purl 1 rnd (foldline for waistline).

Work around in St st for 7 rnds.

Following Chart, begin pattern st, repeating motif across and upward according to size and height. Note that repeat for height (H) is indicated on the right side of the chart for first 3 sizes (2nd 3 sizes, 3rd 3 sizes, 4th 3 sizes), 5th 3 sizes.

Note: Read the chart: only uneven rnds are charted. Even rnds are always knit. The repeat rnds mean you have to repeat the pair rnds (uneven and even rnd). For example, first repeat: Repeat Rnds 1 and 2, two times—4 rnds in all. Even rnds are worked in the same color that the uneven row they follow. Color changes occur only on uneven rows.

When pattern is complete, BO loosely with CC2: K1, *k1, insert left needle into the 2 sts on right needle from the back to the front and k2tog* until all the sts are worked.

Finishing

Fold the waistband in two along the purl st line and sew down on the inside. Leave a little opening, draw the elastic band through, sew both ends together, and close the opening. Sew a few sts on both sides of the skirt; secure elastic together with knit fabric to avoid it rolling up. Darn in the ends but don't cut them off yet. Hand wash in lukewarm water, lay flat to dry. Pull out the scallops and pin. When dry, remove pins and cut off ends.

KEY	
□	k
O	yo
—	p
╱	k2tog
╲	ssk
■	MC, 2 strands
■	CC1, 2 strands
■	CC2, 2 strands
■	CC3, 2 strands
■	CC4, 2 strands
□	CC5, 2 strands
▦	1 strand CC1, 1 strand CC5
▦	1 strand CC5, 1 strand CC4
▦	1 strand CC4, 1 strand CC3
▦	1 strand CC3, 1 strand MC

KLUKKA SKIRT CHART

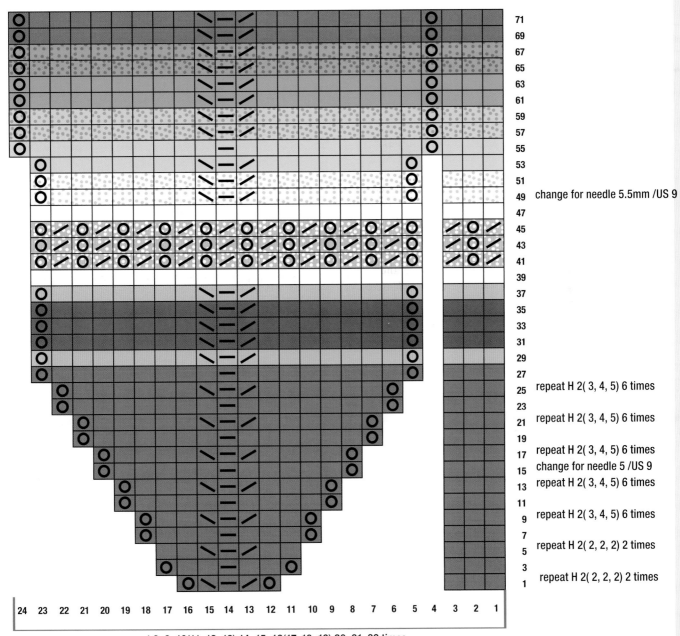

71
69
67
65
63
61
59
57
55
53
51
49 change for needle 5.5mm /US 9
47
45
43
41
39
37
35
33
31
29
27
25 repeat H 2(3, 4, 5) 6 times
23
21 repeat H 2(3, 4, 5) 6 times
19
17 repeat H 2(3, 4, 5) 6 times
15 change for needle 5 /US 9
13 repeat H 2(3, 4, 5) 6 times
11
9 repeat H 2(3, 4, 5) 6 times
7
5 repeat H 2(2, 2, 2) 2 times
3
1 repeat H 2(2, 2, 2) 2 times

24 23 22 21 20 19 18 17 16 15 14 13 12 11 10 9 8 7 6 5 4 3 2 1

repeat 8, 9, 10(11, 12, 13) 14, 15, 16(17, 18, 19) 20, 21, 22 times

Only uneven rnds are charted. Even rnds are always k. Color changes occur on uneven rnds.
When uneven row is indicated as repeated, the following even row is repeated as well.

LACY SKOTTHÚFA

When looking at old pictures, I am always amazed by the rather extravagant headwear Icelandic women were wearing, especially considering the weather and the wind. The *skotthúfa* that was part of the everyday costume, which literally translates to "cap with a tail" in Icelandic, seems very quiet in comparison. This is my new take on the traditional *skotthúfa*. First the tail is knitted in the round, then the cap is shaped from three triangles using spider lace, the most common lace stitch pattern found in Iceland triangular shawls. I reinterpreted the tail and the silver tassel as a few beaded strands with a ribbon. I kept it very light so that the cap will stay in place on the head and not fall apart with the weight of a tassel.

Sizes
Child (Adult)

Finished Measurements
Circumference: 16–18"/40.5–45.5cm
Depth: 6 (8)"/15 (20.5)cm (depth adjustable)

Materials
- Ístex Einband-Loðband, 70% Icelandic wool, 30% wool (fine lace-weight, 1-ply worsted), 1.75 oz/50gr, 246 yds/225m per skein: #0059 black or #0047 red, 1 skein
- Size US 4 (3.5 mm) circ needle
- Magic loop is used for smaller diameters or double-pointed needles
- Darning needle
- Beads and satin ribbon

Gauge
22 sts and 26 rows = 4"/10cm in St st using size US 4 (3.5mm)
Adjust needle size as necessary to obtain correct gauge.

The Textile Museum has a great collection of Icelandic costumes with women wearing the skotthúfa. *Over time, the style of this cap has become smaller and smaller. At the end of the nineteenth century, it was more like a skull cap than a hat, and it was held in place on the hair with bobby pins. The Textile Museum in Blönduós*

LAUFABRAUÐ

The *Laufabrauð*, literally "leaf bread," is a traditional festive bread from the North of Iceland, made at times when wheat was scarce. It is very thin bread but artistically decorated to make up for the poor dough quality. For Christmas, the whole family would gather to carve snowflake-like patterns from the dough. There are many traditional *Laufabrauð* patterns, but you also have the freedom be creative. Every family considers their own recipe the best, and here is the recipe from my family.

4 ⅓ c. (1000 g) flour
¾ c. (200 g) rye flour
1 tsp. sugar
1 tsp. salt
¼ c. (50 g) butter, melted
4 ⅓ c. (1 l) warm milk (heated to just below boiling and cooled slightly)
Oil or fat for frying, about 1 quart (1 l)

In a large mixing bowl, combine flour, rye flour, sugar, and salt. Add melted butter and warm milk until you obtain a smooth dough. Flatten the dough into very thin circles, like pancakes. Decorate by cutting out patterns with a sharp knife. Using the tines of a fork, poke holes all over the dough circles (to prevent the formation of bubbles when frying). To prevent the dough from drying out before frying, stack the breads on top of one another, placing a sheet of parchment paper between each. Heat oil or fat in a deep pan to 350°F (180°C). Using two forks, transfer circles of dough to the oil and fry for about 1 minute on each side, until golden. Remove from oil and immediately press the bread between newspaper and paper towels with a flat pot lid. Store the breads stacked in a tin box in a cool, dry place so they don't break. *Laufabrauð* is traditionally eaten with *hangikjöt* (smoked lamb).

INSTRUCTIONS

Tail

With size US 4 (3.5mm) circ needle, CO 7 sts. Join in the round, taking care not to twist sts, pm EOR (end of rnd). Work around in St st for 1"/2.5cm.

Next Rnd: Knit, inc 1 st—8 sts.

Cont in St st for 2"/5cm.

Next Rnd: Knit, inc 1 st—9 sts.

Cont in St st for 3"/7.5cm.

Tail is 6"/15cm long.

Body

With 9 sts on needle, cont working in the rnd and begin following Chart with Rnd 1, working repeat (*1 central double dec, yo*) 3 times. Cap is made of 3 lace triangles with one st in between. Repeat across and upward as indicated on Chart. Only uneven rnds are charted, even rnds are always knit.
When pattern is complete, work 6 (8) rnds in garter st (*purl 1 rnd, knit 1 rnd*). BO very loosely: K1, *k1, insert left needle in the 2 sts on right needle and k2tog tbl* across.

Finishing

Darn in all ends, but don't cut them off yet. Hand wash in lukewarm water with wool soap. Let it soak in water for at least 20 minutes. Squeeze out excess water in a towel; pin on a ball of head's dimensions or directly on head (pin in hair) and leave to dry. When it's dry, cut off the ends. Thread beads and attach at the end of the tail as shown in picture. Sew on knotted ribbon.

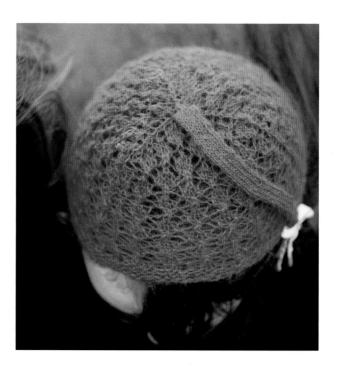

LACY SKOTTHÚFA CHART

repeat 3 times across

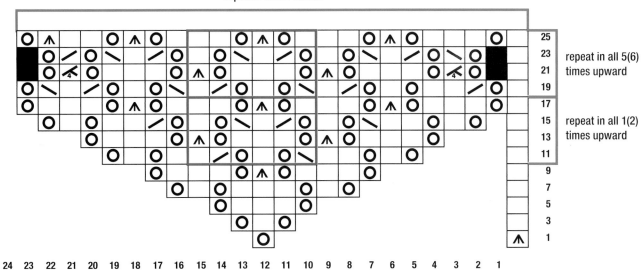

25			
23	repeat in all 5(6)		
21	times upward		
19			
17			
15	repeat in all 1(2)		
13	times upward		
11			
9			
7			
5			
3			
1			

24 23 22 21 20 19 18 17 16 15 14 13 12 11 10 9 8 7 6 5 4 3 2 1

KEY

☐	k
O	yo
∕	k2tog
∖	ssk
⋀	s2sk (CDD)
⊀	s2s2k (triple dec)
☐	repeat
■	no st

Note: Only uneven rnds are charted.
Even rnds are always k.

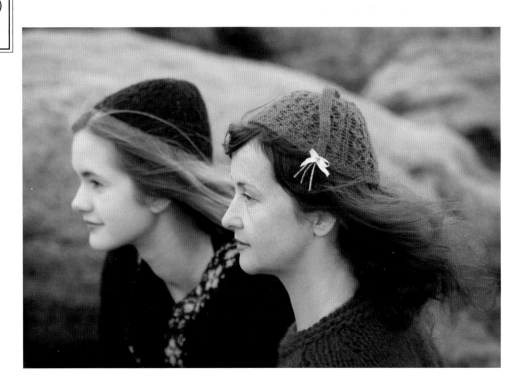

SPECIAL TECHNIQUES

TECHNIQUE 1A: AFTERTHOUGHT THUMB

An afterthought hole can be useful for making a peasant-style thumb or an afterthought sock heel.

To Mark the Hole:

Knit the stitches indicated with contrasting scrap yarn.

Place stitches back on left needle.

Knit them again in pattern motif, k to EOR (1).

Pick up stitches around the hole by inserting needle under the right leg of each stitch

under (2)

above (3)

Remove scrap yarn using a threading needle, for example (4). Stitches are on needle ready to knit (5).

When knitting a stranded motif, some picked up stitches may look strange (6) because they are in fact both the stitch and the float, but once knitted, they will be just fine.

Closing the Gaps

The afterthought hole leaves two gaps on each side of the hole that need to be closed. They can be closed afterward by sewing. The gaps can also be closed by picking up a stitch in the gap; this will make an extra stitch, often desirable for a three-dimensional thumb, which can be suppressed by knitting 2 stitches together in the next round. This may still leave tiny holes that can be closed afterward by sewing.

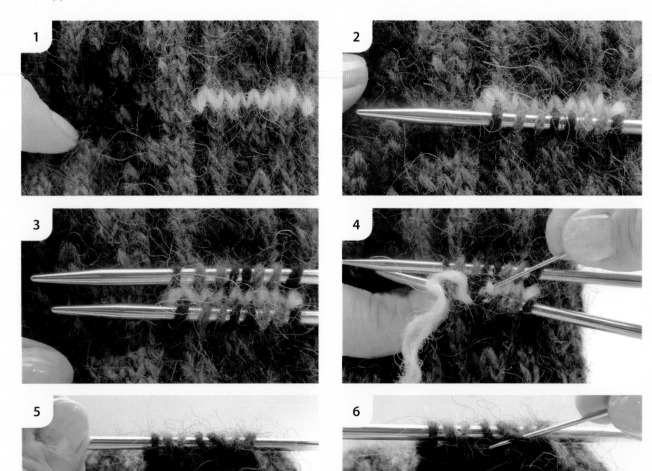

TECHNIQUE 1B: DOUBLE-LIFTED DECREASE

A double-lifted decrease can also be worked to close the gap. This method will add an extra st but leave no holes at all (6).

When coming to the hole, with the tip of right needle, lift the stitch on left needle (1) from the row under onto left needle (2).

With the tip of right needle, lift the stitch on same needle (3) from 2 rows under onto left needle (4) (you can also lift it with the tip of left needle and correct the mount of this second stitch).

Knit the two stitches together (5).

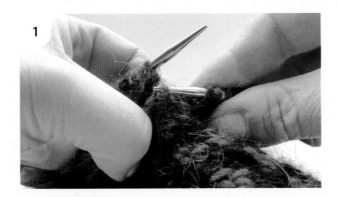

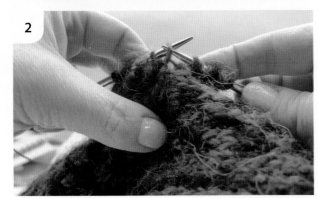

TECHNIQUE 2: LONG-ARMED CROSS-STITCH

The Old Icelandic cross-stitch or long-arm cross-stitch is also known as Slav stitch, long legged cross-stitch, plaited Slav stitch, Greek stitch, Portuguese stitch, and twist stitch.

Stitches are worked from left to right, then in the next row from right to left. To do so, embroider back, reversing the stitches. This way, you don't have to break the embroidery yarn as often as you would if you always stitched in the same direction. However, this makes a different visual effect.

1. Embroider from left to right.

2. Embroider from right to left.

3. When a stitch stays alone, for a similar visual effect, work a cross with 3 legs.

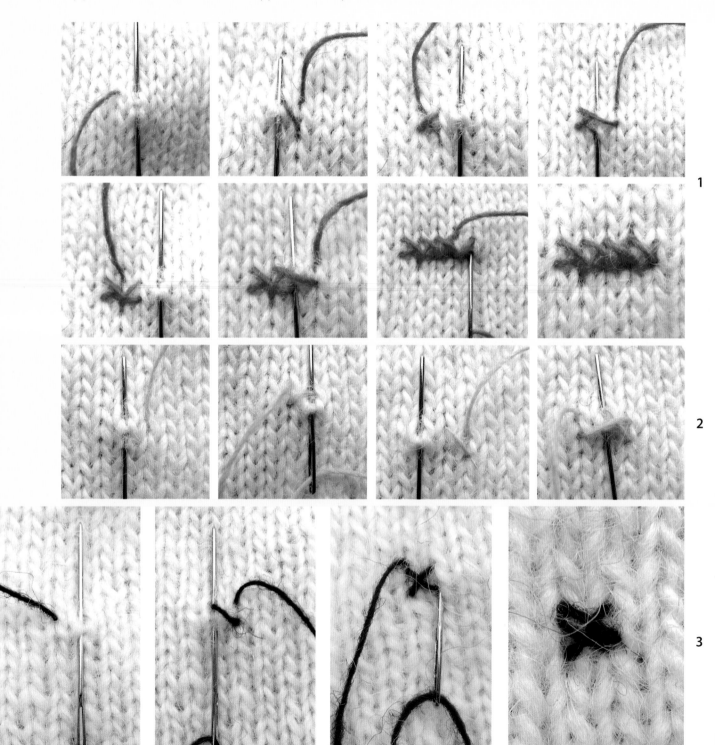

1

2

3

TECHNIQUE 3: KNITTING WITH BEADS

1. Thread needle, make a loop, secure it, and draw the end of the yarn through the loop, leaving a 4"/10cm long tail.

2. Slide beads on yarn.

3. Place bead.

4. Knit stitch.

5. The bead sits at the back of the work between 2 stitches.

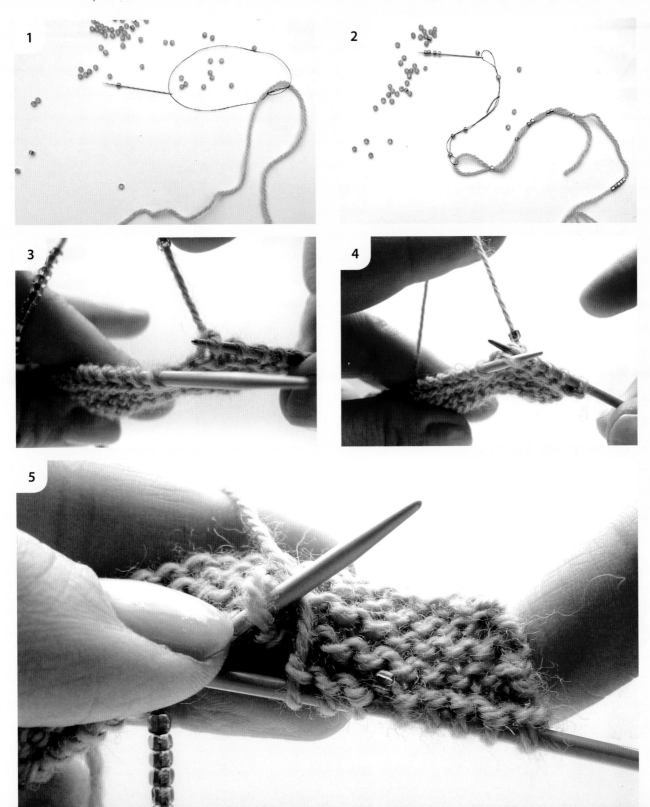

TECHNIQUE 6: JOGLESS JOIN

Because when knitting in the round you are in fact working spiral rows, a disgraceful jog appears at color changes. To avoid it, you can work a jogless join.

At the end of the round (1), when about to change colors, slip last stitch in the round back on the left needle (2).

Knit with the new color (the slipped last stitch included) (3).

Stop at the end of the round, just before the stitch that was slipped (4).

With the tip of right needle, lift the previous color slipped stitch (5) under new color stitch onto left needle (6) and k2tog lifted stitch and first stitch in new color (7).

The color changes are almost invisible (8 and 9).

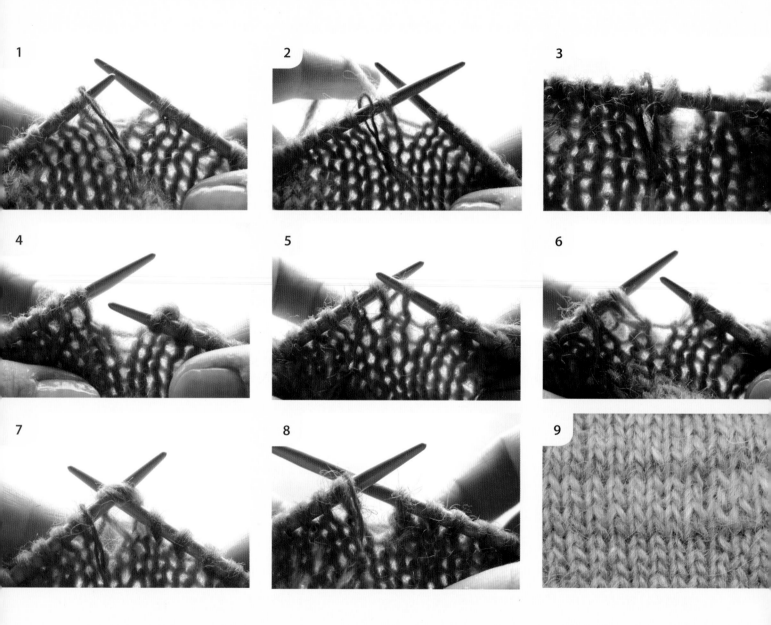

TECHNIQUE 5: YARN OVER SHORT ROWS

A short row is a row that is not fully knitted and thus shorter; the work is turned before reaching the end of the row. At the turning point, this makes a disgraceful hole. Different methods exist to close this gap. In Iceland, the yarn over method seems to be the most popular.

The yarn over (yo) is made after each turning point. When closing the gaps, the yarn over and the stitch on the other side of the gap are knitted together so the yarn over is under the stitch.

If you feel more comfortable with the wrap and turn method, simply read the instructions "turn, yo" as "w&t," and pick up the wraps the way you are used to.

How to make a yarn over (yo) at the beginning of a row:

On knit row, a yo is made by bringing the yarn to the front.

1. The yarn is at the back; bring yarn to the front between the needles.

2. Knit the next stitch.

3. The yarn has formed a loop over the needle.

On purl row, a yo is made by bringing the yarn to the back.

4. The yarn is at the front, bring yarn to the back between the needles.

5. Purl the stitch.

6. The yarn has formed a loop over the needle.

How to close gaps: the yo and the stitch on the other side of the gap are knitted together in such manner that the yo is under the stitch.

7. K2tog if the yo is on the right side of the gap.

8. Ssk if the yo is on the left side on the gap.

When knitting in the round, you are always closing gaps from the knit side, but if you are using the yo method when working back and forth, you may have to close gaps on the purl side. The principle is the same: the yo and the stitch on the other side of the gap are knitted together in such manner that the yo is under the stitch.

9. P2tog if the yo is on the left side of the gap.

10. Ssp if the yo is on the right side of the gap.

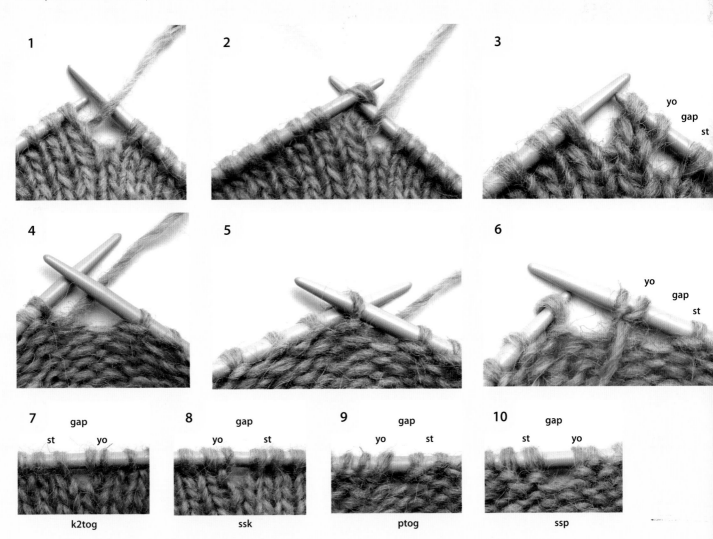

TECHNIQUE 7: CROCHETED CHAIN BIND-OFF

The crocheted chain bind-off makes a very pretty bind-off made of little crocheted arches. It is very elastic and therefore suitable for shawls that need to be stretched extensively.

Using crochet hook, slip stitch required number of stitches together by inserting hook through loops of stitches as if to knit them together through the back loops (1).

Yarn over hook (2).

Pull through all stitches (3).

Yarn over hook (4).

Pull through the 2 stitches (5).

Slip stitches off needle (6).

Chain required number of stitches (7).

Slip stitch required number of stitches together, insert hook through the stitches, and yo hook (8).

Pull the loop through the stitches tbl (9). You can slip stitches off needle right away or keep them on needle while completing step 10 (10).

Yo hook, pull through 2 stitches, yo hook, pull through rem 2 stitches (sc) (11).

Repeat steps 7 through 10 (12).

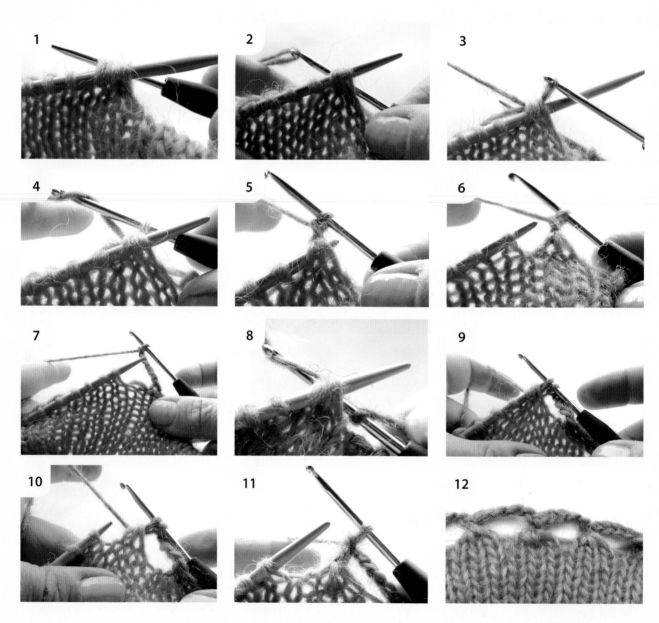

TECHNIQUE 4: STEEK

The word *steek* comes from *stitch*. It is, in fact, some extra stitches that are cast on and are used later to cut the knit.

In the old days, since everything knitted was felted, one would simply cut into the felted knitted fabric without the need for any reinforcement. However, with Icelandic wool, which is rather sticky, it is possible to cut directly into the fabric even if it's not felted. Edges can be simply rolled over 1 stitch and secured with a thread and needle and a few stitches. The steek is later hidden, in a knitted border, for example, and that secures it further.

Nowadays, the most popular method to cut open sweaters in Iceland is to use the sewing machine. One or two extra stitches are added at the cast-on before joining in the round. Those stitches are always purled so you can differentiate them easily, and they are not included in the stitches count.

1–4. Machine-sew a seam on each side of the purled stitches using a small, straight stitch. The idea is to sew where it catches the maximum amount of knitted fabric.

2. Tip: position the machine foot along the edge of the sewing machine, and position the machine needle on the side so the seam is closer to the knit edge.

If you are not using Icelandic wool or sticky wool, you may want to sew a double seam on each side.

5. Cut between seams.

6. The sewing machine is also used to form a "V" neckline. No extra stitches for steeking are included; sew directly in the knit.

7. Cut away the excess fabric.

ABBREVIATIONS

beg	begin, beginning, begins	rnd(s)	round(s)
BO	bind off	RH	right-hand
CC	contrast color	RS	right side (of work)
ch	chain	s2sk	slip 2 sts as if to k2tog, slip 1 st as if to knit, insert left needle in 3 sts and k3tog through back loops (central double decrease)
cm	centimeter(s)		
cont	continue(s)		
dec(s)	decrease(s)	sc	single crochet
dpn	double-pointed needle(s)	sk2p	slip 1 st, k2tog, pass slip st over (RS)
EOR	end of round (row)	sp2p	slip 1 st, p2tog, pass slip st over (WS)
foll	follow(s), following	sl	slip
inc(s)	increase(s)	ssk	[slip 1 st knitwise] twice from left needle to right needle, insert left needle tip into front of both slipped sts, k2togtbl
k	knit		
k1f&b	knit into front, then back of same st (increase)		
		s2kp2	slip 2 sts as if to k2tog, k1, then pass the 2 slipped sts over the knit st, knit both sts together from this position (decrease)
k1f,b&f	knit into front, back, then front again of same st (increase 2 sts)		
k1-tbl	knit 1 st through back loop	s2sk	sl 2 as if to k2tog, sl1, insert left needle tip into the 3 slipped sts, and k3tog tbl
k2tog	knit 2 sts together (decrease)		
k2tog-tbl	knit 2 sts together through back loops (decrease)	s2s2k	[slip 2 as if to k2tog] twice, insert left needle tip in the four slipped sts and k4tog tbl
kwise	knitwise	ssp	[slip 1 st knitwise] twice from left needle to right needle, return both sts to left needle and purl both together through back loops
LH	left-hand		
m(s)	marker(s)		
MC	main color		
mm	millimeter(s)	st(s)	stitch(es)
M1	make 1 (increase)	St st	stockinette stitch
M1k	make 1 knitwise	tbl	through back loop
M1p	make 1 purlwise	tog	together
pat(s)	pattern(s)	w&t	wrap next st, then turn work (often used in short rows)
p	purl		
p1f&b	purl into front then back of same st (increase)	WS	wrong side (of work)
		wyib	with yarn in back
p1-tbl	purl 1 st through back loop	wyif	with yarn in front
p2sso	pass the 2 slipped sts over	yb	yarn back
p2tog	purl 2 sts together (decrease)	yf	yarn front
pm	place marker	yo	yarn over
psso	pass slip st(s) over	*	repeat instructions from *
pwise	purlwise	()	alternate measurements, and/or instructions
rem	remain(s), remaining	[]	instructions to be worked as a group specified number of times
rep(s)	repeat(s)		

YARN SOURCES

Ístex
www.istex.is

Love Story by Hélène Magnusson
www.icelandicknitter.com

Knit Picks
www.knitpicks.com

Laine et tricot
www.laine-et-tricot.com

KNITTING REFERENCES

Bjarnadóttir, Halldóra. *Weaving in Icelandic Homes in the Nineteenth and First Half of the Twentieth Century (Vefnadur á íslenskum heimilum á 10. öld og fyrri hluta 20.aldar, 1966)*. Blönduós: The Textile Museum, 2009.

Guðjónsson, Elsa E. *Notes on Knitting in Iceland*. Reykjavík: Elsa E. Guðjónsson, 1985.

Halldórsdóttir, Sigríður. *Three-cornered and Long Shawls (Þríhyrnur og langsjöl 1988)*. Reykjavík: Sigríður Halldórsdóttir, 2006.

Helgafell, Vaka. *Knitting with Icelandic Wool*. Reykjavík: 2011.

Magnússon, Hélène. *Icelandic Knitting Using Rose Patterns (Rósaleppaprjón í nýju ljósi, 2006)*. Turnbridge Wells, UK: Search Press, 2008.

Magnússon, Hélène. *The Icelandic Lace Dresses of Aðalbjörg Jónsdóttir*. Reykjavik: Prjónakerling, 2013.

Nargi, Lela. *Knitting Around the World: A Multistranded History of a Time-honored Tradition*. Minneapolis, MN: Voyageur Press, 2010.

Shea, Terri. *Selbuvotter: Biography of a Knitting Tradition*. Seattle, WA: Spinningwheel LLC, 2007. www.selbuvotter.com

Sibbern Bohn, Annichen. *Norwegian Knitting Design*. Seattle, WA: Spinningwheel LLC, 2011.
www.norwegianknittingdesigns.com

Icelandic Knitting References

Briem, Elín. *Kvennafræðarinn*. Reykjavík: 1888.

Jóhannsdóttir, Elísabet Steinunn. *Skagfirskir rósavettlingar*. Sauðárkróki: Elísabet Steinunn Jóhannsdóttir, 2003.

Gísladóttir, Hallgerður. *Íslensk matarhefð*. Reykjavík: Mál og menning,1999.

Guðjónsson, Elsa E. *Handíðir horfinnar aldar—Sjónabók frá Skaftafelli*. Reykjavík: Mál og menning, 1994.

Guðjónsson, Elsa E. *Íslenskur útsaumur*. Reykjavík: Veröld, 1985.

Guðjónsson, Elsa E. "Listræn textíliðja fyrr á öldum," *Hlutavelta timans*, Þjóðminjasafn Íslands, 2004.

Jónasson, Jónas. *Íslenzkir þjóðhættir*. Reykjavík: Ísafoldarprentsmiðja, 1961.

Lárusdóttir, Inga Lára, "Vefnaður, prjón og saumur" in Guðmundur Finnbogason, Iðnsögu Íslands, 2. bindi, 1943.

Ólafsdóttir, Fríður. *Íslensk karlmannaföt 1740–1850*. Reykjavík: Fríður Ólafsdóttir, 1999.

Pjetursdóttir, Þóra, Jarþr Jónsdóttir, and Þóra Jónsdóttir. *Leiðarvísir til að nema ýmsar kvenlegar hannyrðir*, Reykjavík: Munstur og Menning, 1886.

Sverrisdóttir, Áslaug, "Tóskapur," Hlutavelta timans, Þjóðminjasafn Íslands, 2004.

Icelandic Magazines

Hugur og Hönd, Rit Heimilisiðnaðarfélags Íslands, Reykjavík

Hlín. Ársrit Íslenskra kvenna, Reykjavík

Standard Yarn Weight System

Categories of yarn, gauge ranges, and recommended needle and hook sizes

Yarn Weight Symbol & Category Names	0 Lace	1 Super Fine	2 Fine	3 Light	4 Medium	5 Bulky	6 Super Bulky
Type of Yarns in Category	Fingering 10 count crochet thread	Sock, Fingering, Baby	Sport, Baby	DK, Light Worsted	Worsted, Afghan, Aran	Chunky, Craft, Rug	Bulky, Roving
Knit Gauge Range* in Stockinette Stitch to 4 inches	33–40** sts	27–32 sts	23–26 sts	21–24 sts	16–20 sts	12–15 sts	6–11 sts
Recommended Needle in Metric Size Range	1.5–2.25 mm	2.25–3.25 mm	3.25–3.75 mm	3.75–4.5 mm	4.5–5.5 mm	5.5–8 mm	8 mm and larger
Recommended Needle U.S. Size Range	000 to 1	1 to 3	3 to 5	5 to 7	7 to 9	9 to 11	11 and larger
Crochet Gauge* Ranges in Single Crochet to 4 inch	32-42 double crochets**	21–32 sts	16–20 sts	12–17 sts	11–14 sts	8–11 sts	5–9 sts
Recommended Hook in Metric Size Range	Steel*** 1.6–1.4mm Regular hook 2.25 mm	2.25–3.5 mm	3.5–4.5 mm	4.5–5.5 mm	5.5–6.5 mm	6.5–9 mm	9 mm and larger
Recommended Hook U.S. Size Range	Steel*** 6, 7, 8 Regular hook B–1	B–1 to E–4	E–4 to 7	7 to I–9	I–9 to K–10½	K–10½ to M–13	M–13 and larger

* GUIDELINES ONLY: The above reflect the most commonly used gauges and needle or hook sizes for specific yarn categories.

** Lace weight yarns are usually knitted or crocheted on larger needles and hooks to create lacy, openwork patterns. Accordingly, a gauge range is difficult to determine. Always follow the gauge stated in your pattern.

*** Steel crochet hooks are sized differently from regular hooks–the higher the number, the smaller the hook, which is the reverse of regular hook sizing.

Ingibjörg Jónsdóttir (1889–1970) sits, in riding clothes, on the horse called Stóra Jarp. Her daughter-in-law, Sigríður Guðmundsdóttir (1896–1955), is riding sidesaddle on the horse Nasa. The children of Ingibjörg—Ottó Finnsson (1920–1988), Gígja Finnsdóttir (born 1922), and Elísabet Finnsdóttir (born 1929)—are standing nearby. The Textile Museum in Blönduós

ACKNOWLEDGMENTS

My husband and family have been very patient and supportive of me, and I thank them and love them for that.

I thank Elín S. Sigurðardóttir, manager of the Textile Museum, for her enthusiasm, for her hard work, and for making the museum such a fantastic place.

Thank you to Fríður Ólafsdóttir, historian and textile expert, Associate Professor in Textiles at the University of Iceland, who was so kind to read over the historical part of the manuscript.

Thank you to Teri Shea, author of *Selbuvotter: Biography of a Knitting Tradition*, for kindly giving her expertise about the Nordic mittens in the Textile Museum.

All the knitters who helped me to knit the garments were wonderful; they did a tremendous job and sometimes did far more than what I expected of them:

Berglind Hafsteinsdóttir, berglindhaf.blog.is/

Ingibjörg Ólafsdóttir

Jóhanna Bibbins, Knitting My Day Away, knittingmydayaway.com

Maria Ekblad, Stickfia on Ravelry

Véronique Chermette, www.barjolaine.com

Véro M, Côtés Passions, verom.canalblog.com

Photographer Arnaldur Halldórsson did a great job taking pictures of frozen models in the snow and the wind. I wanted the photos to convey a sense for a strong and independent Icelandic woman, in the spirit of the energetic Halldóra Bjarnadóttir. Both Arnaldur and the models played along and were very courageous; the book was completed in January and the pictures were taken during a winter storm, complete with lots of snow, wind, and cold temperatures. Sometimes we had to interrupt the shoot because there was so much snow we could no longer see the garments! Fortunately, Iceland also has many outdoor geothermal swimming pools, and we ended every photo shoot in the fuming hot tubs to warm us up.

I thank my fearless models, who braved the elements and the Icelandic blizzard: Brúno the teddy bear, Leó, Jón Gauti, Örmundur, Þórhilldur Steinunn, and yours truly.

And last but not least, I thank Kari Cornell, my editor, for her trust and faith in my work. Thanks to the entire team at Voyageur Press, for turning my ideas into this wonderful book.

ABOUT THE AUTHOR

Hélène Magnusson is an Icelandic knit designer with a degree in textile and fashion. She was featured as an historically significant contemporary designer in Iceland in the book *Knitting Around the World* by Lela Nargi. Her research into, and many publications about, Icelandic knitting traditions have earned her the respect of textile historians and museum curators throughout Iceland and around the world.

Hélène believes that the best way to preserve traditions is to continue using them, giving them new life. This is what led her to found *The Icelandic Knitter*, the first Icelandic online knitting magazine, where she publishes patterns inspired by tradition but with a modern twist. In the same spirit, she produces Love Story yarns, a range of artisanal yarns that make the best out of the Icelandic wool. She shares her extensive knitting knowledge in the hiking and knitting tours she organizes with Icelandic Mountain Guides. The tours attract knitters from all over the world for an unforgettable experience where Icelandic traditions and culture, breathtaking nature, and master knitting workshops perfectly balance one another.

Hélène's exclusive designs have been exhibited widely both in Iceland and elsewhere. She is the author of many books. *Icelandic Color Knitting: Using Rose Patterns*, a colorful book about traditional Icelandic intarsia, has become a classic and has been translated into many languages. Her designs and articles have been featured in many publications, including the "Around the World" books by Voyageur Press and magazines such as *Burda, The Knitter, Yarn Forward, Piece Work*, and *Knitting Traditions*. Learn more about her on her website: icelandicknitter.com

ABOUT THE PHOTOGRAPHER

Arnaldur Halldórsson was born in 1971 in Reykjavík. He studied photography at the Bournemouth and Poole College of Art and Design in England (1990–92) and the Parsons School of Design in Paris, France (1992–93). Arnold's work includes commercial, press, and industrial photography for many of Iceland's largest companies and advertising agencies. Arnold's photography has appeared in *Time Magazine, Dwell, Outdoor Magazine*, the BBC, and Reuters. He is currently the exclusive photographer in Iceland for Bloomberg Financial News. Arnold teaches landscape photography workshops throughout Iceland, offering foreigners a chance to explore and capture the country's beauty and exceptional light. More about him on www.pix.is.

INDEX

accessories
 Perluband: Beaded Hairband & Arm band, 54–57
afterthought thumb, 107, 132
Ágústsdóttir, Ragna, 75

bags
 Skagafjörður Tote Bag, 38–43
Baldvinsdóttir, Guðbjörg, 102
Bjarnadóttir, Halldóra, 10–12, 20, 45, 51–52, 59, 71, 97, 101, 103, 111, 116
blankets
 Broken Rose Blanket, 96–99
Bohn, Annichen Sibbern, 46
Briem, Eirik, 71
Briem, Elín, 111
Brynjólfsdóttir, Sigurbjörg, 23, 35

children's clothing
 Perfect Little Icelandic Sweater, 70–73

Egilsdóttir, Þordís, 109, 129

footwear
 Icelandic Shoe Inserts, 82–87
 Icelandic Soft Shoes, 88–91

Guðjónsson, Elsa E., 97
Guðmundsdóttir, Sigrún, 26
Guðmundsdóttir, Vígdis, 111
Guðmundsson, Sigurður, 61, 67

hats and headwear
 Checkered Beanie & Mittens, 18–22, 75
 Lace Hood, 129–131
 Lacy Skotthúfa, 124–127
 Leaf Mittens, Slouchy Cap & Scarf, 24–33

Perluband: Beaded Hairband & Armband, 54–57

Icelandic intarsia, 81, 83–84, 93–94, 97–98
Icelandic wool, 112
 Love Story yarn, 113

Jóhannesdóttir, Jóhanna, 111
Jóhannsdóttir, Elísabet Steinunn, 36
Jóhannsdóttir, Margrét, 121
Jónsdóttir, Aðalbjörg, 12
Jónsdóttir, Björg, 71
Jónsdóttir, Jónsina, 46
Jónsdóttir, Þuríður, 105
Jónsdóttiri, Kristín, 61

Kristjansdóttir, Vigdís, 97

Lindal, Margrét Jakobsdóttir, 114–115

Magnússon, Skúli, 72
mittens
 Checkered Beanie & Mittens, 18–22
 cross-stitch, 36
 Leaf Mittens, Slouchy Cap & Scarf, 24–33
 Nordic Leaf Mittens, 44–49
 Perlusmokkar: Beaded Wrist Warmers, 50–53
 Skagafjörður Mittens, 34–37
 working, 23

Ólafsdóttir, Fríður, 71

peysuföt costume, 68
pillows
 Step Rose Cushion, 92–95

Þórðardóttir, Sigríður, 97
Þorgilsdóttir, Björg, 46

scarves
 Leaf Mittens, Slouchy Cap & Scarf, 24–33
shawls and capelets
 Halldóra Long Shawl, 110–113
 Margrét Triangular Shawl, 114–119
 Mötull Capelet, 66–69
Símonardóttir, Guðrún, 35
skirts
 Klukka Skirt, 120–123
Snaehólm, Elin Guðmundsdóttir, 76
socks
 Sock Band Socks, 104–107
 Togara Socks, 100–103
sweaters
 lopi, 15, 61, 76
 Missing Lopi Sweater, 74–79
 Mötull Capelet, 66–69
 Perfect Little Icelandic Sweater, 70–73
 Skautbúningur Sweater, 60–65, 67

techniques
 closing the gaps, 36, 62–63, 76, 106, 132
 crocheted chain bind-off, 117, 130, 138
 double-lifted decrease, 20, 26, 46, 102, 107, 133
 jogless join, 45, 106, 136
 knitting with beads, 135
 long-armed cross-stitch, 134
 yarn over method for short rows, 103, 105, 137

Textile Museum in Blönduós, Iceland, 7–12, 15, 19, 35, 45, 51, 59, 75, 81, 83, 89, 93, 109, 111–112, 121, 125